Sony® Alpha SLT-A65/A77

FOR

DUMMIES®

Sony® Alpha SLT-A65/A77

FOR DUMMIES®

by Robert Correll

WILEY

John Wiley & Sons, Inc.

Sony® Alpha SLT-A65/A77 For Dummies®

Published by
John Wiley & Sons, Inc.
111 River Street
Hoboken, NJ 07030-5774

www.wiley.com

For general information on our other products and services, please contact our Customer Care Department within the U.S. at 877-762-2974, outside the U.S. at 317-572-3993, or fax 317-572-4002.

For technical support, please visit www.wiley.com/techsupport.

Wiley publishes in a variety of print and electronic formats and by print-on-demand. Some material included with standard print versions of this book may not be included in e-books or in print-on-demand. If this book refers to media such as a CD or DVD that is not included in the version you purchased, you may download this material at http://booksupport.wiley.com. For more information about Wiley products, visit www.wiley.com.

Library of Congress Control Number: 2012935980

ISBN 978-1-118-24380-0 (pbk); ISBN 978-1-118-33040-1 (ebk); ISBN 978-1-118-33109-5 (ebk); ISBN 978-1-118-33321-1

Manufactured in the United States of America

10 9 8 7 6 5 4 3 2 1

WILEY

About the Author

Robert Correll is the author of several books about digital photography and imaging, including *Digital SLR Photography All-in-One For Dummies.* His most recent titles include *Sony Alpha SLT-A35/A55 For Dummies; Photo Retouching and Restoration Using Corel PaintShop Pro X4,* Third Edition; *HDR Photography Photo Workshop,* Second Edition (with Pete Carr); *Canon EOS Rebel T3/1110D* and *Canon EOS 60D For Dummies* (both with Julie Adair King); and *High Dynamic Range Digital Photography For Dummies.*

When not writing, Robert enjoys family life, photography, playing the guitar, grilling, and recording music. Robert graduated from the United States Air Force Academy and resides in Indiana.

Dedication

To my family.

Author's Acknowledgments

I want to express my profound appreciation to everyone I had the pleasure of working with on this project. Each person devoted their skills, talents, attention to detail, vision, and time. Those are valuable commodities.

In particular, I am deeply grateful to the wonderful publishing team at John Wiley & Sons. Tonya Cupp, Steve Hayes, and Katie Crocker are just some of the talented editors who helped make this book possible. I am also thankful to technical editor Scott Proctor, whose insights and expertise helped keep this book on the straight and narrow.

Many thanks to David Fugate at Launchbooks.com.

I also want to shout out a big "Thank you!" to Pine Hills Church.

As always, my wife and children encourage, support, and sustain me.

Thank you!

Publisher's Acknowledgments

We're proud of this book; please send us your comments at http://dummies.custhelp.com. For other comments, please contact our Customer Care Department within the U.S. at 877-762-2974, outside the U.S. at 317-572-3993, or fax 317-572-4002.

Some of the people who helped bring this book to market include the following:

Acquisitions, Editorial

Project and Copy Editor: Tonya Maddox Cupp

Executive Editor: Steve Hayes

Technical Editor: Scott Proctor

Editorial Manager: Jodi Jensen

Editorial Assistant: Amanda Graham

Sr. Editorial Assistant: Cherie Case

Cover Photo: © Darren Kemper / Corbis

Cartoons: Rich Tennant
(www.the5thwave.com)

Composition Services

Project Coordinator: Katherine Crocker

Layout and Graphics: Claudia Bell, Carl Byers, Melanee Habig, Joyce Haughey, Jennifer Henry, Corrie Niehaus, Lavonne Roberts

Proofreaders: Rebecca Denoncour, Susan Hobbs

Indexer: BIM Indexing & Proofreading Services

Publishing and Editorial for Technology Dummies

Richard Swadley, Vice President and Executive Group Publisher

Andy Cummings, Vice President and Publisher

Mary Bednarek, Executive Acquisitions Director

Mary C. Corder, Editorial Director

Publishing for Consumer Dummies

Kathleen Nebenhaus, Vice President and Executive Publisher

Composition Services

Debbie Stailey, Director of Composition Services

Contents at a Glance

Table of Contents

Introduction

*T*he story of the Sony A65/A77 begins with two other camera manufacturers, Konica and Minolta. These storied names in camera history merged in 2003, but soon thereafter (2006) decided to leave the camera business and focus on other, more business-oriented technologies. Go figure. They transferred all their camera assets to Sony, which has continued developing the Konica Minolta dSLR line under the Sony Alpha brand name. Since 2006, Sony has established itself as a serious player in the dSLR community, offering both entry-level and full-frame professional models.

Recently, Sony has upped the technological ante by introducing cameras, including the A65/A77, with translucent mirrors: *dSLTs* (digital single-lens translucent). Traditional dSLRs, like their SLR forefathers, use a reflex mirror to bounce light coming through the lens up into the viewfinder so you can compose the scene and focus with the assurance that you're seeing what the camera sees. Just before the shutter opens to take the photo, though, the mirror has to flip up out of the way to expose the film or sensor as the shutter opens,. That's the loud "clunk" you hear when you take a picture with a dSLR and why the mirrors are called reflex mirrors. They move. The translucent mirror in the A65/A77 doesn't have to flip up out of the way when you take a picture. The light bounces off it *and* goes right through it, whether you're framing, focusing, or taking the picture. Having a stable, translucent mirror makes the camera quieter, faster, lighter, and more mechanically reliable.

Another new-to-dSLR feature of the A65/A77 is the electronic viewfinder. Instead of seeing light bounced off a mirror, through a prism, and out the viewfinder (a lot of light was bouncing in the old days), you look at a high-contrast, high-resolution electronic display. The electronic viewfinder functions like its optical counterpart in many ways, but it has some major advantages. You can look at camera menus, view photo and movie playback, check shooting functions, turn on a histogram, and see other displays impossible for normal viewfinders.

About This Book

This book's purpose is to put the right information in your hands so you can take advantage of the technological prowess of your A65/A77. You don't need to know anything about photography before opening these pages. In classic *For Dummies* style, I explain everything in easy-to-understand language and use plenty of color photos to show off the cameras and make the photographic concepts easier to understand.

How This Book Is Organized

This book is organized into four parts. Each one has a particular focus. They flow from what you need to start out to more advanced subjects. You can read the book from start to finish and progress from beginner to advanced user — or you can jump to any section in any chapter and dig right in. Use the table of contents, the index, and the chapter cross-references to jump to sections with related information.

Here's a quick look at what you can find in each part.

Part I: Pictures Worth Keeping

This part contains four chapters designed to familiarize you with your A65/A77 and get you started taking pictures and movies as quickly as possible. Chapter 1 is where you get to know your A65/A77. You'll see where all the buttons and dials are, what they do, and how to use them. You find steps for navigating the menu system, the shooting functions, and how to decode the viewfinder and LCD displays. Chapter 2 covers the necessary first settings. You read about the basic shooting modes, other important settings, how to use the flash, how to set picture quality, size, and aspect ratio, as well as which settings make the most sense for you. Chapter 3 is devoted to explaining, in practice, all of the basic shooting modes. Chapter 4 is all about making movies: how to configure the camera, which options are best for you, and how to shoot and review them.

Part II: Playing with Pixels

In this part, you read about what to do after you take a photo. This includes playing back photos on your camera as well as transferring them to your computer. In Chapter 5, you'll see the ins and outs of photo playback. Review pictures, look at the settings you used, change the display to include more or less information, delete photos, rotate photos, set up a slide show, and show off your photos on an HDTV. Chapter 6 is where you read how to transfer what you've stored on your memory card from the camera to a computer. Once there, you can process, print, and share photos and movies.

Part III: Expressing Your Creativity

Part III explains the concepts you need to operate your camera in the more advanced modes, which allows you to make creative decisions on your own. You see how to make exposure and flash decisions in Chapter 7. Use the advanced exposure modes and decide what exposure settings you want to use to create the photos you like. Change the metering mode, use the histogram, and use other advanced exposure tools on the A65/A77. You also

read more about the flash. Chapter 8 is about working with focus and color. Explore the autofocus options, depth of field, and color issues such as setting the right white balance. You also see how to apply creative styles and choose a color space. Chapter 9 is a putting-it-all-together chapter. With this information you can take pictures in advanced exposure modes. Review good general settings, come up with a plan, then photograph portraits, landscapes, close-ups, and more.

Part IV: The Part of Tens

Always a favorite, The Part of Tens concludes the book with two chapters of essential non-essential information. In Chapter 10, you read about how to customize your camera. Feel free to experiment with features like using the save mode, turning off the Live View effects, using peaking to help you manually focus, and configuring the displays you want to see. Chapter 11 concludes the book with a list of ten more interesting features that you might want to check out on a rainy day. These include using picture effects, GPS, and options like wireless flash and the smart teleconverter.

Icons Used in This Book

If this isn't your first *For Dummies* book, you may be familiar with the large, round art (aka *icons*) that decorate its margins. If not, here's your very own icon-decoder ring:

Danger is lurking. Pay attention and proceed with caution. You know, as though you were about to open a hatch you shouldn't (Locke) or be so foolish as to be a minor character lecturing people about the dangers of dynamite while wrapping an old stick of it in a shirt on a deserted island (so long, Artz).

This icon should trigger an immediate data download for storage in your brain's long-term memory. The information is something important that rises above the level of a cute tip but not quite to the danger of a warning. As Spock would say, *Remember*.

Here lies helpful information that's likely to make your life easier. It may save you time, effort, or sanity. (Your mileage may vary.) I love tips. If I could, I would make every paragraph a tip.

Some of the information in this book is pretty technical. If it's not necessary for you to understand, it's marked with this icon. Use the information to impress your family and friends. Or skip it completely.

Conventions Used in This Book

I should point out a few other details that will help you use this book:

- ✔ **Margin art:** Small versions of menu graphics appear in the margin next to relevant material. They will look like what you see to the left.

- ✔ **Software menu commands:** In sections that cover software, a series of words connected by an arrow indicates commands you choose from the program menus. For example, if a step tells you, "Choose File⇨Print," click the File menu and then click the Print command on the menu.

eCheat Sheet

You can find an electronic version of the famous *For Dummies* Cheat Sheet at www.dummies.com/cheatsheet/sonyalphaA65A77. The Cheat Sheet contains a quick reference to all the buttons, dials, switches, and exposure modes on your camera. Log on, print it out, and tape it to the wall above your desk or bed. If you need to, carry it with you when you're out shooting.

Where to Go from Here

Knowing how to operate sophisticated cameras like the A65 and A77 can seem like a daunting task. Both cameras have a plethora of buttons, features, displays, functions, modes, and procedures. In the beginning, you may be assault yourself with negative thoughts such as, "I will never master this!"

Don't panic!

Put the camera in Auto or Auto+ mode and concentrate on feeling the camera in your hands. Take pictures. Take lots of pictures! Become *comfortable* with it. If you don't want to use the flash but it keeps trying to pop up, put the camera in Flash Off mode if you're using the A65. If you're using the A77, turn off the flash in auto mode from the shooting functions. Then take more pictures!

The hands-on experience that you accumulate will sink in. I know. If you practice and don't give up, you'll accomplish what you set out to do. I've put the information in this book that I think you need to get started, and more. Have fun! Slap on the back. Graduation ceremony at 11.

Occasionally, we have updates to our technology books. If this book does have technical updates, they will be posted at www.dummies.com/go/sonyalphA6577updates.

Part I

Pictures Worth Keeping

The 5th Wave By Rich Tennant

"I've got some new image editing software, so I took the liberty of erasing some of the smudges that kept showing up around the clouds. No need to thank me."

*V*ery simply, this part gets you up and running.

It explains all the buttons, bells, and whistles on your A65/A77. See how to set up the camera, navigate the menus, select shooting modes, choose functions, and decide on photo quality and size. Read all about the basic shooting modes so you can start taking amazing photos right off the bat. See how to use scenes, how to Sweep Shoot your way to panoramas, and how to use the super-fast photo-taking mode. The last chapter in this part covers how to shoot movies in full HD.

1

Meeting the A65 and A77

*T*he A65 and A77 are complicated cameras. They have lots of buttons, displays, dials, and knobs. You must know how to attach and remove lenses, insert and remove the battery and memory card, and work the menus and shooting functions. Whether you're upgrading from a simpler digital SLR/SLT or replacing a sophisticated but older camera, this chapter has the information you need to start making full use of your machine.

Comparing Super and Duper

Despite being similar, the two cameras have several key differences. I note them here and explain them more fully where appropriate.

✔ **LCD monitor:** The A65 sports a fancy tilt/swivel monitor, shown in Figure 1-1. The A77 sports an even fancier three-way tilt/swivel LCD screen, also shown in Figure 1-1. I cover both later in this chapter. After that, it's up to you to tilt, swivel, and turn your monitor when you need to.

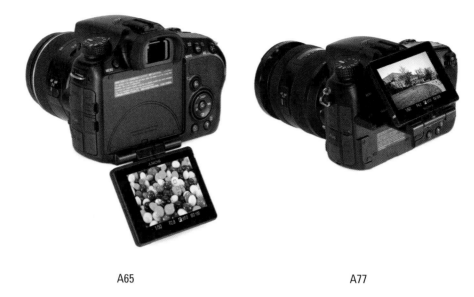

A65 A77

Figure 1-1: These LCD monitors can twist and shout in their own unique ways.

✔ **Buttons and dials:** The A65 and the A77 have physical similarities. Their differences are most obvious in the type, number, and layout of their buttons and dials. The A77 has more buttons on top, as well as a second control dial and a multi-selector instead of a control button. In addition, some buttons that share primary functions, like the AEL and Smart Teleconverter buttons, have different alternate and tertiary roles. All these differences, and the similarities, are covered in detail in this chapter.

✔ **Information display:** The A77 has a cool-looking pro-style information display on the top of the camera, as shown in Figure 1-2. It displays important shooting information and is helpful when you're looking down on the camera.

✔ **Pro-level features:** The A65 has a number of pro-level features, but the A77 has more. You can store your shooting settings in memory (covered in Chapter 11), have fun with more creative styles (see Chapter 8), take advantage of more AF areas

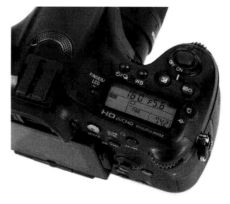

Figure 1-2: Pro-style accoutrements set the A77 apart.

(see Chapter 8), compensate for lens characteristics like peripheral shading and distortion (see Chapter 11), and automatically shoot three exposures with different D-range optimizer settings (see Chapter 2), to mention a few. The A77 also has a flash sync cord terminal to connect external flashes or studio strobes.

Optional vertical grip

Optional vertical grip

The A77 also has an optional vertical grip, shown attached from the front and rear in Figure 1-3, that doubles the battery capacity of the camera and lets you hold the A77 normally while you rotate it to shoot in portrait orientation. It's sure to impress your family, friends, and the general public. It's downright awesome. I call it the "I'm not foolin' around" add-on.

Figure 1-3: Reach the pinnacle of awesomeness with pro-style accessories.

Although there are no plans to manufacture the grip for the A65, industrious photographers are looking to overcome this.

- **Pro-level performance:** The A65 provides pro-level performance in terms of frame rate (up to 10 frames per second), video (1080 Full HD video), and other features. The A77, however, performs better in virtually every category. The A77 shoots up to 12 frames per second and has a faster flash sync speed (1/250 second versus 1/160 second) and faster maximum shutter speed (1/8000 second versus 1/4000 second).

- **Lenses:** You can buy the A65 and the A77 with the Sony DT 18–55mm f/3.5–5.6 lens. This decent amateur zoom lens is worth a few hundred dollars. You'll see the A65 sporting this lens in the book. However, you can get the DT 55-200mm f/4-5.6 telephoto zoom lens with the A65, which is similar to the 18–55mm lens in quality and cost, but covers different focal lengths.

You can find the A77 with the same 18–55mm kit lens as the A65, but the more common kit lens is the DT 16–50mm f/2.8. This lens is a significant step up from either of the two lenses the A65 comes with, both in terms of quality and cost. (See Figure 1-16 for a side-by-side comparison.) The 16-50mm lens is downright *ginormous* compared to its 18-55mm cousin, with an impressive feel (quality design, materials, and construction)

and good performance. You'll see this lens on the A77 in most of the pictures in this book. I had to swap it out for the smaller 16–55mm lens in some pictures, however, because occasionally its size made it hard to photograph aspects of the camera (which is the point, after all). If none of these lenses appeal to you, you can buy each camera body without a lens and use your own, or pick up a new lens separately.

Inspecting from Top to Bottom

You need to know your camera: what the controls do, where they are, and how to work them.

Top controls

The top of the camera (see Figure 1-4) is where the really important controls are located. The mode dial dominates the top left, while the power switch, shutter button, and the display panel (on the A77) take precedence on the top right.

Power switch

This one's pretty obvious.

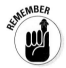

Unlike traditional dSLRs, you can't look through the *electronic* viewfinder and see anything when the power is off.

Mode dial

Aside from the shutter button, the mode dial is probably the most important control. It's how you select an *exposure mode*. Exposure modes determine how the camera operates. Different modes (discussed in Chapter 2) have different creative and practical goals.

The mode dial on the A65 and A77 are subtly different. The A65 has the Flash Off mode; the A77 does not. The A77 has a Memory Recall mode instead.

Shutter button

The shutter button does more than just take pictures:

- Press the shutter fully to take a photo.
- Press it halfway to start autofocus and metering. It is critical that the camera have time to focus and determine the lighting conditions so that the photo is sharp, clear, and properly lit.

Don't punch at the shutter button. It shakes the camera.

Finder/LCD button

The A65/A77 is smart enough to know when you're looking through the viewfinder or at the LCD monitor and switches the display to the appropriate device. Actually, the camera uses the eyepiece sensors to sense when your noggin blocks the light and changes to Viewfinder mode.

Press the Finder/LCD button to switch between the viewfinder and LCD monitor. If you use the viewfinder a lot and don't want the LCD monitor on, disable auto switching from Custom menu 1 and use this button to switch back and forth.

Drive button (A77)

Press the drive button to open the drive selection screen on the A77 and then choose a drive mode such as Single or Continuous Shooting. Chapter 2 has more information about drive modes.

White balance button (A77)

The white balance button opens the white balance selection screen on the A77. This enables you to quickly choose a white balance, as described in Chapter 8.

Exposure button

The exposure button lets you

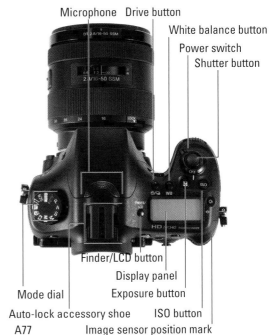

Microphone
Power switch
Shutter button

Finder/LCD button
Mode dial | Exposure button
Auto-lock accessory shoe | ISO button
A65 | Image sensor position mark

Microphone | Drive button
White balance button
Power switch
Shutter button

Finder/LCD button
Display panel
Mode dial | Exposure button
Auto-lock accessory shoe | ISO button
A77 | Image sensor position mark

Figure 1-4: Topside.

dial in exposure compensation: Choose P, A, or S modes. Chapter 7 has more information on exposure compensation.

ISO button

Press to open the ISO menu. See Chapter 7 for information on ISO and how to select different values.

Display panel (A77)

The display panel, located on the top of the A77, gives you another way to view your camera's settings. It shows important exposure and mode information regardless of what's displayed on the LCD monitor or in the viewfinder. The display does reveal different information depending on the mode you're in. The top display panel is covered in more depth later in this chapter.

Display panel illumination button (A77)

Press this baby to light up the A77's top display panel. The panel is backlit with a soft, pleasing, cinnabar glow. (Jump ahead to Figure 1-29.) Press the button again to turn the light off.

Auto-lock accessory shoe

The accessory shoe (otherwise known as a *hot shoe* because it can make an electrical connection between it and the device attached to it) is where you mount an external flash and other accessories. Slide the accessory on the shoe until it snaps in place. The flash has a release button that you press to remove.

Image sensor position mark

This mark tells you exactly where the image sensor is in the camera body. If you ever set up a shot that requires you to know the precise distance between the focal plane on the sensor and the subject (maybe you're taking a photography class, or you plan to set up a shot at the same distance later), use this mark as a reference point.

Microphone

Your A65/A77 has a built-in microphone that lets you record stereo audio for your movies without having to attach an external stereo microphone (although you can do that). Turn to Chapter 4 for more information on making movies and configuring the audio settings.

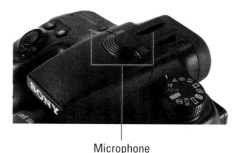

Microphone

Figure 1-5: The mic is close to your face. Breathe lightly.

The mic is close enough to your face that it may record your every breath if you're looking through the viewfinder while recording a movie. Figure 1-5 shows a close-up of the microphone.

Rear controls

The rear of the camera, shown in Figure 1-6, has quite a few important controls, not to mention the viewfinder and LCD monitor. Get to know everything well. Many of the controls are dual use, with a shooting function as well as a playback or other function.

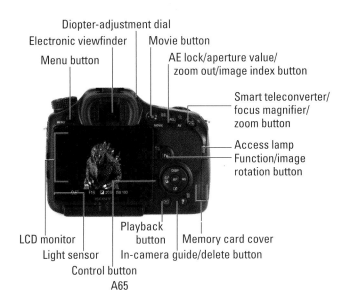

Diopter-adjustment dial
Electronic viewfinder
Menu button
Movie button
AE lock/aperture value/ zoom out/image index button
Smart teleconverter/ focus magnifier/ zoom button
Access lamp
Function/image rotation button
Playback button
LCD monitor
Light sensor
Control button
In-camera guide/delete button
Memory card cover
A65

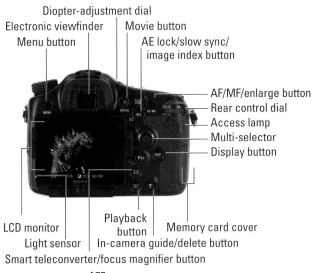

Diopter-adjustment dial
Electronic viewfinder
Menu button
Movie button
AE lock/slow sync/ image index button
AF/MF/enlarge button
Rear control dial
Access lamp
Multi-selector
Display button
Playback button
LCD monitor
Light sensor
In-camera guide/delete button
Memory card cover
Smart teleconverter/focus magnifier button
A77

Figure 1-6: Get a load of all that.

Menu button

Press the Menu button to activate the camera's menu system. This is how you configure the camera and change many of its settings. Menus are covered in this chapter and used throughout the book.

Movie button

The A65/A77 has a Movie button in addition to a Movie mode (which is on the Mode dial). Press the Movie button to start recording auto exposure movies in any shooting mode. Press it again to stop recording. It's that simple. Chapter 4 covers shooting movies in more depth.

AE lock/aperture value/zoom out/image index button (A65)

This button locks the auto exposure settings on the A65 after you've metered the scene, which can be helpful when there's a big lighting difference between your subject and the background. For more information, turn to Chapter 7. You can use this button, in conjunction with the control dial, to change the aperture in Manual mode. It can also zoom out or display the image index when playing back photos. (See Chapter 5 for playback.)

AE lock/slow sync/image index button (A77)

This button serves three purposes on the A77:

- Press it when shooting to lock the exposure.

- When the flash is up, press the button to put the flash in slow sync mode. For more information on locking exposure and using slow sync, please turn to Chapter 7.

- When playing back photos, press the button to view the image index. (Read more on this in Chapter 5.)

Smart teleconverter/focus magnifier/zoom in button (A65)

This button has three functions on the A65:

- Digitally zoom to magnify the center of the photo; it's a teleconverter. (Read more on this in Chapter 11.)

- Magnify the scene you see through the viewfinder or on the LCD and refine the focus. (Read more on this feature in Chapter 8.)

- Zoom in when you are playing photos back.

Sounds like a Make Bigger button to me.

Smart teleconverter/focus magnifier button (A77)

Press this button when shooting to engage the smart teleconverter. (See Chapter 11 for details.) When set to focus magnifier, the same button enables you to zoom in and check your focus; see Chapter 7.

AF/MF/enlarge button (A77)

This handy button lets you quickly switch between auto and manual focus on the A77. (See Chapter 8 for more information.) It also acts as a zoom-in button when playing back photos. (See Chapter 5.)

Rear control dial (A77)

The A77 has a second control dial and it's on the rear of the camera. Use it to zoom in and out when playing back photos or to make other settings changes.

Customize the rear control dial by pressing the Menu button and looking at the Control dial setup and Dial exposure compensation options in Custom menu 4.

Electronic viewfinder

The electronic viewfinder is a versatile piece of equipment. Although you look through it the same way you do on a traditional dSLR, this viewfinder has many more uses. Eyepiece sensors, just above, detect whether you're looking through the viewfinder.

Diopter-adjustment dial

A small but important dial is nestled on the lower-right side of the viewfinder, as pointed out in Figure 1-7. It goes by the super-technical sounding name of *diopter-adjustment dial*. Use this dial to adjust the viewfinder to your eyesight. You find instructions on how to do this later in the chapter.

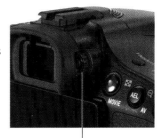

Diopter-adjustment dial

Figure 1-7: Turn the knob to improve your view.

LCD monitor

The LCD monitor has as many functions as the electronic viewfinder. Sony's use of Live view (where you frame the shot based on what you see on the monitor as opposed to looking through the viewfinder) is the best in the business. You can shoot, review, and control the camera from here. You can pull out and rotate the monitor on both cameras. More on this later in the chapter.

Light sensor

The LCD monitor frame on both cameras has a built-in light sensor that adjusts monitor brightness according to the surrounding light level; see Figure 1-8. You can also adjust the monitor's brightness manually (see the LCD Brightness option in Setup menu 1).

Function/image rotation button

You use the Function button when you're shooting. It groups together a lot of shooting settings (also known as *shooting functions*), such as autofocus mode, metering mode, face detection, and creative style. Press the button to see and change the settings. The types of functions you can access depend on whether you're shooting in an automatic (see Chapter 3) or an advanced mode (see Chapters 7 and 8).

Light sensor

Figure 1-8: The sensor helps the monitor stay bright.

Don't use the Function button to get back to shooting when you're playing back photos. When I want to change settings based on what I see in photo playback, I naturally try pressing the Function button to access the shooting functions. The problem is that this button initiates image rotation in playback! If you accidentally press it, don't panic. Simply press it again to cancel image rotation and then press the playback or shutter button to get back to business.

Control button (A65)

The five buttons on the A65 listed in this section are collectively known as *the control button*. However, this book rarely refers to them as that, instead preferring their individual names.

The outer ring is composed of four buttons — one at each cardinal point. Although they're part of the same physical structure, they're considered separate buttons. To press one, simply press that side. The center button is more distinct. Each of the buttons has a shooting purpose and a navigational purpose. The shooting purpose is printed on the back of the camera and is therefore easy to remember. The navigational purpose is also straightforward, once you pair the direction with the correct side of the button.

- *Display/up button:* Press to change the display. Press when you need to go up in a list or menu.

- *White balance/right button:* Press to open the white balance options. It's also the right button.

✏ *Picture effect/down button:* Press to open the Picture Effect menu, which is covered in Chapter 11. This button is also down.

✏ *Drive/left button:* This button opens the drive selection screen. It also navigates left.

✏ *AF/enter button:* Press the AF button as a different way to initiate auto-focus. When you're using local AF area, press the AF button to call up the AF area setup screen and choose an area. This button also serves as the enter button. Think of it as a clicking a mouse or pressing Enter on a keyboard. Use the AF/enter when choosing options from menus, on the Function screen, and in other option screens. A round white button labeled OK in the menu system refers to this button.

Multi-selector (A77)

The A77 doesn't have a control button like the A65. It has a joystick-like device called a *multi-selector.* Unlike the control button on the A65, the multi-selector has no other function. Its sole purpose is to navigate menus, selection screens, and make choices.

You can see the multi-selector from the rear in Figure 1-6. You can see how far it sticks out from the camera back in Figures 1-2 and 1-4.

To make life simpler, I tell you to go left, right, up, or down, or press the enter button, whether you have an A65 or an A77 (although technically they have different controls). This is possible because of the similarity between the A65's control button, *when used to navigate and make selections,* and the A77's multi-selector.

Here's how it works:

✏ **Enter:** Press the center of the multi-selector so that it registers as something like a mouse click.

✏ **Left:** Move the multi-selector to the left.

✏ **Right:** Move the multi-selector to the right.

✏ **Down:** Move the multi-selector down.

✏ **Up:** Move the multi-selector up.

Therefore, when you read a passage that tells you to navigate using the down button and then press the enter button, use the A77 multi-selector to perform those tasks. Press down and then press the center button.

Display button (A77)

Press the Display button to change the shooting or playback display. This concept is explained later in this chapter and in Chapters 4 (for movies) and 5 (for still photos). Chapter 10 has information on how to customize the displays you see.

Playback button

This button is single-mindedly focused on playback. Press it to play back photos or movies. Chapter 5 is devoted to playback as a whole. Chapter 4 has a bit more info on movie playback.

In-camera guide/delete button

Press this button to activate the in-camera guide for help using the menus or when the Function screen is displayed. You'll see help related to the function or menu option you have highlighted. The in-camera guide will also tell you how to activate disabled functions or settings. You can also use this button to delete photos or movies. You can see how in Chapter 5.

Access lamp

This light shines when the camera is reading from or writing to the memory card. Don't open the battery or memory card cover when the lamp is lit.

Front gizmos

The front of the camera has a few important controls and other gizmos. Practice identifying them so you don't have to turn the camera around to see them:

- The front left has the first set of controls (seen in Figure 1-9): a control dial, remote sensor, self-timer lamp, AF illuminator (A77), and preview button.
- The front right of the camera (see Figure 1-10) has the second group of controls: the flash pop-up button, lens release button, and the focus mode switch/dial.

Control dial

The control dial is just under the power switch, within easy reach of your right index finger. In the basic modes, the control dial doesn't do much. You can, however, get through menu options and lists quickly by spinning it left or right. (It acts almost like a track ball in that respect.) In advanced exposure modes, use the control dial to turn up or down the shutter speed or f-number.

Remote sensor/self-timer lamp (A65)

The A65 hides a remote sensor with the self-timer lamp. The remote sensor picks up signals from a compatible wireless remote. The self-timer lamp works based on how you have set the self-timer:

- ✓ 10-second self-timer: Blinks for the first nine seconds and then remains steady for the last second.

- ✓ 2-second self-timer: Lights up but doesn't blink. Goes off just prior to taking the photo.

You can find more on drive modes, including a remote and the self-timer, in Chapter 2.

Remote sensor (A77)

On the A77, the remote sensor is located by itself.

AF illuminator/self-timer lamp (A77)

The AF illuminator is with the self-timer lamp on the A77. The illuminator fires in dark conditions to help the camera autofocus. The self-timer lamp acts just like the A65's.

Preview button

Use the preview button to check the depth of field before taking the photo. (See Chapter 7 for more on depth of field.) You won't notice much of a difference between your normal view and the preview if the f-number is set to a large aperture.

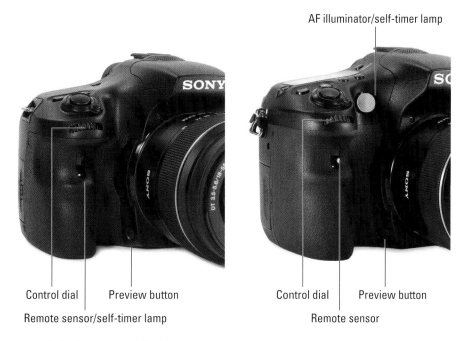

AF illuminator/self-timer lamp

Control dial | Preview button Control dial | Preview button

Remote sensor/self-timer lamp Remote sensor

Figure 1-9: You'll rarely see this side of your camera.

Flash pop-up button

Press this button, pointed out in Figure 1-10, to pop the built-in flash. The flash on the A65/A77 has a unique way of popping up. Rather than acting like a simple lever, such as a door does when opening, the base slides forward as the top rotates upwards. I can't think of any practical purpose in saying that, but I think it's interesting nonetheless.

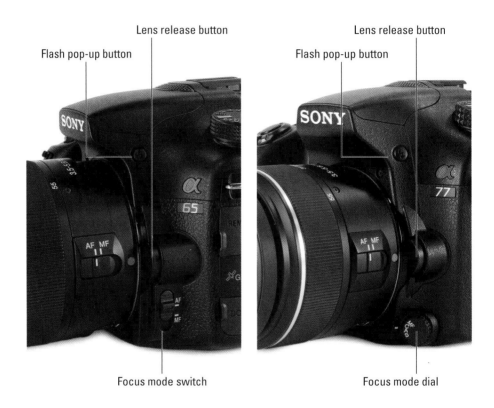

Figure 1-10: This side is functional and attractive.

Lens release button

Press this button all the way in to release the lens. Instructions for attaching and removing lenses are in this chapter.

Focus mode switch (A65)

In the absence of the same switch on the lens, this switch switches from auto to manual focus modes. If you have a lens with the same switch, set this to AF and forget it on the A65. The A77 works a little differently. For more information, look for the "Changing to manual focus" section in this chapter.

Focus mode dial (A77)

The focus mode dial on the A77 gives you more control when you're in auto-focus mode than the focus mode switch on the A65. As with the A65, if your lens has an AF/MF switch, choose between auto and manual focus.

However, when in autofocus mode, you can identify the specific autofocus mode you want to use with this switch on the A77:

- A for Automatic AF.
- S for Single-shot AF.
- C for Continuous AF.

These settings are explained more in Chapter 8.

And the rest

The A65 and A77 have several other controls and features scattered around their bodies.

Terminals

All terminals are on the left side of the camera, as shown in Figure 1-11. If you don't need them, you can ignore them.

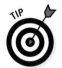

- **Flash sync terminal (A77):** Flash sync terminals have become a rarity on all but decidedly professional camera models. While sync cords (aka *PC cords*) are sometimes cumbersome, they're a reliable way of controlling remote flashes from your camera. Alternatives include the various types of wireless triggers, including the one built into your camera.

- **Remote terminal:** Open the rubber cover and plug in the RM-L1AM remote commander or other Alpha-compatible remote shutter release.

- **DC in terminal:** Connect the AC-PW10AM AC adapter to provide uninter-rupted power when shooting, playing back, downloading, or brewing coffee.

- **Microphone jack:** It's karaoke time! You can connect an external stereo microphone to your camera with this jack. Doing so disables the on-board microphone. See Chapter 4 for more information about recording movies with audio.

- **HDMI terminal:** Connect the mini end of an HDMI cable into this termi-nal to play back your photos and movies on an HDTV with HDMI input. Chapter 5 has details on connecting your camera to an HDTV. The cable isn't included.

- **USB terminal:** Use the USB terminal to connect your camera to a com-puter. The USB cable is included with your camera.

Terminal covers (closed)

A65

Remote terminal | USB terminal
Speaker | HDMI terminal
DC in terminal | Microphone jack

Terminal covers (closed)

A77

Remote terminal | USB terminal
Speaker | HDMI terminal
DC in terminal | Microphone jack
Flash sync terminal

Figure 1-11: The terminals are hidden away underneath rubbery covers.

Speaker

The speaker, shown in Figure 1-11, is on the left side of the A65/A77, amidst the GPS logo and terminal covers. Audio comes out of the speaker when you play a movie with sound. The camera also beeps when it establishes autofocus and when the self-timer counts down. You can turn off the beeps from the Audio signals option in Setup menu 2.

Memory card cover

The memory card cover is on the right side of the camera on the A65/A77. See the section later in this chapter on how to insert and remove memory cards.

Underneath it all

The bottom of the camera, shown in Figure 1-12, has a door and a place to screw in a tripod or quick mount plate. Otherwise, no controls or displays live here.

- **Tripod receptacle:** The tripod receptacle is in the bottom-center of the camera.

- **Battery compartment cover:** This cover protects the battery compartment. It's spring-loaded, which means the cover pops open when you slide the release toward the back of the camera.

Battery compartment cover

Tripod receptacle

Figure 1-12: Even the bottom of the camera sports a few important features.

Doing a Lens Switcheroo

Until you get used to it, changing lenses makes you feel like being an octopus would be a good thing. You have to support the camera with one hand and use the other to hold the new lens. That leaves a third to handle other lenses and lens caps. A fourth would be nice so you don't have to do everything one-handed.

The kit lenses, including the Sony 18–55mm and 16–50mm models featured in this book, are compatible with your camera. If you're buying a new lens, look for an *A-mount.* If it says that, it will mount on your camera.

Your camera is also compatible with DT lenses. That means you can use modern lenses specifically designed for smaller sensors *and* lenses designed for full-frame cameras (for example, the Sony Alpha 900). However, DT compatibility doesn't go both ways. DT lenses aren't compatible with full-frame cameras like the Alpha 900. Sony's NEX cameras use E-mount lenses, which aren't compatible with Sony's Alpha cameras.

If you have a different lens than the one shown in this section, don't worry. All A-mount lenses work similarly. If you have any doubts, check the documentation that came with your lens or visit www.sony.com to research compatible lenses.

Attaching a lens

The capability to use different lenses is one thing that differentiates these cameras from their smaller compact camera cousins. You get a feeling of satisfaction knowing you're customizing your camera for the task at hand. Figure 1-13 shows the A77 with the lens off. Notice the orange mounting index that looks like a dot. You align the index on the lens with this dot when you attach the lens.

Sony produces lenses that work with APS-C–sized sensors, which are smaller than a 35mm frame of film. They're designated as DT (digital technology) lenses.

When you follow these instructions, the back of the camera will face you. You have to reach around to the front. Same thing if you use a tripod. These steps are written from that perspective. If you hold the camera facing you, reverse the directions you turn the lens and body cap. To attach that lens, follow these steps:

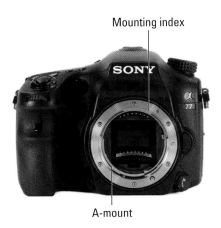

Mounting index

A-mount

Figure 1-13: The Alpha mount (A-mount) in all its glory.

1. **Get everything ready and have a plan.**

 When you're changing a lens, you're exposing the camera's internals. You want to do that as little as possible. It's also a good idea to have a place to stick the lens you're removing. Knowing where you're going to put things like caps, covers, and lenses is a good idea. You'll fiddle with things less that way.

2. **Turn off the camera.**

 It isn't absolutely necessary to power down, but it is good practice unless you need to change lenses lightning fast.

3. **Put the camera strap around your neck.**

 In case you drop the camera. The back of the camera will face you.

4. **Rotate the body cap towards the shutter button (clockwise), pull it off, and stick it in your pocket.**

 Face the camera partially down so it's harder for dust and other debris to get into the camera opening. If you need to remove another lens instead, refer to the steps for taking off a lens.

5. **Remove the rear lens cap or lid from the lens you want to attach.**

6. **Align the orange mounting index on both the lens and the camera, as shown in Figure 1-14.**

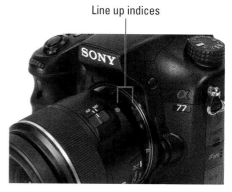

Line up indices

7. **Gently insert the lens into the camera.**

8. **Turn the lens toward the mode dial (counter-clockwise) until it clicks.**

 The click indicates the lens is locked in position. Remember, the camera is facing away from you. If you're looking at the front of the camera, rotate the lens clockwise.

Figure 1-14: Align the indices with decisiveness.

9. **Remove the front lens cap and turn on the camera.**

Removing a lens

Removing a lens can feel scarier than attaching one — like you're going to drop something. If you need to, practice while sitting on your bed. This will give you the peace of mind you need to concentrate.

When you follow these instructions, the back of the camera will face you. These steps are written from that perspective. If you hold the camera *facing* you, reverse the direction in which you turn the lens and body cap. Follow these steps to remove a lens:

1. **Turn off the camera.**

 It isn't absolutely necessary to power down, but good practice. It's also good practice to put the front lens cap on the lens you're removing now.

2. **Get a grip.**

 Until you get the hang of it, removing a lens is a bit nerve-wracking, because you don't want to drop it. Get a good grip on things before

continuing. These steps are written from the perspective of how you will most likely use the camera, which means it will be in front of you, ready for use.

In the manual, the camera points towards you. This makes it easier to see the illustrations, but it isn't as realistic. Therefore, hold most of the camera's weight with the bottom two fingers of your left hand. Form a shelf for the camera to rest on and place your thumb on the mode dial. This frees your left index finger to press the lens release button. Your middle finger supports the camera where it can.

3. **Press in the lens release button fully. (Refer back to Figure 1-10.)**

 Support the camera with your left hand and use your left index finger to press the release button. Cradle the attached lens with your right hand.

 Although it is difficult to do, face the camera partially down and away so it's harder for dust and other debris to get into the camera opening. Know how it feels so you aren't always angling the camera up to see it. In fact, after some practice you should be able to do this blindfolded.

4. **Twist the lens towards the shutter button (clockwise) until it stops.**

 Use your right hand to twist and support the lens. Actually grab it. When it's free, it can drop out of the camera and fall, so don't let go of it.

5. **Pull out the lens and quickly put it somewhere safe.**

 Don't worry about putting the rear lens caps on the lens you just took off. While you stop and fiddle with the lens, the camera is open to the world, which includes dust and other bad things.

6. **Attach the body cap or another lens with your right hand.**

7. **Put the rear lens cap on the lens you removed and put it securely away.**

Changing to manual focus

Your camera's outstanding phase detection auto-focusing system works perfectly in most situations. It may, however, have difficulty focusing on subjects in low light and low-contrast situations (like hazy, foggy days). The camera simply can't tell what you want to focus on given the circumstances.

The Sony DT 18–55mm F3.5–5.6 SAM and 16–50mm F2.8 SSM kit lenses have a focus mode switch on the side, in front of the orange mounting index. Not all lenses do. Therefore, the A65 has the same basic switch, just below the lens release button. This redundancy is necessary. If your lens doesn't have the focus mode switch, you would be up switch creek if you want to change focus modes. However, this arrangement is confusing. There are two switches that appear to do identical things.

The switch on the lens overrides the switch on the camera. Therefore, if you have both switches, keep the switch on the A65 camera body set to AF and forget about it. Don't touch it again. Use the switch on the lens to change focus modes. If your lens doesn't have the switch, use the switch on the camera.

The focus mode switch (aka dial) on the A77 has more options. It has an MF setting, just like the A65. This means the following steps apply to the A77 too. Instead of setting the focus mode dial to AF, however, you have to choose between one of the three autofocus modes: Continuous (C), Automatic (A), or Single (S) when in autofocus mode. I recommend setting the dial to A for general use.

Although you can read more about advanced autofocus techniques in Chapter 8, you may need to take control and manually focus. Here's how:

1. **Switch the focus mode switch on the lens from AF to MF.**

 This takes you from auto to manual focus; see Figure 1-15. To change back to auto focus, move the switch on the lens from MF to AF.

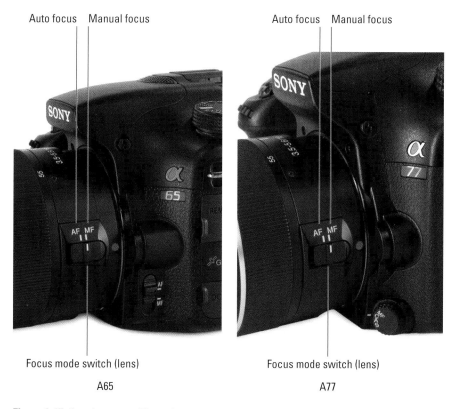

Figure 1-15: Set phasers to Manual.

2. **Look through the viewfinder or at the LCD monitor and rotate the focus ring until your subject is sharp.**

If you're using the viewfinder, make sure you've calibrated it to your eyesight using the diopter-adjustment dial. Those steps are in this chapter's section "Seeing 20/20 Through the Electronic Viewfinder." If you don't, what looks focused to your eye will actually be out of focus.

The focus ring on the 18–55mm lens (mounted on the A65) is at the end, as shown in Figure 1-16. It's pretty small and is smooth, as opposed to the zoom ring. When you zoom in and out, the focus ring extends or retracts with the lens. This can be distracting if you're not expecting it. The 16–50mm lens (mounted on the A77) has a much larger focus ring, complete with grippy ridges. It's easier to find and use without having to look at the lens.

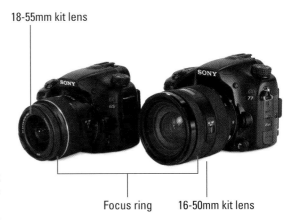

18-55mm kit lens

Focus ring 16-50mm kit lens

Figure 1-16: The focus rings are near the end of these lenses.

Try using this technique to manually focus: Keep your left thumb and index finger on the zoom ring to zoom in and out, and use your middle or ring finger (and possibly thumb) to focus. That way, you never lose contact with either ring, and you only need to move your thumb back and forth.

Zooming in and out

The Sony 18–55mm and 16–50mm kit lenses have a zoom ring, which is shown in Figure 1-17. Turn the zoom ring to change the distance between the camera sensor and the rear lens element. That distance is known as the *focal length,* and it changes the lens magnification and the field of view. Turn these zoom rings clockwise (from the perspective of the rear of the camera looking forward) to zoom in; turn them counterclockwise to zoom out.

Numbers on the kit lenses tell you the current focal length. Take the 18–55mm lens off the camera and carefully look in the rear. Turn the zoom ring and see what happens. As you turn it toward the smaller focal lengths, the rear lens element gets closer to the opening. This reduces the distance between it and the sensor when it is mounted on the camera. When you turn it towards its maximum focal length — 55mm — the rear lens element retreats inside the lens to increase the distance between it and the image sensor.

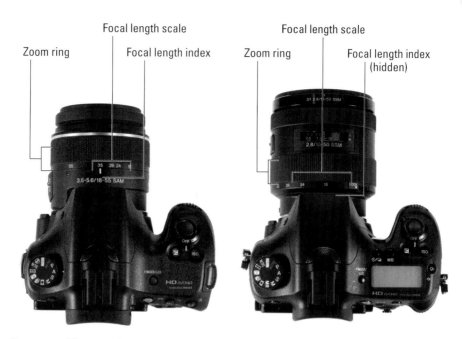

Figure 1-17: The zoom ring is the large, ridged one.

Using Batteries and Memory Cards

Working with batteries and memory cards are important skills that you should quickly master. Memory cards aren't made out of glass. They won't break if you drop them on the carpet. In fact, they're pretty durable. If you treat them with a reasonable amount of care, they will last for as long as you have your camera. If you have protective cases for your cards, use them.

However, keep in mind these memory card don'ts:

- ✔ Don't bend them.
- ✔ Don't stack heavy objects on them.
- ✔ Don't use them as ninja throwing stars.
- ✔ Don't microwave or bake them.
- ✔ Don't let them sit in the sunlight in your car.
- ✔ Don't go out of your way to magnetize them. Don't put a bunch of memory cards on your person when you go in for an MRI, for example.

✔ Don't touch the gold contacts (see Figure 1-18) with your fingers.

✔ Don't forget to use the locking tab so the photos aren't accidentally erased.

Inserting the battery

The key to putting the battery in your camera is to push the blue lock lever out of the way as you slide in the battery. Don't push down on the lever or you could break it off. Here's how to insert the battery:

1. **Make sure the camera is off.**

2. **Slide the battery compartment cover lever toward the back of the camera.**

 The spring-loaded cover should pop open, as shown in Figure 1-19.

3. **Put the battery in the camera.**

 The battery goes in contacts first and facing the rear of the camera. First, angle in the side of the battery closest to the blue lock lever so that it shoves the lever out of the way.

4. **Press the battery in until the blue lever pops out over the battery and it locks in place. See Figure 1-20.**

 If the battery doesn't go all the way down, you may have it in incorrectly. Pull it out and double-check the orientation of the contacts.

5. **Close the battery compartment cover.**

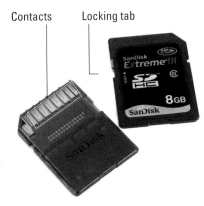

Figure 1-18: SDHC cards relaxing in the studio.

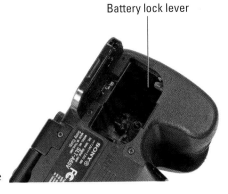

Figure 1-19: When you get enough practice, you won't even need to look.

Figure 1-20: The blue lever holds the battery in place.

Removing the battery

The key to removing a battery is pressing the blue lock lever with your thumb or finger. If you look at the battery compartment when it's empty, you can see the spring that pushes up on the battery. (It's visible in Figure 1-19.) When it's unlocked, the battery pops right up. Here's how to remove it:

1. **Make sure the camera is off.**

2. **Slide the battery cover lever toward the back of the camera.**

 The cover pops open.

3. **Carefully use your finger to push the blue lock lever in until the battery pops up.**

4. **Pull the battery out of the camera.**

 Put a fresh one in and go to Step 5 or just continue to Step 5.

5. **Close the battery compartment cover.**

Inserting the memory card

Take care when you're inserting the memory card. Make sure it's facing the right direction and that you slide it into its compartment smoothly and straight. Here's how:

1. **Make sure the memory card access lamp isn't lit.**

 You can turn the camera off if you want, but you don't have to as long as the lamp isn't lit. See Figure 1-21 for a comparison. If the lamp is shining, that means a card is in the camera and in use.

No activity Activity

Figure 1-21: The red light indicates card activity.

2. **Slide the memory card cover toward the *back* of the camera to open the cover.**

 The spring-loaded cover should pop open; see Figure 1-22.

3. **Insert the memory card into the camera, as shown in Figure 1-23.**

 If there is already a memory card in the camera, remove it by following the next sequence of steps.

 The contacts go in first, but SDHC cards are different than Memory Stick PRO Duo or Memory Stick PRO-HG Duo. SDHC contacts face the front of the camera. Memory Stick contacts face the back of the camera. No matter what type, put the notched corner of the memory card upward.

4. **Press the card in all the way.**

 You will feel a spring pushing back. Push until you feel or hear a slight snap as the card locks in place. If you don't feel it latch, pull the card out and check to see if it's oriented correctly.

5. **Swing the memory card cover closed and push it in to lock it.**

Slide back to unlatch...

Door springs open

Figure 1-22: The memory card compartment door slides back and springs open.

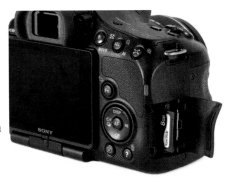

Figure 1-23: Inserting the memory card.

Removing the memory card

Removing your memory card is easier than putting it in because you don't have to line anything up or worry about getting things in upside down and backwards. Here's how to go about it:

1. **Make sure the memory card access lamp is not lit. Refer to Figure 1-21.**

 If it is, wait a moment. You can turn the camera off if you want, but there is no reason to as long as the card isn't being written to.

2. **Slide the memory card cover toward the rear of the camera to open the cover.**

 The spring-loaded cover should pop open.

3. **Push down on the memory card and then release.**

 The card will give a bit, which releases the catch (which you can't see), then push up. It should literally spring up a bit.

4. **Pull out the card.**

 At this point, put in a fresh card or leave it empty. When you're done transferring photos, put the card back in the camera. This protects the card, keeps you from spilling something on it, makes it harder to lose, and lets you take photos at a moment's notice.

5. **Swing the memory card cover closed and push it in to lock it.**

Moving the Monitor

Both the A65 and the A77 have adjustable, sometimes called *articulated,* LCD monitors on the back. An LCD monitor with Live view gives you the flexibility of shooting when you can't look through the viewfinder, but having an *adjustable* LCD monitor lets you shoot from a number of otherwise impossible positions, such as down low, up high, or even around a corner.

Both monitors come stowed, as shown in Figure 1-24.

When you aren't using it, return your tilt/swivel LCD monitor to its upright and locked position. (That never gets old.) Storing the LCD with its face toward the camera will protect it nicely. The monitor stays cleaner when it faces in.

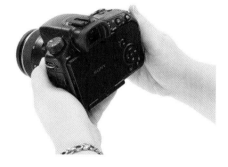

A65

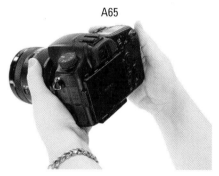

A77

Be careful when manipulating the tilt-swivel LCD. Your camera isn't a Transformer that you can jerk around, push, pull, and twist into shape.

Figure 1-24: The LCD monitors in their protective position.

A65

The A65 monitor flips out from the back of the camera and then tilts and swivels. You can use the monitor when it's flipped out from the camera,

turned toward you, or turned to the side. It tilts 180 degrees out and rotates 270 degrees.

To pull the monitor out of its storage position, follow these steps:

1. **Pull the monitor out from the back of the camera.**

 See Figure 1-25, where it's being carefully pulled toward the user. You can use your thumb from the side or the top, or pull with your fingers.

2. **Rotate the monitor clockwise so the screen faces down.**

 Figure 1-25 shows the monitor turned half way. Keep twisting it until it stops.

3. **Flip the monitor back up, as shown in Figure 1-26.**

 The monitor ends up facing you and the camera is ready for action.

A77

The A77 monitor has the same tilt/swivel capability as the A65, but it has an extra articulated arm that you can pull up and out of the camera body. This lets you situate the monitor at the same level as the viewfinder. It looks like it is sitting propped on a shelf.

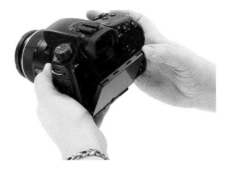

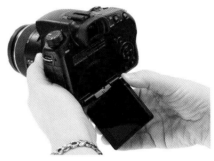

Figure 1-25: Tilt and swivel.

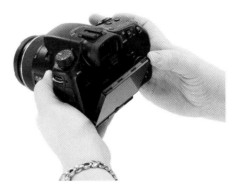

Figure 1-26: Flipping the monitor into position, but now it faces out.

If you want to pull the monitor out of its storage position and use the basic tilt/swivel capability, follow the same steps as the A65. Figure 1-27 shows the A77 monitor being pulled into position.

If you look closely, the A77 has an additional swing arm that swings up and away from the camera body. The monitor is attached at its end, so you can elevate the monitor at and above the level of the viewfinder. Figure 1-28 shows the swing arm in greater detail.

Of course, you can rotate and use the monitor in any of the positions between the extremes. Experiment with what works best for you in any situation.

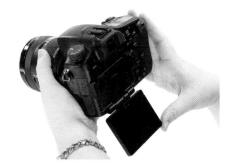
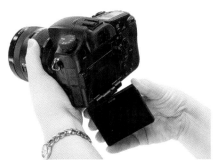
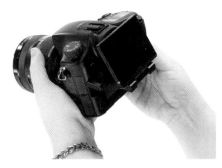

Taking a Look at the Display Panel (A77)

The A77's top display panel (shown lit in Figure 1-29) is very similar to those on other semi-professional and professional cameras. It gives you a quick and easy way to check the camera's mode, exposure, and other settings. Of course it's overkill. That's what top-tier cameras do. They give you more than you need and let you decide which method you want to use in a given situation.

Figure 1-27: Tilt and swivel.

The display panel won't show you anything that you can't get from the viewfinder or LCD monitor on the back of the camera. (It displays less, actually.) However, because you can program the Display button to show more or less information on those displays, the top display can serve as the place you can look at to double check really important stuff like the drive mode, shutter speed, aperture, and ISO.

Here are the main display modes for the top panel. The battery strength is always displayed.

- **Normal:** When shooting, the top panel displays the shutter speed, f-number, battery power, white balance, drive mode, image quality, and number of shots left on the memory card. It's down and dirty. The good stuff.

- **Shutter speed and aperture:** When you're in a mode that lets you change shutter speed or aperture, you see only those values and the battery remaining.

- **ISO:** Likewise, when you press the ISO button, everything is cleared from the top display and you only see the ISO and battery, as shown in Figure 1-30.

Figure 1-28: Elevating the A77 monitor.

- **Drive mode:** The drive mode shows you the general drive mode, plus all the details when it comes to *brackets* (the range plus number of exposures).

- **Exposure and flash compensation:** When you press the exposure button, or set flash exposure through the shooting functions screen, the amount you're currently setting appears on the top display.

- **White balance:** Similarly, when you press the white balance button, the current white balance (including shifts) is shown.

Figure 1-29: The top display (currently lit) is a great way to check important information.

- **Image quality:** When setting image quality, the current setting is shown on the top panel.

Seeing 20/20 through the Electronic Viewfinder

This diopter-adjustment dial matches the focus of the viewfinder to your eyesight. If you wear glasses, you should adjust the camera so you can see everything clearly through the viewfinder. Even if your eyesight is perfect, you may need to adjust the camera.

Here's how to do it:

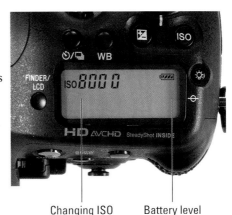

Changing ISO Battery level

Figure 1-30: The top display panel changes depending on what button you've pressed.

1. **Turn on the camera.**

2. **Press the Menu button.**

3. **Support the camera with your left hand.**

4. **Use your right thumb to turn the diopter-adjustment dial, looking at the menu text in the viewfinder.**

 When the text is sharpest, the viewfinder is adjusted to your eyesight. If you go the wrong direction and things get worse, click back the other way. If you've gone as far as possible in either direction and you can't see the menu clearly, the camera probably can't adjust to your eyesight. Try switching eyes to see if you can get the other one dialed in. Or go see an optometrist.

What You Have? Menus, Buttons, and Dials

Sometimes you have more than one option for doing things. Try getting to know them all; experiment to find the one that works best for you. If that means you want to look through the viewfinder 63 percent of the time, good. Someone else might love working with the LCD monitor 76 percent of the time.

Menus

The internal menu system is your gateway to lots of settings. Press the Menu button. You'll see the active menu tab at the top of the screen, along with the other menu icons. Within each tab, there may be submenus, which are described in Table 1-1. (FYI: This isn't an exhaustive list of every possible menu option; it's just a sample so you know what the menus generally contain.)

All menu tabs are accessible, but not every menu line item is available in all exposure modes. For example, you only have access to panorama settings when the Mode dial is set to Sweep Panorama or 3D Sweep Panorama. Other options (noise reduction settings, for example) aren't available in the automatic modes, but are accessible when you're in one of the advanced modes (P, A, S, or M).

Table 1-1	**Alpha A65/A77 Menus**	
Symbol	*Menu Name*	*Types of Functions*
📷	Still Shooting menu 1	Photo size Aspect ratio Quality settings Panorama options
📷	Still Shooting menu 2	Noise reduction settings Flash control Power ratio (A77) AF illuminator Color Space SteadyShot
📷	Still Shooting menu 3 (A77)	Exposure step AF-A setup AF w/ shutter Memory
🎞	Movie Shooting menu	Movie format Size Audio Wind noise reduction SteadyShot
✳	Custom menu 1	Eye-Start AF Finder/LCD settings Red-eye reduction Release w/o lens A few Auto+ options
✳	Custom menu 2	Display options such as grid line and histogram Auto review Display button options Peaking Live view display

Symbol	Menu Name	Types of Functions
✿	Custom menu 3	AEL ISO AF/MF (A77) Preview Focus hold smart teleconverter button behavior/options
✿	Custom menu 4 (A77)	Control dial setup Exposure compensation Bracket order AF drive speed
✿	Custom menu 4 (A65) Custom menu 5 (A77)	Lens characteristics Front curtain shutter Face registration
▶	Playback menu 1	Delete View mode Slide show Image index (A65) 3D viewing Protect Specialty (DPOF/date) printing
▶	Playback menu 2	Volume Playback display (auto rotate)
◀	Memory Card Tool menu	Format, file number, and name options Folder options Recover image database Display card space
🕐	Clock setup menu	Date, time, and location setup
🔧	Setup menu 1	Menu start LCD and viewfinder brightness GPS power save HDMI settings

(continued)

Table 1-1 *(continued)*

Symbol	Menu Name	Types of Functions
	Setup menu 2	Eye-fi and USB setup Audio settings Cleaning mode Delete confirmation (A77) AF Micro adjust (A77)
	Setup menu 3	Version Language Mode dial guide Initialize

The left image in Figure 1-31 shows Still Shooting menu 1. Notice that the Still Shooting menu tab is lit and the page is highlighted. The other menu tabs are grayed out. The selected line is highlighted (in this case, Image Size). That tells you at a glance where you are in the menu. Grayed-out menu choices (Panorama and 3D Panorama settings) aren't available in your current configuration. This is most likely due to the exposure mode you're in, but not always. You can only change the settings that appear in white.

Still Shooting menu

Press the enter button when a line is highlighted to see the settings associated with that option. Image Size options are shown in Figure 1-31. Use the up or down buttons to get to your choice. The current setting has a small dot next to it. Your position is indicated by highlighting. Press the enter button to make the change.

Figure 1-31: Navigating the menu system is like using a computer.

The menu system is important. Remember these techniques:

✔ **Navigate:** Use the directional buttons (left, right, up, or down) to move between menus, tabs, and menu options. Use them to highlight options when you see a list or choices like Enter or Cancel. You may also use the control dial to go up and down between the menu options and menus.

The A77 has the option of putting Enter or Cancel first in confirmation screens. Go to Setup menu 2 and choose the Delete confirm option to configure.

✔ **Choose:** Press the enter button (labeled AF on the back of the A65; it is the center of the multi-controller on the A77) to lock in your choices.

✔ **Exceptions:** Sometimes you're prompted to press the Menu button, rather than the enter button, to continue. Pay attention to the prompts at the bottom of the screen.

✔ **Cancel:** You can generally press the Menu or playback button, or press the shutter button halfway, to ditch the menu and get back to shooting. Pressing the Function button takes you to the functions for your current exposure mode.

Displays

Press the Display button to change displays, whether you're looking through the viewfinder or at the LCD. You will cycle to the next available display each time you press. To see how to customize what displays you see, turn to Chapter 10.

There are several types of display:

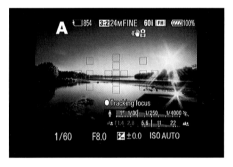

Figure 1-32: The graphic display shows you how dynamic exposure can be.

✔ **Graphic display:** Aside from displaying other parameters (including battery level, shooting mode, and photo quality), this display shows the shutter speed and aperture graphically. The graphic changes depending on the light, if you're in an advanced exposure mode, and your settings. Use this display when you don't need to see the functions and modes. See Figure 1-32.

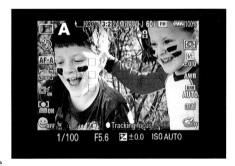

Figure 1-33: Display All Info shows the most information.

✔ **Display All Info (Live view):** This display, shown in Figure 1-33, shows the camera's many modes to the left and right sides. Here is how you can see the most information; it's a great way to scan settings besides exposure. For example, it's easy to forget the fact that you changed the metering mode to Spot.

✔ **Viewfinder:** This display shows a wealth of shooting information in a grid without Live view. You *can't* see this display through the viewfinder — only on the back of the camera. When using it, you must compose your shot using the viewfinder. Select this view from Custom menu 2. Highlight Display Button (Monitor) and select For Viewfinder. One part of Figure 1-34 shows the display when you are in Auto, Auto+, or Scene Selection mode. The other part of Figure 1-34 shows the display when you are in Continuous Advance Priority AE, P, A, S, or M modes.

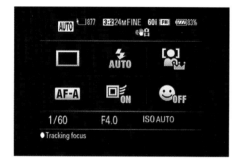 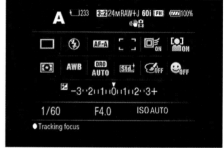

In Auto, Auto+, or Scene Selection In Continuous Advance Priority AE, P, A, S, or M

Figure 1-34: This display, although a bit retro, is effective.

✔ **No display info:** This simpler display mode shows only the AF areas and minimal exposure information. See Figure 1-35.

✔ **Digital level gauge:** This display shows the digital level, as shown in Figure 1-36. When the camera is level from side to side, the triangles on the sides turn green. When the camera is level from front to back, indicators in the center of the display turn green.

Figure 1-35: A minimalist display.

✔ **Histogram:** The histogram (see Figure 1-37) is a graph that charts pixel brightness. The vertical axis is the number of pixels at low or high brightness. Use the histogram to see how light is distributed in the scene and whether you're in danger of under- or overexposing the photo. For more information on histograms, turn to Chapter 7.

Figure 1-36: Lining up with the level.

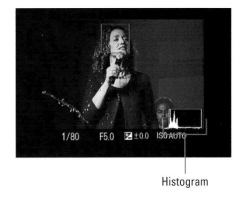

Histogram

Figure 1-37: Use the histogram to evaluate exposure.

Using the Function button

The Function button is your portal to photography features: the ways you can customize each shooting or exposure mode so that you can take the photo *you* want to take given the situation at hand. For example, if you want the camera to process the photos more vividly, choose the Creative Style function.

You can also think of many of the functions as problem solvers. If the flash is too bright, reduce it (if possible) with flash compensation. Table 1-2 summarizes the functions and their effect while telling you in what modes they're available and in what chapter you can find more information.

Table 1-2	What's Your Function?		
Name	*Effect*	*Availability*	*Chapter*
Scene Selection	When the mode dial is set to Scene, you can select different scenes with the Function button.	Scene Selection	3
Movie	Select an advanced movie exposure mode.	Movie	4
Memory recall (A77)	Recall a preregistered memory setting.	MR	11

(continued)

Table 1-2 (continued)

Name	Effect	Availability	Chapter
Drive mode	Change how many photos you can take with a shutter press. Includes the self-timer.	All but Continuous Advance Priority AE	2
Flash mode	Sets the flash function. Choose between Auto, Fill Flash, Flash Off, and so forth.	All but Flash Off (A65), Sweep Panorama, 3D Sweep Panorama, and Movie	2 and 7
Autofocus mode (A65)	Change between Continuous, Single, or Automatic Autofocus.	P, A, S, M, Continuous Advance Priority AE	8
AF area	Sets the autofocus area.	P, A, S, M, Continuous Advance Priority AE, Movie	8
Object tracking	Turns object tracking on or off. You must be in autofocus and can't use the teleconverter.	Auto, Auto+, Flash Off (A65), Scene (except Handheld Twilight), P, A, S, M, Movie	8
Face detection	Enables face detection, which optimizes exposure for people's faces.	Auto, Auto+, Flash Off (A65), Scene selection, P, A, S, M, and Movie	2
Smile Shutter	Enables Smile Shutter, which automatically takes a photo when the camera detects a smile.	Auto, Auto+, Flash Off (A65), Scene selection, P, A, S, and M	2
ISO	Changes the sensor sensitivity.	P, A, S, M, and Movie	7
Metering mode	Changes how the camera evaluates scene brightness.	Sweep Panorama, 3D Sweep Panorama, Continuous Advance Priority AE, P, A, S, M, and Movie	7

Name	*Effect*	*Availability*	*Chapter*
Flash compensation	Makes the flash output either stronger or weaker.	Continuous Advance Priority AE, P, A, S, M, and Movie	7
White balance	Changes how the camera establishes the color tone of the photos it processes.	Sweep Panorama, 3D Sweep Panorama, Continuous Advance Priority AE, P, A, S, M, and Movie	8
DRO/Auto HDR	Enables D-range optimizer or the auto HDR function.	Sweep Panorama, 3D Sweep Panorama, P, A, S, M, and Movie	7
Creative style	Changes the processing style you want applied to your JPEGs.	Continuous Advance Priority AE, Sweep Panorama, 3D Sweep Panorama, P, A, S, M, and Movie	8
Picture Effect	Changes the picture effect you want applied to your JPEGs.	P, A, S, M, and Movie	11

You move around the Function screen much like you do the menu system, but you press the Function button to start. Figure 1-38 shows the Function screen in Auto mode. Notice that there are few options. Figure 1-38 also shows the Function screen when the camera is in an advanced exposure mode. In this case, all the options are available.

Normally, you can see the scene when you access the functions instead of a black screen. That's fine in the real world. When placed in a book, however, it makes this display busy and almost impossible to benefit from. I made the decision, therefore, to remove the distraction by blacking out the outside world showing the functions.

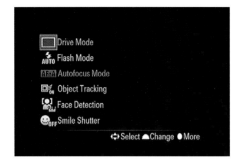 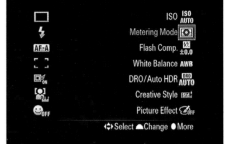

Figure 1-38: Functions control a number of important shooting functions.

Use the directional buttons to move up, down, left, and right. Highlight a function and press the enter button to get to its options. Highlight an option with the directional buttons and press the enter button to change the setting; see Figure 1-39. You can also highlight a function and spin the control dial to change the setting.

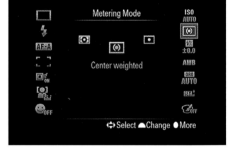

Figure 1-39: Change functions like the menu options or spin the control dial.

Getting Set Up

Check out several menu items before you take the camera out for a spin. These settings aren't related to photo size or quality; they affect your camera in other ways.

Table 1-3 isn't exhaustive, but it does offer a good representation of what you should check. Press the Menu button to find the tab and specific option.

Table 1-3	Check Settings before Shooting	
Name	*Access*	*Misc.*
Image Size and Quality	Still Shooting menu 1	Check to make sure you're shooting the type of photos you intend to.
SteadyShot	Still Shooting menu 2 Movie Shooting menu 1	Make sure it's on if you're shooting handheld.

Name	Access	Misc.
Color Space	Still Shooting menu 2	Set to sRGB unless you have reason to change it. More in Chapter 8.
Memory	Still Shooting menu 3 (A77)	Configure or recall your own combination of settings. See Chapter 11.
Movie Settings	Movie Recording menu	Movie size, format, audio recording, SteadyShot. See Chapter 4.
Red-eye Reduction	Custom menu 1	Enable if you're shooting flash photography indoors. Chapter 2 has more.
Grid Line	Custom menu 2	Turn on if you want lines in the viewfinder or on the LCD monitor. Read Chapter 2.
Auto Review	Custom menu 2	Turn on if you want shots displayed after you take them. See Chapter 5.
Display Button Behavior	Custom menu 2	Set up the displays you want to see in the viewfinder and LCD. More in this chapter.
Lens Characteristics	Custom menu 4 (A65) Custom menu 5 (A77)	Compensate for lens characteristics. See Chapter 11.
Format	Memory Card Tool menu	On first use, formats the card; see Figure 1-40.
Date/Time Setup	Clock setup menu	Affects photo metadata.
Area Setting	Clock setup menu	Affects photo metadata. Remember to change it if you travel. See Figure 1-41.
LCD brightness	Setup menu 1	Adjust the brightness.
Viewfinder Brightness	Setup menu 1	Adjust the brightness.
GPS Settings	Setup menu 1	Turn to Chapter 11.
Power Save	Setup menu 1	How much time the camera waits to go into battery-saving mode. See Chapter 10.
Mode Dial Guide	Setup menu 3	On by default. If you don't want hints for each shooting mode, turn it off.
Audio Signals	Setup menu 2	On by default. If you like hearing beeps when you autofocus, keep the sound on.

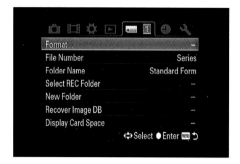

Figure 1-40: Format your memory cards to keep them in tip-top shape.

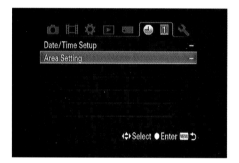
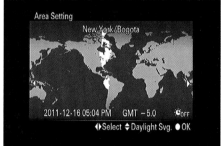

Figure 1-41: Set your area as well as the date and time.

Resetting the Camera

Don't worry for a minute about changing any setting for fear that you'll forget what the initial setting was. If you need to, you can revert the entire camera back to the default settings.

If you've changed lots of settings, write them down before resetting the camera. That way you can pick and choose the settings you want to keep.

To reset the camera, follow these steps:

1. **Press the Menu button.**

2. **Go to Setup menu 3.**

3. **Highlight Initialize and press the enter button.**

4. **Highlight your choice and press the enter button.**

The three levels of initialization appear in Figure 1-42:

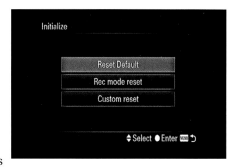

 WARNING!

- *Reset Default:* This is the nuclear option. It resets most settings in the camera to their default setting. The camera needs to reboot to clear its mind afterwards.

- *Recording Mode Reset:* This option resets most shooting functions and modes to their default setting,

Figure 1-42: Reset the camera to go back to the factory defaults.

including image size, quality, movie file format, and so forth.

- *Custom Reset:* This option resets several non-recording functions to their default. This includes functions such as resetting the AEL and ISO button functions, resetting Peaking Level to Off and Peaking Color to White, turning off Red Eye Reduction, and turning off grid lines.

5. **Highlight Enter and press the enter button.**

Cleaning the Camera Sensor

You have two ways to clean the camera's sensor: automatically and manually. If you don't want to do it automatically, take it to a professional camera shop so they can clean it. The automatic mode is easy and you should do it if you see dust spots on your photos. Here's how:

 WARNING!

1. **Start with a fully charged battery.**

Don't cheat yourself with this step. Although you won't see a drop in battery percentage remaining, it takes a lot of oomph for the camera to clean the sensor. You get the most oomph with a fully charged battery.

2. **Press the Menu button and go to Setup menu 2.**

3. **Select Cleaning Mode and press the enter button.**

See Figure 1-43.

4. **Select Enter to confirm and press the enter button again.**

WARNING!

The camera vibrates very quickly to clean the sensor. It feels like a cell phone putting out a powerful burst. Don't set the camera somewhere it can fall off if. The cleaning doesn't last long, but it is powerful. You don't want it falling off a table.

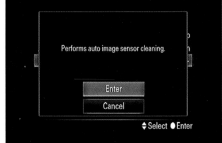

Figure 1-43: Cleaning the camera's sensor.

5. Turn off the camera.

This resets the camera and, when you turn the camera back on, makes it ready for normal operation.

2

Setting Up for Snapshots

*Y*ou've got your A65/A77 out of the box. Fannntastic. Don't be afraid to run out and take as many photos as you want without knowing anything more than how to turn your camera on and press the shutter button. It's all good. That experience will be valuable and set you on the path of knowing what sorts of things bother you and what you might want to change. This chapter is designed to help you make those initial connections between what you want and how the camera comes set up.

You'll probably be familiar with some of the upcoming information. You might have heard of a few of the shooting modes or understand the general idea of setting photo size and quality. That's good! Each camera is ultimately a unique learning experience, however. Have fun with the options, features, and settings explained in this chapter. There's no test.

Giving It Your Best Shooting Mode

REMEMBER

The first thing you should do when preparing to take a photo is choose what mode you want to use.

On the one hand, you can let the camera handle much of the work and make the decisions. On the other hand, you can take complete control of the camera. In between are a plethora of basic shooting and advanced exposure modes that provide different solutions. The choice you make has important ramifications. Without further ado, the A65/A77 modes fall into two broad classifications, plus a special advanced Movie mode.

Basic shooting modes

These modes (see Figure 2-1) are oriented towards a shooting condition or purpose. Identify what you want to do, such as automatic shooting or portraiture, and select the appropriate mode based on that. It's like ordering from a menu. Do you want a nice close-up? Choose Macro. Do you want to shoot an automated panorama? Choose Sweep Panorama. The basic shooting modes are listed in Table 2-1.

Table 2-1	Basic Shooting Modes	
Icon	*Mode Name*	*Description*
—	Auto	Turns the Alpha 65/77 into high-quality point and shoot camera. Use when you're learning about your camera and photography or when you want to relax and have fun.
⊘↓	Flash Off (A65)	Like Auto, but the camera can't use the flash.
—	Auto+	Like Auto, but smarter. Senses shooting conditions.
SCN	Scene Selection	Window to a number of specific scenes. See Chapter 3 for scenes.
⌒	Sweep Panorama	Creates panoramas while you press the shutter and pan. Camera stitches shots together and creates a single file. See Chapter 3.
3D	3D Sweep Panorama	Same as Sweep Panorama, but in 3D. See Chapter 3.

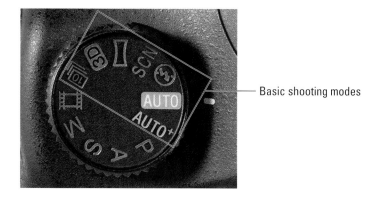

Basic shooting modes

A65

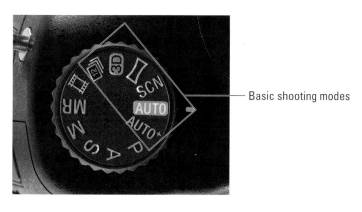

Basic shooting modes

A77

Figure 2-1: The basic shooting modes mean to make it easier for you.

Advanced exposure modes

Your A65/A77 has four advanced still photo exposure modes and one advanced movie mode. The A77 also has a memory recall mode. This chapter doesn't tackle these options, but this is a good place to introduce you to their names so you know what they are on the Mode dial:

- ✔ P: Program Auto
- ✔ A: Aperture priority

✔ S: Shutter priority

✔ M: Manual

These modes give you much more control over the camera than the basic shooting modes. In the end, though, they have the same purpose: to enable you to take the photos you want of the subjects that you choose. The still photo modes are covered fully in Chapter 7.

You'll notice that the A65/A77 have a two other advanced modes. The first is Memory Recall, which allows you to store and recall up to three camera configurations (see Chapter 11). The second is a dedicated Movie mode. The Movie mode (as opposed to using the Movie button, which you can press in any other still photo mode to start taking movies) gives you manual control over exposure. It's covered in Chapter 4.

✔ MR: Memory Recall (A77)

✔ Movie: Access to more advanced Movie modes

Flooring It to Drive Mode

The term *Drive mode* harks back to the days of film, when, if you wanted something faster than a single frame shooting, you had to install a fancy motorized *drive* to speed the film through the camera. Now, of course, motorized drives and film have nothing to do with how fast you can take photos. Instead, it has to do with the number of pixels the camera sensor has and the rate at which data can be read, processed, and stored from them.

The Alpha 65/77 have different drive modes that control what happens when you press the shutter button. You can record a single photo, a series of shots, take a picture after a short delay, and initiate two types of *brackets* (in this case, taking three or five exposures with slightly different settings, or taking one photo that is processed by the camera three times differently). Your options are explained in the following sections.

To change the Drive mode, follow these steps:

1. **Press the Drive button.**

 A65: It's the left control button. A77: A separate Drive button is on top of the camera. You can also access the Drive mode through the function button.

2. **Highlight the Drive mode you want to select, as shown in Figure 2-2.**

Notice that not all Drive modes are available in all the basic shooting modes. If you're in an advanced exposure mode, you have total control.

3. Press the Enter button.

Single Shooting

When you press the shutter button, you take one photo and only one photo. You're like Barney Fife with a single bullet. Available in all modes except the Sports Action scene.

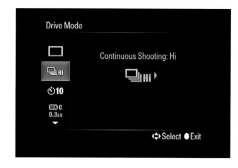

Figure 2-2: Select a Drive mode from those available.

Continuous Shooting

Continuous Shooting is where the action is. Literally. This option offers two modes. One is faster than the other. They're available in all modes and all scenes with two exceptions: Sweep Panorama and 3D Sweep Panorama.

When shooting continuously, press and hold down the shutter button.

Hi

Aside from choosing Continuous Advance Priority AE , this is the fastest drive mode you have. On Hi — and given optimum conditions (JPEG only and face detection off, among other things) — both cameras can shoot up to eight images per second (also known as frames per second, or fps). That's fast.

Table 2-2 shows how many photos you can rattle off shooting continuously (which isn't the same as frames per second, but the length of time you can shoot at the fastest rate). If speed is the name of your game set, the image quality accordingly.

Table 2-2	Maximum Number of Continuous Shots	
Quality	*Alpha 77*	*Alpha 65*
Extra Fine	13	—
Fine	18	18
Standard	18	18
Raw & JPEG	11	11
Raw	13	13

When the camera is set to either Continuous Advance Priority AE or the Sports Action scene, the drive is automatically set to Continuous Hi and can't be changed.

Lo

Lo is a little less than half as fast as Hi, coming out to three images per second for both cameras. Use Lo when you need to shoot continuously but don't need twice the number of photos clogging up your memory card. This mode is more achievable if you're saving high-quality Raw _and_ JPEG photos (two files per photo).

Self-timer

The self-timer comes in two flavors, both of which delay the shutter after you press the shutter button fully. The self-timer is available in all shooting modes except Hand-held Twilight, Sweep Panorama, 3D Sweep Panorama, and Continuous Advance Priority AE.

2-second

You can't run far and pose in two seconds, so don't use this to take self-portraits. Rather, use it to reduce camera shake by giving the camera a moment to stabilize after you've pressed the shutter button. You can use this mode when holding the camera by hand, but I think it makes the most sense when you're using a tripod. In that scenario, you press the shutter button and are able to take your hands completely off the camera for the entire two seconds. Look Ma, no hands!

10-second

Use the 10-second timer to photograph yourself solo or with friends, family, teammates, schoolmates, or random passers-by. Figure 2-3 is a photo I took of my boys and me to illustrate the 10-second self-timer. Not only that, but I wanted to show how easy and fun photography can be. I called the kids together and told them I needed their help. I set the camera up on the tripod, chose a basic shooting mode (High Contrast Monochrome Picture Effect), and changed Drive mode to 10-second

Figure 2-3: My boys with me, demonstrating the 10-second timer.

self-timer. I framed the shot, pressed the shutter button, and ran around to get into the shot. It took about five minutes from start to finish (we even got some Smile Shutter pictures in) and we had a blast.

Exposure Bracketing

Exposure bracketing shoots three or five photos, each with a different exposure. Depending on whether you choose to shoot three or five brackets, one to two photos are underexposed, one is right on target, and one or two photos are overexposed. The under and overexposed shots "bracket" the good exposure.

Use this Drive mode when one of these applies:

- ✔ You aren't quite sure you're getting the right metering but don't want to stray too far

- ✔ You want to use the brackets for High Dynamic Range (HDR). See Chapter 9 for more.

You have three options when you select Exposure Bracketing.

- ✔ **Continuous or Single:** First select whether to shoot continuous brackets (Continuous) or shoot each photo one at a time (Single). The advantage of shooting continuous brackets is that they fire off rapidly and with one press and hold of the shutter button. (If you let up, the sequence starts over.) Shooting single brackets gives you time to think about it.

- ✔ **Bracket step:** Your choices are +/- 0.3EV and +/- 0.7EV. (EV stands for exposure value; 1EV is the equivalent of one stop, as shown in Chapter 7.) The display shows each bracket as a downward-pointing arrow that disappears when the shot is taken.

- ✔ **Number of brackets:** Select either three or five brackets. More brackets give you a greater overall dynamic range, or a greater margin of exposure error you're correcting for, depending on your purpose.

White Balance Bracket

White balance brackets work somewhat like exposure brackets, except that white balance is the variable and only one photo is taken. After taking the single photo, the raw data is processed three times, each with a different setting. You have one option with two settings: Lo or Hi. In this case you're determining the white balance shift. To see an example of white balance bracketing, turn to Chapter 8.

White balance bracketing is most helpful when you're shooting JPEGs only and aren't going to process the Raw photos. You get three chances of getting just the right color temperature.

DRO Bracketing (A77)

DRO bracketing, available only on the A77, is similar to white balance bracketing: You take one photo and the camera processes the data three times. Rather than changing the white balance settings, DRO bracketing changes the DRO level for each file (by a lot: Hi or a little: Lo). See Chapter 7 for more information.

Just like white balance bracketing, DRO bracketing makes the most sense when you shoot JPEGs, and therefore don't have the Raw files to tweak in software. You get three chances to nail the final product right out of the camera.

Remote Commander

Using the Remote Commander drive tells the A65/A77 to listen (figuratively speaking) for an RMT-DSLR1 Wireless Remote Commander (batteries not included and sold separately). You can use the remote commander's shutter or 2Sec button to trigger the camera's shutter from a distance — no cables to trip over! For more information, please refer to the remote's manual.

I Spy a Face

Face detection identifies faces and alters the normal autofocus routine to ensure faces are kept in focus. The mode also adjusts the exposure, flash settings, and processing routine to make faces look their best. What's more, it may detect up to eight faces! Wow. That's the good news. The bad news, taken from the manual, is that it may miss a face. Or it may think something is a face that isn't. "Crumb," as my wife would say. I'm a bit saltier. Despite the warning, face detection is actually pretty reliable.

Using face detection

Using face detection is pretty fun. Here's how to do it:

1. **Set the mode dial to a mode that supports face detection.**

 You can't use face detection in Sweep Panorama, 3D Sweep Panorama, or Continuous Advance Priority modes.

2. **Press the Function button.**

 Face detection is always on the left side of the screen, towards the bottom. It is on by default. If face detection is off, highlight Face Detection, as shown in Figure 2-4, and press the enter button.

3. **Press the down button to high-light an option.**

 Choose On (Registered Faces) to turn on face detection, but give faces that you have registered priority. This is discussed later in this chapter.

 Choose On to enable face detection for any face.

4. **Point the camera at someone.**

 The camera should detect people's faces and surround

Figure 2-4: Enable face detection if it is off. That is, if you want it on.

 them with a rectangle. That rectangle can be any of the following colors:

 - *Gray:* The camera has detected a face. It can't yet focus on it.

 - *White:* The camera has a priority face. You can focus.

 - *Purple:* A registered face is recognized.

 - *Green:* The camera has focused on a face. This happens in the next step.

5. **Press the shutter button halfway or press AF.**

 If everything works, you will see one or more rectangles turn green, as seen on the right of Figure 2-5.

 At times, the face detection rectangle disappears and one or more of the autofocus area boxes turns green. If that happens, release the shutter button and try again, or release the shutter button and press the AF button. If the AF button works, then follow up with the shutter button halfway to meter.

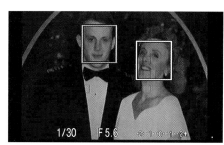

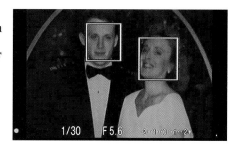

6. **Press the shutter button fully to take the photo.**

Registering faces

Figure 2-5: Face detection is so good it works even when pointed at photos on screens: me with my mom in 1987.

The only thing "funner" than face detection is face registration. By pre-registering up to eight faces, the camera can quickly detect and identify that face in the future.

To register them, follow these steps:

1. **Gather the people whose faces you want to register beforehand.**

 You must have the faces to register. This isn't something you can do by yourself.

2. **Press the Menu button.**

3. **Go to Custom menu 4 (A65) or 5 (A77). See Figure 2-6.**

4. **Select Face Registration and press the enter button.**

5. **Select New Registration and press the enter button.**

 See Figure 2-7.

6. **Place the guide frame on the face you want to register, as shown in Figure 2-8.**

 Here are some tips:

 • Get in close or zoom in so the face fills the frame.

 • Try to minimize shadows. Place people in good light.

 • Pets may not register. I tried registering one of our cats for about 15 minutes before giving up.

 • Use a picture if the person is not available.

7. **Press the shutter button.**

 If the face can't be registered, you'll be told there was a problem. Make sure the face fills the frame and is in focus.

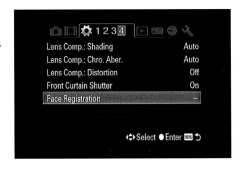

Figure 2-6: Choosing Face Registration.

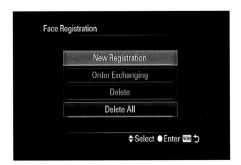

Figure 2-7: Going through the Face Registration menu.

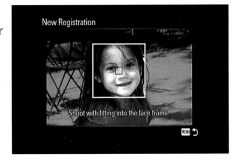

Figure 2-8: Make sure to fill the frame.

8. **Highlight enter (see Figure 2-9) and press the enter button to confirm.**

Managing faces

You do can more than just register faces. You can also prioritize them (hint: wives and husbands should come before pets), delete registered faces, or delete all registered faces and clear the camera's memory.

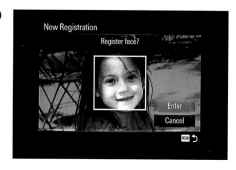

Figure 2-9: Confirming the registration.

 Press the menu button and go to Custom menu 4 (A54) or 5 (A77) to do each of the following tasks:

- **Change priority:** Select Order Exchanging, then select the face (see Figure 2-10) to prioritize followed by the level.

- **Delete a face:** Select Delete when choose the face you want to delete. One thing to point out. Even when you delete it, the face data remains in the camera. If you need to sanitize it, you must choose Delete All.

Figure 2-10: Reordering my family's faces.

- **Delete all registration data:** Choose Delete, then select Delete All.

Setting Up for Smiles

Wouldn't it be neat if you could program your camera to detect smiles and automatically take a picture when it sees one? Your wish is Sony's command. The A65 and A77 both have a smile detector. It's called the Smile Shutter, and it comes complete with a sensitivity meter. Despite sounding ridiculous, it works.

Using Smile Shutter

Here's how to use Smile Shutter:

1. **Set the Mode dial to a mode that supports Smile Shutter.**

 You can't use Smile Shutter in Hand-Held Twilight, Sweep Panorama, 3D Sweep Panorama, Continuous Advance Priority AE, or Movie mode. You can't use the Smile Shutter when in manual focus.

2. **Get everyone ready.**

 Since you're not in charge of when the camera takes the photo (a practical flaw with this feature), everyone should be ready to have their photo taken. Or not, if you want to make it a bit more spontaneous. If this is going to be a posed shot and you're using a tripod (like I did for this example), compose the shot so everyone is in the frame.

3. **Press the Function button.**

 Smile Shutter is off by default. If it is already on, you can adjust the sensitivity.

4. **Highlight Smile Shutter and press the enter button.**

5. **Use the down button to highlight On, as shown in Figure 2-11.**

6. **Use the left or right buttons to select sensitivity:**

Figure 2-11: Setting up Smile Shutter.

 • **Slight Smile:** Sandra Bullock, the Mona Lisa, Edward Cullen (at least, he smiles more than Bella).

 • **Normal Smile:** Han Solo, David Tennant, me (my wife says I'm generally all or nothing, which averages out to Normal).

 • **Big Smile:** Tom Cruise, The Joker, Jacob Black (just Google it), Reese Witherspoon, my wife.

 The levels reflect the minimum smile that will trigger the shutter. For example, setting the sensitivity to Big Smile will ignore smaller smiles.

7. **Press the enter button and...**

 Here's where it gets really interesting. Your mileage may vary between experiences. You may either need to hoof it to get in the shot or have everyone smile bigger so the camera will take the photo.

 • *Run!* I used Smile Shutter as a remote shutter button for the example in Figure 2-12.

- *Smile!* This is where Smile Shutter can be almost like a party game. People smile. The camera thinks. People smile harder. The camera still doesn't take the photo. People grin and make crazy faces. The camera should eventually take the photo.

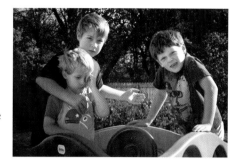

8. Repeat Steps 3 through 5 to turn off Smile Shutter.

Getting control of yourself

When Smile Shutter is on, it keeps taking pictures as long as someone's smiling. It takes one, then another, then another. It can feel like you've lost control of the camera (because you have), which makes everyone smile. To wrest control back, point the camera away from the smile, then turn off Smile Shutter.

If a Smile Shutter frenzy is reached, you can just turn the camera off. This turns off Smile Shutter, even if you turn the camera right back on again.

If you're having trouble getting the Smile Shutter to work, try these techniques:

Figure 2-12: Having fun with Smile Shutter.

- ✐ **Brute force:** Tell people to smile harder. That's always fun. This trick works with kids longer than it will with adults.

- ✐ **Change the sensitivity:** Set the sensitivity higher. (Go back to Step 2.) If the camera goes off at the slightest sign of a smile, then set the sensitivity lower.

- ✐ **Combine technologies:** Position a person's face, and therefore their smile, under an AF area.

- **Say "Ahhh":** Have people smile with their mouths open.

- **Show teeth:** Tell people to bare their teeth when they smile. (Yes, this is getting ridiculous.)

- **Uncover:** Have people take off things that are hiding their faces or smiles, such as sunglasses, masks, and helmets.

- **Take the photo anyway:** Press the shutter button and take the photo yourself.

Easy Bake Flash

This section covers the fundamentals of using the built-in flash in the basic or more automatic modes. There is more to the flash than this, but all you need to get started is here. After you master the basics, turn to Chapter 7 for more advanced information (or read Chapter 11 for material on wireless flash).

Changing Flash mode

At the most basic level, you have two choices when it comes to using the flash. You can let the camera decide when and where to pop the flash and fire it or turn the flash off entirely:

- **Flash Off:** In this mode, the camera is on auto-pilot with the exception of flash control, which you've disabled. If you're using the A77, you have to control the flash from the shooting functions; press the Function button. You don't have a Flash Off mode on the Mode dial.

- **Camera control (mostly):** Whether you're starting out or just don't want to mess with it, letting the camera control the flash is probably the best solution. It makes pretty good decisions. Chapter 3 has more information on the default Flash mode for each of the basic shooting modes and scenes. Some shooting modes disable the flash by default, such as the Landscape scene. In other shooting modes, the flash is set to Auto. If that's the case, the camera pops and fires the flash when necessary. It's so automatic that you can't even pop the flash by yourself. The camera won't let you.

However, there's a twist. You can take back limited control by changing Flash mode. Do so in any of the basic shooting modes except Sweep Panorama, 3D Sweep Panorama, Flash Off (A65), and the night scenes (Night View, Handheld Twilight, and Night Portrait) by pressing the Function button and changing the Flash mode.

To change the Flash mode, follow these steps:

1. **Set the Mode dial to a basic shooting mode that allows you to change the Flash mode.**

They are Auto, Auto+, Scene Selection (with the exceptions listed earlier), and Continuous Advance Priority AE.

2. **Press the Function button.**

3. **Highlight the Flash mode and press the enter button.**

4. **Highlight a flash mode, as shown in Figure 2-13.**

 Available modes have white icons. The others are grayed out. You may be able to choose these settings:

 - *Flash Off:* Turns off the flash and keeps it from firing, regardless of the shooting mode you're in.

 - *Auto Flash:* Turns control over to the camera.

Figure 2-13: Available Flash modes have white icons.

 - *Fill Flash:* Forces the flash to fire.

 Continuous Advance Priority AE offers only the advanced Flash modes (Fill Flash, Slow Sync, Rear Sync, and Wireless Flash). See Chapter 8.

5. **Press the enter button to return to shooting.**

 Or press the Function button to return to the Function screen.

Understanding flash cues

REMEMBER

As long as you're in the right display mode, the viewfinder and monitor both show flash cues (symbols that show you whether the flash is ready or charging, as described in the following list). For the monitor, valid modes include Graphic Display, Display All Information, and For Viewfinder. Only one viewfinder display mode (disabled by default) shows flash cues: Graphic Display. See Chapter 10 for information on customizing the displays.

As shown in Figure 2-14, the flash-charging indicator is near the top of the display. It has a flash symbol and an orange dot. Together, they tell you specific information about the current flash status. If the flash is up, you'll see one of the following indicators:

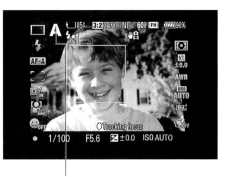

Flash change indicator

Figure 2-14: The flash is charged and ready to fire.

✔ *Flashing:* When the orange flash charging indicator is blinking, the flash is charging and you can't take the photo. If the AF illuminator fires to get a better focus, the flash indicator may blink once as the flash recharges.

✔ *Steadily lit:* When the orange flash charging indicator is steadily lit, the flash is ready to fire.

Using red-eye reduction

If you're taking flash photos of people and they have red eyes, consider using the red-eye reduction feature. All you need to do is activate the feature from the menu system. The camera takes care of the rest.

1. **Press the Menu button.**

2. **Go to Custom menu 1.**

3. **Highlight Red Eye Reduction and press the enter button. See Figure 2-15.**

4. **Select On and press the enter button again.**

 The flash shoots several low-level pre-flashes after you press the shutter button fully but before firing the main burst and taking the photo. Those pre-flashes convince pupils to constrict and therefore reduce the chance of scary orbs.

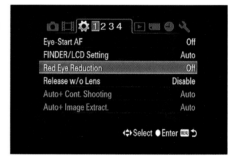

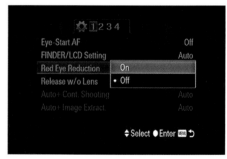

Figure 2-15: Gets the red out.

Although easy to use and enable, consider these factors when using red-eye reduction:

✔ **Flash overload:** Warn the person you're photographing that they will see several bursts from the flash and not to move or freak out. Often, as soon as they see the flash, they think you've taken the picture and move.

✔ **Steady as she goes:** That goes for you too. When you press the shutter button fully, there will be more of a lag between that time and when the shutter triggers. Try to stay steady during this time.

Choosing a memory card

Tons of different memory cards and sizes out there, from 2GB to 32GB. The idea that you should get the largest possible size is wrong. Choosing one that's right for you depends on how often you shoot, how much, your size and quality options, and how often you transfer photos. The following table shows you how many photos you can fit on different cards, from 2GB to 32GB. The photos are large and have an aspect ratio of 3:2. At 5,500, the 32GB wins the size and space war, hands down. However, you may never use that much space. If you shot 100 standard JPEGs a day, it would take you almost 2 months to fill up a 32GB card! Chances are, you will transfer the photos off the card well before you fill it up.

My recommendation is to determine the highest quality photos you will take, on average, and figure out how long you need to go without transferring them. If you like shooting Raw + JPEG and shoot a few hundred photos a day, you will have to transfer once or twice if you use an 8GB card. You can also buy more cards and swap them out. That's pretty reasonable. In that case, a larger card remains largely empty — or, if filled, would only make disasters more disastrous. Would you rather lose 880 photos or 220?

Smaller cards are fine if you only ever shoot standard JPEGs, and especially if you pick up a couple of cards (I love backups). Seriously consider buying larger cards if you work with Raw photos. You only need the *largest* cards if you shoot as much as a serious professional photographer or will be out of contact with civilization for an extended period of time. Even then, you would somehow have to be able to recharge your batteries.

Setting	2GB	4GB	8GB	16GB	32GB
Standard	335	680	1,350	2,750	5,500
Fine	205	410	830	1,650	3,300
Raw + JPEG	54	105	220	440	880
Raw	74	145	300	600	1,200

✔ **Software solution:** It's easier to correct red eye before it ever happens. However, if you need to fix it in software, most photo editors have easy-to-use red-eye removal tools.

✔ **Pets are less compatible:** Pets don't like flash in the first place, but when you stick a strobe light in front of them, they really don't like it. Chances are, pets will not sit still with red-eye reduction enabled.

Rustling up a Photo Size, Aspect Ratio, and Quality

You've got a modern-day marvel in your hands. The A65/A77 can take magnificently clear, compelling photos. And let me tell you something more: You can achieve such photos in several sizes, aspect ratios, and qualities.

The thing is, the A65/A77 has no *bad* setting. There are good ones and better ones. Which one you should use depends on your situation. In general, if you plan on printing large copies of your photos, select the highest quality photo possible. If you're going to be use them on a computer screen or small prints, even the smaller, lower quality settings are fantastic.

The rest of the section has information on the specific sizes, aspect ratios, and qualities. To change any of the three image parameters, follow these steps:

1. **Press the Menu button.**

2. **Go to Still Shooting menu 1.**

3. **Highlight the setting you want to change.**

 These steps apply to Image Size, Aspect Ratio, and Quality, which you can see in Figures 2-16 through 2-18. Remember that there's more information on each of these parameters in the other parts of this section.

4. **Use the up or down buttons to select a new setting.**

5. **Press the enter button.**

6. **Press the Menu button to exit the menu.**

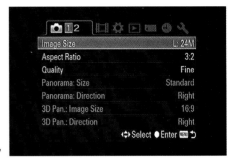

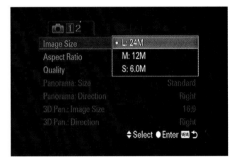

Figure 2-16: Setting the image size.

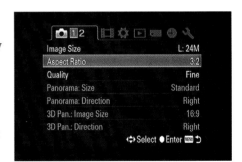

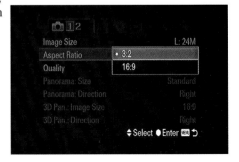

Figure 2-17: Choosing an aspect ratio.

Changing the image size

The A65/A77 has more photo sizes than you can shake a stick at. They are divided into large, medium, and small, which makes sense, but these sizes have different meanings depending on whether you're referring to a 3:2 versus 16:9 aspect ratio. What's more, panoramas have sizes of their own, divided into standard versus wide, horizontal versus vertical, or 3D versus non-3D.

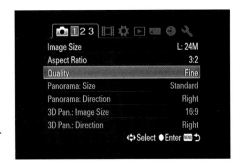

Table 2-3 shows the standard photo sizes. It helps to look at the table's two columns: the pixel dimensions (Dimensions) and how large the print could be at a resolution of 300 dpi, which is a high-quality printout (Print@300dpi).

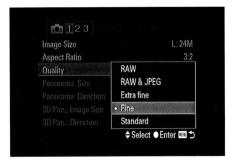

Figure 2-18: Deciding on a quality on the A77.

When you choose a photo size, consider how good it should look set at Medium. If you're looking at the photo on a computer monitor, you won't need an exceptionally huge photo. Even the smallest image size (at 3:2 aspect ratio) is larger than most desktop resolutions. Medium offers a good compromise: large desktop size and good-sized printout.

Beware. All of these photo sizes are going to look close to the same when you look at them on your computer monitor because the monitor (or software you're using) scales them to fit.

Table 2-3		Image Size (3:2 Aspect Ratio)		
Symbol	*Setting*	*Dimensions*	*Megapixels*	*Print@300dpi*
L	Large	6,000 x 4,000	24	20.0 x 13.3 in
M	Medium	4,240 x 2,832	12	14.1 x 9.4 in
S	Small	3,008 x 2,000	6	10.0 x 6.7 in

Figure 2-19 illustrates the three photo sizes in action. I took these photos of a single subject (in this case, of a funny fish we gave my mom for her kitchen some years back) under controlled conditions. Each size is shown, from small, to medium, to large. The aspect ratio was set to 3:2. At this magnification you can tell a size difference, but not a quality difference. You would have to print out relatively large copies or view them at extreme magnification to discern those types of differences.

Figure 2-19: Big, bigger, and biggest.

Table 2-4 shows the sizes when applied to photos with a 16:9 aspect ratio.

Table 2-4	Image Size (16:9 Aspect Ratio)			
Symbol	*Setting*	*Dimensions*	*Megapixels*	*Print@300dpi*
L	Large	6,000 x 3,376	20	20.0 x 11.3 in
M	Medium	4,240 x 2,400	10	14.1 x 8.0 in
S	Small	3,008 x 1,688	5.1	10.0 x 5.6 in

Panorama sizes are listed in Table 2-5. The top line for each setting refers to the size of panoramas shot horizontally. That is, sweeping from the camera's left to right or from its right to left (regardless of how it is oriented to the ground). The second line for each setting refers to vertical panoramas. Those panoramas are taken sweeping from the camera's top to bottom, or from its bottom to top. (If you flip the camera on its side and shoot a vertical panorama from top to bottom, you will actually sweep horizontally across the landscape.)

Table 2-5	Panorama Sizes	
Setting	*Dimensions (Horizontal/Vertical)*	*Print@300dpi*
Standard	8,192 x 1,856	27.3 x 6.2 in
	3,872 x 2,160	12.9 x 7.2 in
Wide	12,416 x 1,856	41.4 x 6.2 in
	5,536 x 2,160	18.5 x 7.2 in

Figure 2-20 shows the difference between a standard versus wide panorama. Both were taken horizontally. The standard panorama used a wide-angle focal length (18mm), which means that even though the photo is smaller, it covers the entire field. The wide panorama allowed me to shoot at 26mm and still cover quite a bit of real estate.

The biggest difference isn't so much the length, though, as the aspect ratio. This affects overall appearance of each panorama. The wide panorama is very narrow while the standard panorama is chunkier. They are, interestingly, the same height: 1,856 pixels.

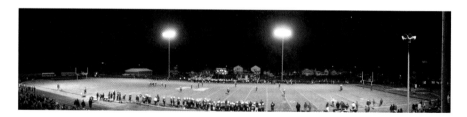

Standard

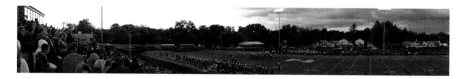

Wide

Figure 2-20: Wide and wider.

Table 2-6 shows the three available sizes for 3D panoramas. The 16:9 version is the smallest. These have no print size because they must be viewed on a 3D-capable HDTV or monitor.

Table 2-6	3D Panorama Sizes
Setting	*Dimensions (Horizontal)*
3D 16:9	1920 x 1080
3D Standard	4912 x 1080
3D Wide	7152 x 1080

Don't let all the numbers scare you away from choosing the right image size for you. Here is what I recommend:

✔ **Better safe than sorry:** Choose the largest photo of whatever type you happening to be shooting. This preserves your option to print high-quality photos at 300dpi whether you intended to use them in print when you took them or not. Large photos also give you room to crop without losing too much detail or print resolution.

✔ **When to compromise:** If space or speed is more important than ultimate print resolution, then choose medium for each type. You can still view and print high-quality photos. What you lose is being able to print them at larger sizes, and to some degree, visual detail when viewing them magnified.

Picking an aspect ratio

Aspect ratio, unlike size or quality, has more to do with your artistic goals than quality. Here are the aspect ratios you can choose from:

- ✓ **3:2:** This is the standard photo ratio. It represents the same aspect ratio of a 35mm frame of film.

- ✓ **16:9:** This ratio is the same as widescreen movies (we used to call them Letterbox editions) and HDTVs.

Figure 2-21 shows the difference between a photo shot at 3:2 versus 16:9.

If you want the wide-screen effect to make a photo feel elongated and expansive, you can't beat the 16:9 version. The thing about it that makes it so compelling is that you don't have to do any more work. The JPEG is already cropped and saved.

3:2

Here are the basic reasons to choose one aspect ratio over the other:

- ✓ **Automatic:** If you want a wide-angle photo and don't want to load a standard image into a photo editor and crop it yourself, choose the 16:9 aspect ratio. It's one and done, baby. You have the finished product as soon as you take the photo.

16:9

Figure 2-21: Digging in the dirt.

If you shoot Raw + JPEG or Raw, you still have the Raw file to work with. It remains uncropped. Open the Raw image in Image Data Converter SR, which is explained in Chapter 5. The 16:9 area with the cropped material shaded is displayed, but you can output the entire image to a new JPEG or TIFF and load the photo into a separate photo editor and crop on your own.

- ✓ **Do-it-yourself:** If you want to crop photos yourself, choose either approach. If you go with 3:2, you can do all the work in whatever photo editing application you choose. If you shoot using Raw + JPEG quality, select 16:9 and decide whether to take the JPEG or edit the Raw file yourself later.

Choosing photo quality

Choosing the quality of the photos you take is just as important as choosing their size. It helps to know a few things about the differences between JPEGs and Raw files before getting to the quality settings.

- ✔ **Raw** files store image data and converts into digital form. Beyond this, they are unprocessed. Sony uses the three-letter file extension .arw, to identify Raw files created by its digital cameras.

- ✔ **JPEGs** begin life with the same original data as Raw files. The camera processes that data using a set of pre-defined routines to create the best all-round photo. The processed data is then compressed and saved using the JPEG standard.

Despite what it sounds like, you do have some control over how the camera processes Raw data and converts it into a JPEG. This control takes the form of creative styles. For example, when you select Vivid Creative Style, you're telling the camera to convert the Raw data with greater saturation and contrast.

Aside from the compression issue, using Raw files lets you put off making processing decisions. You have control over exposure, saturation, contrast, noise reduction, and many other parameters. You can undo them if you change your mind, or create several alternatives and choose the one you like best. Using Raw files empowers you to make potentially better artistic decisions than the camera. The downside is having to learn how to process Raw photos, and of course, the extra work it requires.

The quality options follow.

Standard

Standard-quality photos are JPEGs saved with the *lossy* compression scheme. When compared to fine JPEGs, they're tipped a little toward saving space rather than preserving data.

JPEGs use complicated mathematical algorithms that take the photo's original data and change it into something that takes up less space (compression). The problem is, the result isn't an exact copy of the original, and the original can never be resurrected from what's left (lossy). Something really close can be, but not the original. It's like breaking an egg for an omelet. It's still an egg, but you can't go back to the original.

The lossiness part can be adjusted, which is why the camera can save a fine or a standard JPEG. High-quality JPEGs like Fine photos lose less data, but they're still not exact copies. And oh, by the way, every time you save a JPEG,

the algorithm is reapplied, which means applying lossiness upon lossiness. Now that I've scared you away, I want to bring you back to standard JPEGs.

These photos are astoundingly good. They actually are. Don't be fooled by the fact that they have the *least* quality. It's all relative. Because they aren't the best, standard-quality photos get a bad rap. However, they are still very, very good.

Consider using standard JPEGS in these situations:

- ✔ When you want to maximize the number of photos on a memory card or minimize the space storing and archiving them on your computer.

- ✔ When you're taking photos to put on the web. By the time you reduce a 24 megapixel photo down to something you can put on Facebook, no one will be able to tell whether it was a Standard or Fine JPEG.

- ✔ When you need files that are easier to save and store than Raw + JPEG, which means that you can take photos faster.

Fine

Fine is like Standard (a lossy JPEG), but better. Standard JPEGs err towards saving a bit more space than fine JPEGs, but the difference is not like night and day. Given today's cheap storage solutions and fast processors, fine JPEGs don't put that much stress on your system. Therefore, if you want the best possible JPEG the A65 can produce, this is it.

Extra fine (A77)

With the A77, you get the executive treatment. Extra Fine JPEGs are like Fine JPEGs, but they use even less lossy compression. You get the same number of pixels as Fine or Standard JPEGs, but because of the compression difference, the file size is much larger (close to the Raw file, in fact, for a Large Extra Fine JPEG) and the quality is better.

If you want to process your JPEGs after you shoot, Extra Fine JPEGs will hold up much better than Standard or Fine JPEGs. If you set the camera to RAW + J, you get a Raw file and a large Fine JPEG, *not an Extra Fine JPEG.*

Therefore, you can only choose Extra Fine JPEGs when shooting JPEGs only.

Raw

You can abandon JPEGs entirely and have store photos in Raw file format. This method preserves the photo's original quality. It also sets the photo to the maximum size. The problem is, you don't have a JPEG and you will have

to do all the work of photo processing. If you want a Raw photo, this option is slightly quicker than Raw + JPEG because you're only saving the one file.

Auto HDR isn't possible when photo quality is set to Raw.

Raw + JPEG

This quality setting is the best (or worst, depending on your viewpoint) of both worlds. The camera stores both a fine JPEG and a Raw file. The JPEG is nice to have if you want to browse through the photos and send some off to clients or friends before you do the intense Raw processing. The Raw file is great if you want to do your own processing. The potential downsides are space (two files are larger than one) and time (it takes longer for the camera to process and save them).

Choosing

The tale of the tape, then, is this:

- ✔ **Choose JPEG** if you want a final product coming out of the camera. (You can tweak Extra Fine JPEGs more without it becoming obvious.) You don't want to mess with processing the Raw file yourself. You don't need the ultimate in quality and are happy with what the camera produces. You're happy using JPEGs on your computer or putting them online. (You can't upload Raw files to Flickr, Facebook, your blog, or your web page. Don't even think of tweeting them.)

- ✔ **Choose Raw or Raw + JPEG** if you want creative control over your photos and don't mind doing the processing yourself. You want the flexibility of making multiple edits throughout the process. For you, saving storage space and speeding up transfer rates aren't as important as quality.

Don't get too cocky about the superiority of Raw files over JPEGs. Unless you're good at processing Raw files, the JPEGs may look better.

Figures 2-22 through 2-24 illustrate the battle of size and quality with some head-to-head comparisons. Each of the images is a separate photo. I didn't cheat and resize them in software. I shot them in sequence with the same exposure settings and later processed them identically. To be honest, all the images in Figure 2-22 through 2-24 look okay to me.

- ✔ Figure 2-22 compares two large JPEGs. One is standard and one is fine. Can you tell which one?

- ✔ Figure 2-23 compares two medium JPEGs at standard and fine.

- ✔ Figure 2-24 compares two small JPEGs at Fine versus Standard quality.

Now, for one final test. At normal magnifications, the photos essentially looked identical. When you zoom in, there is the chance you'll see differences. Figure 2-25 shows six sections from the previous photos at a higher magnification. It's almost impossible to tell the difference. The large/fine JPEG looks a tiny bit sharper. That's about it. There's no clear *stinker* in the bunch at this size, which is saying a lot.

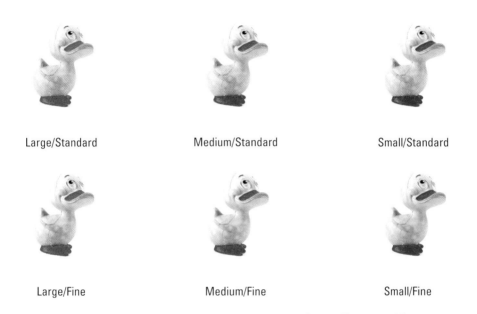

Large/Standard Medium/Standard Small/Standard

Large/Fine Medium/Fine Small/Fine

Figure 2-22: Breaker, breaker. Figure 2-23: This here's Rubber Duck. Figure 2-24: We got us a convoy.

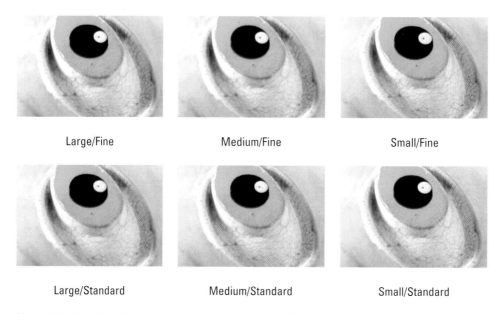

Large/Fine Medium/Fine Small/Fine

Large/Standard Medium/Standard Small/Standard

Figure 2-25: Actual quality is very close, no matter what setting you use.

3

Pointing and Shooting Your Way to Great Pictures

In This Chapter

▹ Handling your camera

▹ Using automatic modes

▹ Shooting with scenes

▹ Taking fantastic panoramas

▹ Getting super-fast shots

Although your A65 or A77 is far more than a point-and-shoot camera, it has automatic modes that turn it into just that (and fantastically so). The automatic modes work so well that this chapter is devoted to explaining them. The three fully automatic modes (Auto, Auto+, and Flash Off for the A65) require little to no intervention from you. In addition to them, you can choose from several scenes, which allow you to tell the camera what you're trying to photograph. You can also shoot incredible, automated panoramas without using a computer, and rattle off high-speed bursts of action shots. This chapter can help whether you're a complete novice and need a helping hand so that you can start taking great photos, or you're pretty darn good and want a quick reference to show you what the easier modes are all about.

Holding on Tight

Handling your camera is one of the most important skills you can master as a photographer, even if you're interested only in taking casual photos. If you don't provide a stable platform for the camera, you'll be plagued with poorly composed, often blurry shots. Even though the A65/A77 has an internal camera de-shake-ifier called SteadyShot, excess movement makes it hard to frame the scene the way you want it.

The A65/A77 is large enough that you have to start thinking about seriously supporting them. Depending on the lens, you add even more weight and bulk.

You'll know if you're moving the camera around too much if you see the camera shake warning icon flashing in the viewfinder or on the LCD monitor. in all modes except Manual, Shutter priority, and Movie, it warns you to settle down.

Faceplant

In Figure 3-1 I'm holding the camera in a traditional pose, looking through the viewfinder. Try this stance if you're starting out, and modify it to suit your style as you get more experience.

Whether you're shooting vertically or horizontally, keep your knees bent a bit and almost hunch into the camera. It feels like you position it first and then bring your body up to meet it. Stand with your feet apart, as if you're bracing yourself, but don't lock your knees. Keep them a bit springy.

Hold your head close to the camera, pressing your eye into the Eyepiece cup (the hard plastic piece surrounding the Viewfinder). Don't be afraid to use the space just below your eyebrow to help support the camera. Stick the eyepiece cup right in there. However, if that's not comfortable, simply float your eye behind the viewfinder and try to stay still.

Figure 3-1: Hold your camera steady.

Your right hand should be on the grip with your index finger on the shutter button. Curl the lower fingers of your right hand around the grip and use them, in part, to hold onto the camera. That leaves your right thumb and index finger free to work controls on the front, top, or back of the camera.

Your left hand does most of the work of supporting the camera. Notice that I have it under the lens near the body of the camera, with my thumb and index finger on the lens's zoom ring. This hold is optimized for autofocus. If you want to manually focus, your left thumb and index finger should move to the front of the lens and support it by the focus ring. Your elbows should be reasonably close to your body, with your left elbow almost propped against you. If you keep your arms firm and close, that will stabilize you quite a bit more. The camera strap is there in case of an emergency. When holding the camera like this, it bears no weight.

Figure 3-2: Adjust your arms to reposition the camera.

In Figure 3-2, I'm shooting vertically. The only thing that changes is my right elbow, which I extended up so my right hand could hold the camera.

Keeping your distance

Maybe you'll be more comfortable shooting with Live view (looking at the LCD monitor on the back of the camera). You can see me checking my composition in Figure 3-3.

Hold the camera away from your face so you can see the LCD monitor. When zooming or focusing, move your left hand back to the lens to operate these controls. Your right hand doesn't change at all.

Shooting in Live view from the LCD monitor is a much more casual setup, with benefits. Aside from comfort, you're able to keep track of what's going on around you better, whether that's kids playing football in your yard or cars going by. You're also able to talk and interact with your subjects better without your face being grafted onto the camera. However, the style has drawbacks. This position is much harder to stabilize than when holding the camera up against your body.

Figure 3-3: Relaxing in Live view.

Automatically Taking Great Pictures

Automatic shooting modes help new photographers get into the swing of things. It can take time to learn where all the buttons are and what they do, not to mention figure out the menu system and decipher all the displays. I encourage you to use the auto modes (as well as the scenes in the next section) to become familiar with your camera as you take photos. When you feel like you're ready to step up and take more of the workload yourself, do so. Chapter 7 can ease that transition.

Modes of transportation

The A65 has three and the A77 has two automatic photo-taking modes that make your life ridiculously easy. You can see both in Figure 4-3.

- **Auto:** Probably the mode that needs the least explanation. You point the camera. You press the shutter button halfway to focus, and then fully to take the photo. The camera figures out how bright the scene is. Simple.

- **Flash Off (A65):** Auto without the flash. Easy to remember.

 Sony had to make room for the Memory Recall mode on the A77's Mode dial so they took off Flash Off mode. However, you can duplicate Flash Off by choosing Auto mode and setting Flash mode to Flash Off in the shooting functions. (Press the Function button.)

✔ **Auto+:** Smarter than Auto. The camera senses the shooting conditions, not simply the brightness, and sets the correct exposure. The A65/A77 recognizes these scenes in Auto+ mode:

- *Night View*
- *Backlight Portrait*
- *Backlight*
- *Spotlight*
- *Hand-held Twilight*
- *Portrait*
- *Macro*
- *Low Brightness*
- *Landscape*
- *Tripod Night Scene*
- *Night Portrait*
- *Baby (yes, you read that right)*

Then the camera uses one of these shooting functions, and notifies you by putting the name in the viewfinder or on the LCD, to keep you out of trouble:

- *Continuous Shooting* takes 3 quick photos.
- *Daylight Sync* fires the flash. Otherwise known as *fill flash*.
- *Slow Sync* fires the flash setting but slows the shutter a bit.
- *Slow Shutter* lets you know that the shutter speed is going to be slow. The camera may choose this function when you're shooting dark scenes.
- *Auto HDR* take three shots with different exposures and combines them. Saves the best exposed shot and the combined version. For manual HDR, read Chapter 9.
- *Hand-held Twilight* takes six photos and combines them into one shot to reduce blurring and noise.

Auto modes

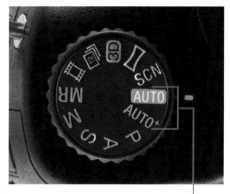

Auto modes

Figure 3-4: Automatic modes on the main dial.

Each of these automatic modes transfers much of the technical workload of operating your camera to the camera. Instead of *you* having to configure settings and options, the camera senses what needs to be done. Ego is the number one reason people bypass an Auto setting in favor of something more complicated. That's a shame, because no matter how smart or technically driven you are, it can be fun to just take pictures.

Using auto modes

To use Auto, Auto+, or Flash Off (A65) modes, and assuming you aren't using a tripod, follow these steps:

1. **Set the mode dial to the automatic mode of your choice: Auto, Auto+, or Flash Off (A65).**

 - Choose Auto+ if the lighting conditions are challenging.

 - Choose Auto in the case of a normal snapshot.

 - Choose Flash Off if you need to keep the flash from firing with the A65. If you're using the A77, enter Auto or Auto+ mode and turn the flash off from the Shooting Function menu.

2. **Set the focus mode switch (on the lens and the body) to AF, as shown in Figure 3-5.**

 On the A77, set the focus mode dial on the camera to A. This puts the autofocus system in AF-A (automatic mode). The camera tells the difference between a moving and still subject and focus accordingly (see Chapter 8).

 Not all lenses have a focus mode switch. Figure 3-5 shows the 18-55mm lens, which does indeed have one.

 The focus mode switch on the lens overrides the switch on the camera. If the camera is set to AF (A65) or C, A, or S (A77) and lens is set to MF, the camera is in manual focus mode — *not* autofocus. If you have both switches, always set the A65 focus mode switch on the camera to AF; on the A77, set it to C, A, or S and then leave it alone. Use the lens switch to switch from manual to auto focus.

 Don't use the manual focus ring unless the lens is switched to MF. Otherwise, you could damage your lens. You will feel the camera release the focus ring so that it turns easily when you're in manual focus.

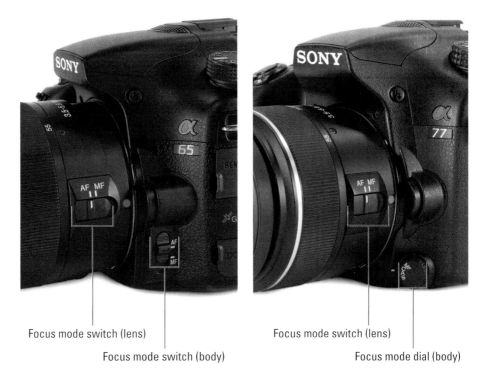

Focus mode switch (lens) Focus mode switch (lens)

Focus mode switch (body) Focus mode dial (body)

Figure 3-5: Set focus mode to AF.

3. (Optional) Press the Function button to check the mode's settings.

You can, for the most part, bypass this step and use the default settings. See Figure 3-6. However, even the most automatic modes have some settings you can change:

- *Drive Mode:* This determines how the camera advances to the next photo. Your options are Single Shooting, Continuous Shooting (Lo or Hi), Self-Timer (2 or 10 seconds), and Remote Commander. These settings are covered more fully in Chapter 2.

- *Flash Mode:* When in Auto+ or Auto modes, lets you control the flash. Options are Flash Off, Autoflash, and Fill Flash. Flash is covered more fully in Chapters 2 and 7.

- *Autofocus Mode:* Shows you the AF mode, and is covered in Chapter 8.

- *Object Tracking:* Tracks targets to keep them in focus. See Chapter 8.

- *Face Detection:* This feature identifies faces in the scene and is covered in Chapter 2.

- *Smile Shutter:* This mode automatically triggers the

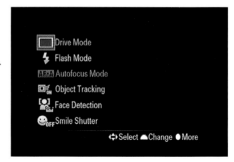

Figure 3-6: Automatic mode Function options.

shutter when it detects a smile in the scene. For more information, turn to Chapter 2.

4. **Look through the viewfinder or at the LCD monitor for these indicators.**

- Current exposure mode (should be what you set the main dial to in Step 1)

- Battery power (to make sure you aren't running out)

- Image size and quality; see Chapter 2

- Number of shots left on your card

- Camera shake warning indicator (a warning that your photo might turn out blurry if you don't increase shutter speed)

- Functions (quickly scan to confirm flash, autofocus, drive, tracking, face detection, and smile shutter status unless you are in another display mode)

Figure 3-7 shows how the LCD monitor looks. You won't see the symbols on the left through the viewfinder. In this case, the camera has yet to focus, which means the Autofocus areas remain dark. Face detection frames the faces it can find. The frame is white in the figure because I haven't focused yet. It will be green when it's focused.

You can choose from several display modes (covered more fully in Chapter 1). Each changes the details that appear in the display. Press the display button to rotate through them.

5. **Steady yourself and compose the scene.**

Although not technically demanding, this is one of the most important steps in photography. This is where you decide what's in the photo and where it sits in the frame.

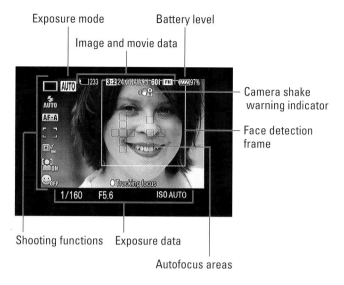

Exposure mode

Battery level

Image and movie data

Camera shake warning indicator

Face detection frame

Shooting functions Exposure data

Autofocus areas

Figure 3-7: Check your mode and status.

6. Zoom in or out using the zoom ring on the lens; see Figure 3-8.

One of the lenses that comes with the A65/A77 can zoom from 18mm to 55mm. Read more on this in Chapter 8.

7. Press the shutter button halfway to focus and meter.

The focus indicator lights up and reads steady when you're focused, as shown in Figure 3-9. If it's flashing, the camera can't focus. The AF areas and/or the face detection frames turn green. In this case the flash is ready to fire, as shown by the orange indicator near the top of the display. (You only see this in certain display modes; see Chapter 2.)

Zoom ring

Figure 3-8: Zoom in or out using the zoom ring.

8. **Finish composing the scene.**

 Make sure it looks good right before you take the shot, and adjust, if necessary.

 If you see the camera shake warning indicator, your shutter speed is slow. (The warning shows up whether you're bumping and grinding or not.) Try to be as steady as possible when you take the shot.

9. **Press the shutter button fully to take the photo.**

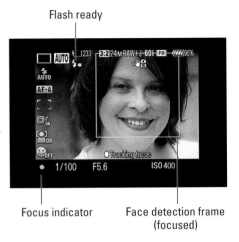

Flash ready

Focus indicator

Face detection frame (focused)

Figure 3-9: Just prior to taking the photo.

Making a Scene

Scenes are fantastic time savers. While the camera handles everything for you in Auto+, Auto, and Flash Off modes, they have a significant drawback: They don't know what you're photographing. Your A65/A77 doesn't know if you're taking a photo of a running child or a potted plant. It can't tell if you want a photo of something very close, far away, or at night. These things matter.

Enter scenes. Scenes tell the camera what's happening without detailed settings. It's like a personal chef. You want ribeye (not to be confused with red-eye) but don't know how to cook it. Just submit your order and the chef delivers it. Sounds delicious!

Scene selections

Here's the menu you have to choose from:

- ✔ **Portrait:** Take photos with nicely blurred backgrounds and sharp subjects.

- ✔ **Sports Action:** Optimized to photograph moving subjects with a fast shutter speed. You can also use Sports Action when *you're* moving.

- ✔ **Macro:** A close-up.

- ✔ **Landscape:** Scenic scenes full of scenery, processed to make the colors stand out. Use Landscape mode to photograph cityscapes as well as traditional shots of nature.

- ✔ **Sunset:** You got it. This scene is ideal when photographing sunsets. It brings out the red, orange, and yellow colors well.

- ✔ **Night View:** Think landscape at night with city lights. The point is to leave the scene dark but have something bright in the scene to see.

 ✓ **Handheld Twilight:** Shooting at night without a tripod.

 ✓ **Night Portrait:** Shoot portraits in the dark.

Setting up for scenes

Here's how you can set up your camera to shoot scenes:

SCN
1. **Set the mode dial to Scene and press the enter button.**

 The A65's mode dial is shown in Figure 3-10.

2. **Press up or down on the control button or multi-controller (A77) to select a scene.**

 See Figure 3-11 for scene labels.

3. **Press the enter button to lock in your choice.**

 Press function if you change your mind and want to choose a new scene. After pressing function, highlight Scene (shown

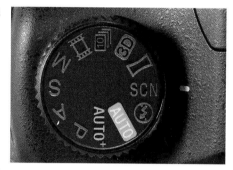

Figure 3-10: Choosing scene selection.

on an A65 in Figure 3-12). Turn the main dial to scroll through the other scenes. Press enter to make the selection.

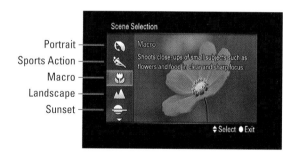

Portrait
Sports Action
Macro
Landscape
Sunset

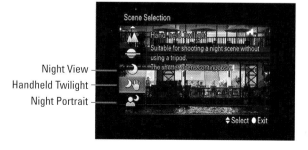

Night View
Handheld Twilight
Night Portrait

Figure 3-11: Select the scene you want from a range.

4. **Compose your shot.**

5. **(Optional) Press the Function button to customize more.**

 You can view or change these settings:

 - *Scene selection:* An iconic reminder of the scene you're in; the place to change it if needed.

 - *Drive Mode:* How the camera advances to the next photo. Covered more fully in Chapter 2.

 - *Flash Mode:* Flash is covered more fully in Chapters 2 and 7.

 - *Autofocus (AF) Mode:* Whether the camera auto focuses continually. Read Chapter 8.

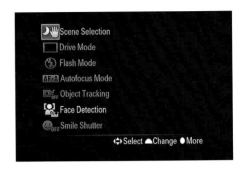

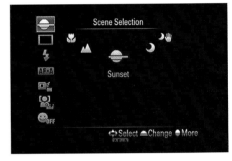

Figure 3-12: Choosing a new scene.

 - *Object Tracking:* Automatically tracks objects to keep in focus. See Chapter 8.

 - *Face Detection:* Identifies faces; read Chapter 2.

 - *Smile Shutter:* Triggers shutter when it detects a smile. Read Chapter 2.

6. **Focus, meter, and press the shutter button to take the picture.**

Customizing scene settings

Press the Function button to view and alter these camera settings when you're in any scene:

- ✔ **Scene Selection:** Choose any of the eight scenes.

- ✔ **Drive Mode:** Choose Single Shooting, 10-second Self-Timer, or 2-second Self-Timer. In Sports Action, Continuous Shooting (Hi or Lo) is the option instead of Single Shooting.

- ✒ **Flash Mode:** Choose between Flash Off (the default) or Fill Flash. In night View, it's set to Slow Sync and can't be changed.

- ✒ **Autofocus Mode:** Set to AF-A (Automatic AF) in all but two cases. In Sports Action scene, it's set to AF-C (Continuous AF — the camera focuses for as long as you hold the shutter button halfway). In Macro, it's set to AF-S (Single AF).

- ✒ **Object Tracking:** Choose On (the default) or Off.

- ✒ **Face Detection:** Choose On (the default) or Off. (The only option available to change in Handheld Twilight.)

- ✒ **Smile Shutter:** Choose On or Off (the default).

Smile for the birdie: Portrait

Use Portrait scene whenever you want to take a nice photo of someone. Don't let the name intimidate you, though. Shooting a portrait doesn't mean setting up a model in a studio with a nice background and expensive lighting. Nope. You can do that if you want, but you can also use Portrait scene in casual settings. Chapter 9 gives you helpful portrait-shooting tips (whether you're using the scene or making your own settings).

Figure 3-13 is a case in point. My family met up with some friends for dinner and I snapped this photo of their brand new baby daughter expressing her hunger. The background is nicely blurred and the focus is on the youngster. Her skin tones are very nice. This is an ideal application of portrait mode.

Chapter 8 covers depth of field in depth. The camera makes blurring the background a priority when in

Figure 3-13: She's getting hungry!

portrait mode. The camera also processes the photo to soften skin tones and make them more appealing, then saves the file as a JPEG. If you set the image quality to Raw, you lose out on the extra processing because the camera does not save a JPEG file. You'll have to do your own processing using Image Data Converter SR (see Chapter 6) or another Raw converter.

Ready, set: Sports Action

The Sports Action scene is ideal for taking photos of, well, sports and action. Think *movement* when you choose this mode. Use this mode if you or your subject is moving. Figure 3-14 shows a great example of photographing a friend who's shooting hoops.

Keep these things in mind when shooting in Sports Action mode:

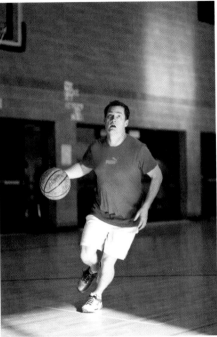

Figure 3-14: A great time to use the Sports Action scene.

- ✓ **Blurring:** You can't control the shutter speed in Sports/Action mode, which means the action might move too quickly for the camera to capture it without blurring. If that's a problem, switch to shutter speed priority mode and set a fast shutter speed. Chapters 7 and 9 have more information on shutter speed and shooting fast action shots yourself.

- ✓ **Kids and pets:** You don't have to be photographing sports to use this scene. This mode excels at capturing blur-free photos of kids and pets around the house or at a party.

- ✓ **Flash and speed:** If the flash keeps popping up and slowing you down, switch to Flash Off mode (from the function menu). Figure 3-15 shows my son tossing a football in the back yard. One image was shot without the flash. The shutter speed was 1/2000 second. That's blazingly fast — so fast that there isn't a hint of blurriness to this photo. The only problem is that the light looks a tad dull. The other image shows what the photo looks like when the flash is activated. Using the flash makes the lighting look much better. However, the shutter speed had to slow to 1/160 second (the A65's flash sync speed). To get a faster shutter speed, you have to use a different camera (the A77, whose flash sync speed is 1/250 second), or an external flash with high speed sync.

- ✓ **Focus indicator:** In Sports Action mode, the focus indicator has arcs around it to indicate that the focal point moves with the subject and is continually updated.

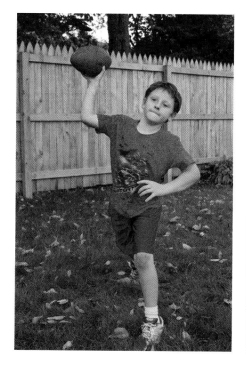

No flash Flash

Figure 3-15: Two action shots showing the difference between Flash Off and Flash.

Mac daddy: Macro

Stick your camera as close as you can to something (within limits) and take a picture. The *macro* photo looks larger than life. Figure 3-16 shows a classic photo taken in the macro style using the Macro scene. A butterfly landed on our driveway. I noticed it, yelled to the kids not to squish it, and ran to get the camera. In situations like this, Macro mode is the best choice.

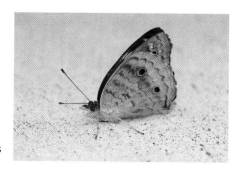

Figure 3-16: Your classic bug macro.

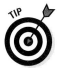

These tips can help you when you're shooting in Macro mode:

✔ **In general, use small subjects:** Small things in particular benefit from Macro mode. Large photos of bugs, flowers, and water drops are prime examples.

✔ **Minimum focus distance:** Although the scene says Macro, it doesn't change how close you can get to your subject and still focus. That distance is called the *minimum focus*, and depends on the lens. The 18–55mm lens that comes with the A65 has a minimum focus of just under 10 inches (25 cm), while the 16–50mm that comes with the A77 has a minimum focus distance of just under 12 inches (30 cm). Figure 3-17 shows four die sitting on a table. The closest are too near for the lens to focus on. The green die sits at the exact minimum focus distance. The red die is slightly out of focus because of the shallow depth of field that the aperture (f/4.0) and distance create.

Figure 3-17: The dice in front are too close to focus on.

✔ **Use Flash Off mode:** If you're shooting within 3.3 feet (1 meter), turn the flash off for best results. If you're inside, use other lighting or open the shades to brighten the room. To find out how to change the flash mode, please turn to Chapter 2.

✔ **Be creative:** Macros aren't just about bugs and flowers. I took the camera to a football game hoping to capture some action shots. The girl in front of me had this unique hat that was impossible to miss. See Figure 3-18. Eventually, I realized I should take a photo *of* it instead of trying to work *around* it. I chose Macro and got close.

Figure 3-18: Making lemonade out of lemons.

- **Use focus magnifier with manual focus:** You can't change the AF area or select a specific AF point in Macro mode. For best results, switch to manual focus (MF) and turn on the focus magnifier. For more information on how to turn the focus magnifier on and use it, turn to Chapter 8.

- **For super-duper close-ups:** Try using the smart teleconverter (see Chapter 11) in Macro mode. That's right, you can combine the two modes to get close and then digitally zoom into your subject.

Taking it in: Landscape

Landscape scene captures scenic scenes filled with sumptuous scenery. Use it to take photographs of fields, parks, and other landscapes, as well as scenes with water and city skylines. Think *distance* and *depth* when shooting in Landscape mode.

The camera uses a small aperture so the depth of field is very deep. (See Chapter 7 for more information on depth of field and aperture.) It also processes the colors so they're vivid. Figure 3-19 was taken from Belle Isle looking west at downtown Detroit. You can see the Renaissance Center clearly (it's the tallest building in the scene) and the Ambassador Bridge to its left. The bridge really stands out in the distance. Everything to the left of the bridge is Canada. The scene was photographed using the kit lens at a focal length of 18mm.

Figure 3-19: Seascapes work too.

End of days: Sunset

The Sunset scene captures the warm colors of the sunset, which are full of oranges, reds, and yellows. Figure 3-20 illustrates how mesmerizing sunsets can be. In this case, yellow dominates the scene and casts a glow into the air, on the water, and into the receding trees.

Figure 3-20: The sun and golden hue are beautifully captured using the Sunset scene.

Here are some more helpful pointers when using this mode:

- **Sunsets are perishable:** Every minute of a sunset is precious, and the nature of the sunset changes from beginning to end. Don't be late and don't wrap things up too quickly.

- **Sunsets are always to the west:** If you have a scene that looks great but you have to be to the west of it, you can't photograph it and the sun in the same shot. You have to choose one or the other. If you're shooting something (besides the sunset itself) in the west, you get golden light and wonderful shadows.

- **Flash:** If you want to light something nearby, they must be close enough for the flash to go off. Set Flash mode to Fill-Flash. (Chapter 2 has the information you'll need to change the flash mode.) This won't brighten a skyline, but will let you see nearby people or objects.

Don't need goggles: Night View

Use the Night View scene to capture bright scenes at night like buildings, cities, and other objects that have a range of dark and bright areas.

Think *distance* (like in Landscape mode), *dark* and *light.* The latter points are important. Night View works best when you're photographing a scene that contrasts with the night. In other words, something has to stand out. You're not capturing the night itself.

Figure 3-21 shows the Cadillac Tower in downtown Detroit. This shot was taken well into the evening and shows off how Night View works. The building and lights are bright and visible, yet the sky is dark, as it should be. The shutter speed was relatively long, 1/4 second, and the ISO was elevated to 1600.

Figure 3-21: Downtown Detroit at night is scenic.

Here are some Night View pointers:

- **Tripod:** If you look at your Night View photos and they are blurry, try using a tripod or rest your camera on something to keep it stable.

- **Noise reduction:** Night View scenes tend to have higher ISOs than other shots. If there's too much for you, use noise reduction software to reduce the noise in the Raw file (ideally) or a JPEG. Turn to Chapter 6 for more information on working with Raw images and noise reduction.

- **Be creative:** You can take photos of lots of things using Night View scene. Figure 3-22 shows what a football game in Indiana looks like at night with clouds sweeping in from the north in the fall. The dynamic range of light in this scene is also nicely preserved. The dark regions in the crowd and trees remain dark, while the sky beyond the clouds as well as the action on the field are well lit. Perfect for Night View.

Figure 3-22: Night View does a great job capturing darks and lights at this football game.

A new saga: Handheld Twilight

Use Handheld Twilight scene to photograph night scenes without a tripod. The camera shoots a burst of photos and merges them together, after it does some blur and noise reduction. It's a lot like nighttime High Dynamic Range (HDR) photography in that the burst provides more data but you end up with one final file. Figure 3-23 shows an alley in downtown Fort Wayne on Christmas Eve. Our routine is to go out and look at the lights before we wrap things up and put the kids to bed. I was walking down the street to take a picture of another building when I looked right and saw this interesting scene. The contrast — light and dark, color versus drab, modern versus decrepit — fascinated me, so I dialed in Handheld Twilight and took the shot. This mode is perfect for scenes at night with bright and dark areas. I didn't use the flash.

TIP

Use these tips and tricks when shooting in Handheld Twilight mode:

- **Don't freak out:** When you press the shutter all the way, the camera seems to take off. Don't worry. This is how it's supposed to work. You don't even need to keep the shutter button pressed down.

- **Steady does it:** Although you don't need a tripod to use this scene, it's somewhat unnerving to move around as the camera takes all the photos. Relax and check the picture after the camera processes it. If you moved too much and the photo is too soft or blurry, steady yourself and try again.

- **JPEG only:** Handheld Twilight scene produces only JPEGs, not Raw files.

- **Depth of field:** This mode's larger apertures reduce the depth of field. This is more noticeable when shooting close objects, but not a problem at all when shooting from a distance.

Figure 3-23: This alley is well lit because of the lights and mode, not the flash.

Work on your moves: Night Portrait

The Night Portrait scene is best when taking photographs of people at night. The idea is to use the flash to light the subject, but leave the shutter open long enough to brighten the background. Figure 3-24 is a photo I took of my family and me. We were winding up a day-long adventure at historic Fort Defiance. My wife wanted a photo of everyone together to cap off the day. I set the camera up on the tripod, chose the Night Portrait scene, and changed Drive mode to the 10-second self-timer. I framed the shot, pressed the shutter,

Figure 3-24: Night portraits work great with the self-timer too.

and got into position. The end result is nice! You can see the dark river and sky in the background, adding to the ambiance, and we are well lit by the flash. The shutter speed is 1/8 second, with an aperture of f/2.8 and an ISO of 800.

Keep these things in mind when shooting in Night Portrait:

- ✔ **Tripod:** Ideally, you'll use a tripod (because the Night Portrait scene lets the shutter stay open longer than during a normal portrait). The shutter speed in Figure 3-24 is too long to hold still for. (You still have to get your subject to remain still, but at least you've limited the problem to one side of the camera!)

- ✔ **Portrait:** It's still a portrait, so frame up your subject like you would during the day using Portrait mode.

Shooting Sweeping Panoraaaaamas

The A65/A77 has a tremendously cool feature called Sweep Panorama (and the related 3D Sweep Panorama). Instead of manually photographing several frames of a panorama and then using software to stitch them together so they look like a single, large photo, Sweep Panorama handles everything.

All you do is point, shoot, and pan. Here are the details:

1. **Set the mode dial to Sweep Panorama and press enter.**

 See Figure 3-25. If you want to shoot a 3D panorama, select 3D Sweep Panorama instead.

2. **Choose Panorama Size from Still Shooting menu 1: Standard or Wide.**

 - *Standard:* 3,872 x 2,160 pixels when taken vertically and 9,182 x 1,856 pixels when taken horizontally.

 - *Wide:* 5,536 x 2,160 pixels when taken vertically and 12,416 x 1,856 pixels when taken horizontally.

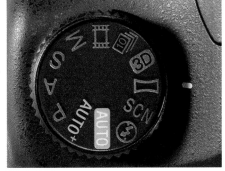

Figure 3-25: Select the panorama mode from the dial.

3. **Set Panorama Direction from Still Shooting menu 1: Right, Left, Up, or Down.**

 This indicates the direction you're supposed to sweep in, assuming you're holding the camera horizontally (landscape orientation). If you

hold the camera vertically (portrait orientation) and chose Down, sweep to your right.

Figure 3-26 shows a wide panorama taken with the camera held horizontally (landscape orientation). The other image was taken with the camera held vertically and swept *down* (actually to the right). The first shot is nice and wide; really wide. Proportionately, however, it is very thin. The other shot is a good balance between width and height.

Camera held horizontal

Camera held vertical

Figure 3-26: Shooting creatively with wide panoramas.

4. **Frame the scene so you're capturing what you want at the beginning.**

 A bar in the display shows an area that *won't* be taken. You'll also get an arrow pointing you in the direction you should sweep. *Pay attention to the arrow, Luke.*

5. **Press the shutter button fully and sweep the camera slowly in the direction you set in Step 3.**

 You don't have to keep holding the shutter button down. Once you press it, you're off and running until the end of the program. Also, the shooting display shows a guidance bar that tells you how far you have to go. The real awesomeness of this feature is that when you're done taking the photo, you're done. No extra computer work is required.

 The menu's sweep directions assume that you're holding the camera horizontally. If you're holding vertically (with the right side up or down), or upside down, you have to adjust your actual sweep accordingly.

In 3D

If you want to shoot 3D panoramas and have a 3D-compatible TV set, set the Mode dial to 3D Sweep Panorama. A 3D panorama is saved as two files. The first is a standard JPEG. It's not 3D, which means you can look at it on your camera, computer, or a non-3D TV. The second file has additional data in it to make the image look three dimensional. This file is saved with the same name but with an extension of .mpo. For the 3D effect to work, you must have both files.

Keep some tips and tricks in mind while shooting panoramas:

✔ **JPEG only:** Because of the shooting and processing demands placed upon the camera, Sweep Panorama produces only JPEGs. You don't get a Raw file.

✔ **Panorama only:** When shooting panoramas manually, you photograph each section and move the camera to take the next shot. When you're finished shooting the individual sections, you load them into a program on your computer that can stitch them together. That's a lot of work, but because you have the sections of the panorama in hand, you can try different fixes when things don't line up right. (When they do, the panorama looks seamless.) This often involves choosing a different layout, such as Perspective, Cylindrical, or Spherical. Sweep Shooting doesn't let you fix anything. If there's something wrong with the panorama, you're stuck with it.

✔ **Straight and level:** It can be hard to pan without tilting the camera. Pay attention to the indicators in the viewfinder, on the LCD, and in the scene. If necessary, turn the level on. See Figure 3-27.

Figure 3-27: It's sometimes hard to stay level even when you have such obvious visual cues.

✔ **Stitching problems:** Sweep Panorama is awesome most of the time, but when it's off, it's off. Figure 3-28 shows a wide shot of Lake St. Clair. The camera had trouble with the waterline. It jumps up and down throughout the scene. Try shooting from a different orientation.

Figure 3-28: The water was really choppy!

✔ **Keep at it:** It can be hard to center your subjects. The series of photos in Figure 3-29 show my attempts to get all my boys in one shot. I cropped one's head in the first, overreacted and short-changed another in the second. The third is just right.

✔ **Zoom and inspect:** The moral of this story is that you need to zoom in and inspect your panoramas before moving on. It's easy to see if they aren't level. The problems come into play when you look at a small thumbnail of a huge panorama on the back of your camera. You can't possibly tell if there are stitching problems without zooming in and panning around. (See Chapter 5 for information on reviewing photos.)

Figure 3-29: You often have to keep trying to get it right.

You have some control over some of the camera's settings when in Sweep Panorama mode. Press the function button to change some settings:

✔ **AF Area:** Choose Wide (default), Zone, Spot, or Local. Determines how the focal point's chosen in the scene. These settings are covered in Chapter 7.

✔ **Metering Mode:** Choose Multi-segment (the default), Center Weighted, or Spot. Determines how the camera evaluates brightness.

✔ **White Balance:** Choose Auto, Daylight, Shade, or Cloudy. White balance is covered in detail in Chapter 8.

✔ **Creative Style:** Choose Standard, Vivid, Landscape, or Black and White. Creative Styles are covered in Chapter 8.

Rapid Fire

Both the A65 and A77 have a special high-speed mode called Continuous Advance Priority AE. This means the drive is set to rattle off photos as fast as possible.

Here's how to shoot in Continuous Advance Priority AE:

1. **Set the mode dial to Continuous Advance Priority AE. See Figure 3-30.**

2. **Press the shutter button halfway.**

 Doing that starts autofocus and metering. Alternatively, manually focus.

 You can control the aperture and ISO if you're in AF-S or Manual focus mode.

3. **Press the shutter button fully to begin shooting.**

4. **Hold down the shutter to continue.**

 Figure 3-31 shows a range of shots taken during my son's baseball game. (FYI: He has good form and got a hit.) The camera set the shutter speed to 1/500 second, the aperture to f/5.6, and the ISO to 1000.

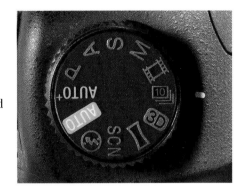

Figure 3-30: Set the mode dial to your version of Continuous Advance Priority AE.

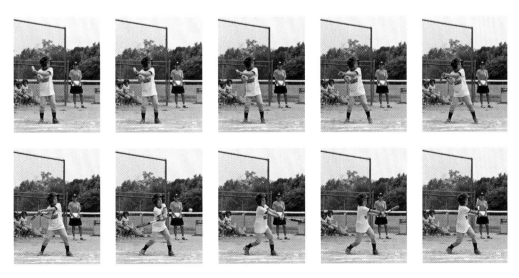

Figure 3-31: It's more than just action; you see the entire sequence.

5. **Release the button to stop shooting.**

 The speed you can get depends on the size and quality of the photos and whether you're saving Raw files in addition to JPEGs or JPEGs only. Anything that makes the camera work harder will slow you down. The A77 can shoot a maximum number of 12 frames per second (fps), and the A65 shoots 10 fps.

 Keep these tips in mind as you go out and take your own high-speed shots:

- **Subjects:** You don't have to stick to shooting sporting events in Continuous Advance Priority AE. Use the mode to photograph someone opening a present or blowing out the candles on their cake. Photograph pets or children as they play.

- **Timing is everything:** If you can't press the shutter button once at precisely the right time, choose Continuous Advance Priority AE and shoot continuously. You stand a much better chance of capturing the perfect moment (or, as in the case of Figure 3-32, several perfect moments).

- **Flash:** You can pop the flash to go off, but then you'll capture many fewer frames. Your mileage may vary.

- **Space and time:** You'll use lots of memory card space when shooting so many photos, especially if you shoot Raw and

Figure 3-32: Kids and high-speed photography go well together.

JPEG. In addition, you'll spend more time reviewing your photos to pick out the best.

✔ **Focus indicator:** It indicates that the focal point moves with the subject and is continually updated.

Here are the changes you can make by pressing the function button:

✔ **Flash Mode:** Choose Fill-Flash (default), Slow Sync, Rear Sync, or Wireless. These options are only implemented when you pop the flash. Otherwise, the flash is off.

✔ **Autofocus Mode:** Choose AF-C (Continuous AF) or AF-S (Single-Shot AF). You might choose AF-S when photographing a person who isn't moving around. For example, you can use Continuous Advance Priority mode to photograph a baby's changing expressions (I wish I'd this when ours were that young), but you don't need continuous autofocus because they aren't running around the yard yet. That comes later.

✔ **AF Area:** Choose Wide (the default), Zone, Spot, or Local. These settings are covered in Chapter 7.

✔ **ISO:** Set to Auto. If you want to limit the ISO and are in bright conditions, set it to a low level.

✔ **Metering Mode:** This determines how the camera evaluates the brightness of the scene. The options are Multi-segment (the default), Center weighted, and Spot.

✔ **Flash Compensation:** Set to 0, but can be changed. Read Chapter 9 for details.

✔ **White Balance:** Set to Auto, but can be changed to match the conditions you're in. White balance is covered in detail in Chapter 8.

✔ **DRO/Auto HDR:** Set to DRO: Auto by default. You may select a level or disable the D-Range Optimizer.

✔ **Creative Style:** Choose Standard, Vivid, Landscape, or Black and White. (The A77 has a few more Creative Styles than the A65.) Creative Styles are covered in Chapter 8.

4

Making Movie Magic

*L*ately, everyone shoots movies: compact digital camera, cellphone, and game device. Everything but wristwatches shoot HD video. Digital SLR makers came to this trend late, but they realized that the dSLR (and now the dLST) make good video platforms and have jumped in with both feet. Today, you can shoot high-def movies with cameras like the A65/A77.

Shooting photos and making movies are different enough from each other to warrant a chapter. You need to know how to select a movie format and size, enable audio recording, decide whether to hook up an external microphone, and transition to capturing continuous action (versus a moment in time).

You'll also read about the difference between shooting autoexposure movies and the more advanced movie modes; plus, you need to know how to play back movies on your camera or HDTV. In the end, whether you want to experiment with movie-making on your A65/A77 or become a serious videographer, this chapter is for you.

Making Some Movie Decisions

⌨ Before you press the Movie button, choose a few options. You'll make your choices in the Movie Shooting menu.

File format

AVCHD and MP4 are your movie types.

Each movie type has different options, explained here and in the following section. Choose wisely. In the end (and quite unlike photos), you decide based on what medium you plan to distribute and watch your movies:

✔ A computer (native or streaming over the Internet).

✔ Devices that only do certain things, such as MP3 players.

✔ On televisions, and distributed on discs such as DVD and Blu-Ray.

Table 4-1 tells you what goes with what.

Table 4-1		Movie Madness		
Quality (target media)	**Type**	**Recording**	**Size**	**Display***
Highest (Computer)	AVCHD	50p/60p 28M	1920 x 1080	PS
High (Blu-ray)	AVCHD	50i/60i 24M	1920 x 1080	FX
Standard (DVD/ Blu-ray)	AVCHD	50i/60i 17M	1920 x 1080	FH
High Cinema (Blu-ray)	AVCHD	24p/25p 24M	1920 x 1080	FX
Standard cinema (DVD/Blu-ray)	AVCHD	24p/25p 17M	1920 x 1080	FX
High (Computer)	MP4	1440 x 1080 12M	1440 x 1080	1080
Low (Other)	MP4	VGA 3M	640 x 480	VGA

*You will see this 2-letter, 3-letter, or 4-digit identifier on the LCD at the top of your display in what looks like a frame of film. There are three FXes, so you can't use this as an unique identifier. From highest quality to lowest: PS, FX, FH, 1080, VGA.

Movie nitty gritty

For AVCHD movies, you need to be able to decode the Recording setting number (for example, 50p/60p 28M). The first number is the frame rate in frames per second, followed by a letter that indicates scan type: progressive or interlaced. 50p/60p, for example indicates 50 frames per second using a progressive scan. Notice that there are two frame rate options.

The thing is, only one applies. In other words, you see either the 50 or 60, but not both. The last number is the bit rate in megabits per second (28M, for example). MP4 movies show their size followed by the bit rate. I know. It would be nice if it were consistent, but this is what you'll see in the camera menu.

Record setting

This setting includes some serious technobabble. The combination of settings results in a movie identifier. Record setting has four components:

- *Frame rate:* How many frames of video are recorded and then projected per second. High-quality video is 50/60 frames per second, and video that has a cinema-like quality is 24/25 frames per second. Your location determines which rate you see (either 50/60 fps or 24/25 fps). This element only applies to AVCHD movies.

- *Progressive (P) or Interlaced (I):* Progressive scanning is better than interlaced, which draws every other scan line of a frame and then returns to draw the others, but requires greater video bandwidth. This component only applies to AVCHD movies.

- *Bit-rate:* How much data is being pushed and pulled. This affects overall video quality greatly. More data equals more quality. For AVCHD movies, the bit rate helps identify the unique movie type.

- *Video size (dimensions):* AVCHD movies are all 1,920 x 1,080 pixels. MP4 movies have two sizes: 1,440 x 1,080 (HD, but not full HD), and VGA, which is 640 x 480 pixels. The video size for MP4 movies sets the bit rate and identifier.

Sound

You have two settings for sound:

- *Audio:* Yay or nay
- *External microphone:* Yay or nay

Choosing a Movie Type

Choose a movie type that matches what you will be eventually watching on: an HDTV or on your computer. The A65/A77 has two types of movies: AVCHD and MP4. Each is optimized to be seen on different devices, HDTV and computer monitors, respectively. With the MP4, you also get a few different sizes, so you can shoot high-quality or more of a standard quality.

If you plan on shooting high-def movies a lot, consider investing in Memory Stick PRO Duo or Memory Stick PRO-HG Duo cards rather than SDHC or SDXC. The Memory Stick PRO-HG, in particular, is optimized for the data rates required to shoot HD video (up to 50MBps maximum transfer speed compared to a 30MBps for a representative class 10 SDHC card).

To select a movie type, follow these steps:

1. **Press the Menu button.**

2. **Go to Movie Shooting menu 1.**

3. **Highlight the File Format option and press the enter button.**

 See Figure 4-1.

4. **Select AVHD or MP4 and press the enter button.**

 - *AVCHD:* Think of AVCHD as Full HD, because it is. AVCHD movies come in one size on the A65/A77: 1,920x1,080. They are also shot at 50 or 60 frames per second, depending on the where you bought your camera. You can tell what your camera supports by looking for 50i or 60i on label affixed to the bottom of the camera. Choose AVCHD when you want Full HD video and high-quality audio, and if you want to create your

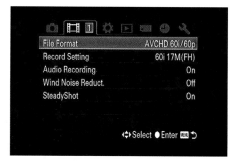

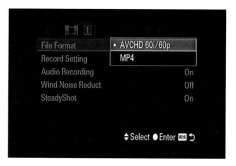

Figure 4-1: Set the format based on what you're going to do with the final product.

own HD video discs. The files will be large, but the movies will look good when played on an HDTV or computer. Don't worry that this option has 50i/50p or 60i/60p in the name. You get a chance to choose the frame rate in the next section.

- *MP4:* MP4 videos are based on Apple's QuickTime video format specification and are better suited to playing back on computers and over the Internet. They are high-quality, but not in the same league as AVCHD. The A65/A77 has two types of MP4 movies to choose from: 1080 and VGA. You'll choose between the two in the next section.

5. **Press Menu to exit the menu system.**

Selecting Recording Options

Choosing good recording options is just as important as identifying the file type you want to use. Choose the record settings that let you shoot the quality of video that fits your output and transmission goals. Not everything has to be the highest quality possible. Some compromises are worth it, depending on your goals.

To set recording options, follow these steps:

1. **Press the Menu button.**

2. **Go to Movie Shooting menu 1.**

3. **Highlight Record Setting and press the enter button.**

 See Figure 4-2, which shows what the name looks like depending on if you've previously set the file format to AVCHD or MP4.

4. **Select an option and press the enter button.**

 Your AVCHD movie options are shown in Figure 4-3:

 - *50/60i 24M (FX):* Full HD. High quality. You must use a Blu-ray disc to preserve the original quality.

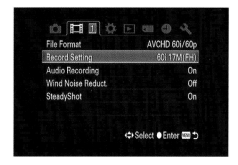

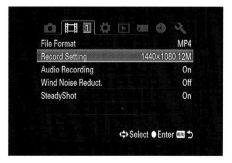

Figure 4-2: Highlighting the oddly labeled Record Setting.

- *50/60i 17M (FH)*: Full HD. Standard quality. Fine for DVD or Blu-ray.

- *50/60p 28M (PS):* Full HD. Highest quality. So high that you must watch on your computer to see the original quality. Even converting to Blu-ray degrades this video.

- *24/25p 24M (FX):* High-quality HD with a cinema-like feeling. You must use a Blu-ray disc to preserve the original quality.

- *24/25p 17M (FH):* Standard quality HD with a cinema-like feeling. Use DVD or Blu-ray discs.

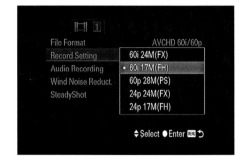

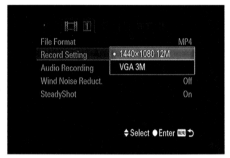

The identifier in parentheses appears in the shooting display. Check that it's what you want before shooting.

Figure 4-3: AVCHD and MP4 recording options.

If you've chosen MP4 as your file format, the options (also shown in Figure 4-3) are:

- *1440 x 1080 12M:* These movies are sized at 1,440 x 1,080 pixels. This is considered HD, but not as large as the AVCHD movies (which are full HD). Choose 1080 when you want a high-quality HD video for your computer, the Internet, or an HDTV.

Unfortunately, if you shoot an MP4 movie in 1080, you can't use Sony's PMB software to create a standard or HD video disc. You can share the movie online (and in the process convert it), but you must use other software to burn a disc.

- *VGA 3M:* VGA movies are 640 x 480 pixels, which is standard defini-tion. Choose VGA when you're doing a project for your boss and you just don't care. (You know I'm kidding.) Choose VGA when you know you won't need to view the movie on an HDTV and don't need the hassle of working with a huge file. My kids have inexpen-sive MP3 players that play videos on a small screen. This size is perfect for them.

5. **Press Menu to exit.**

Figure 4-4 shows all three movie formats together so you can compare their size. The AVCHD and MP4: 1080 formats look the same size. This is because the MP4: 1,080 pixels aren't square to begin with. They're 1.3333 times as wide as they are tall. When displayed, they stretch to fill 1,920 x 1,080, which is the same size as AVCHD.

AVCHD

Enabling SteadyShot

SteadyShot is Sony's in-camera de-shake-n-bakifier (image stabilization). The camera's sensor moves slightly to counteract small movements caused by your shaking hands. (Drink some coffee. Or lay off the coffee.) You're probably used to enabling SteadyShot when taking still photographs. You can also enable SteadyShot when shooting movies. It's nice that the settings are independent of each other, but you have to remember to set them up separately.

To turn on SteadyShot for movies, follow these steps:

MP4: 1080

1. **Press the menu button.**

2. **Go to Movie Shooting menu 1, highlight SteadyShot, and press enter.**

3. **Pick your poison.**

 Choose On to enable SteadyShot. Choose Off to disable it. When using a tripod, you don't need it. Leaving SteadyShot on wastes battery power.

4. **Press menu to exit.**

MP4: VGA

Figure 4-4: Lava never looked so good.

Turning on Audio

Turning on audio recording is easy. You simply have to decide whether you want it on or off. Afterwards, choose whether to reduce wind noise and decide to connect an external microphone to your camera or not (those are in the next sections).

To turn audio recording on or off, follow these steps:

1. **Press the Menu button.**
2. **Go to Movie Shooting menu 1.**
3. **Highlight Audio Recording, as shown in Figure 4-5, and press the enter button.**
4. **Select On to turn Audio Recording on.**

 By default it's on. Choose Off to disable it.

5. **Press Menu to exit.**

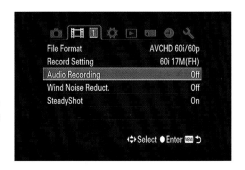

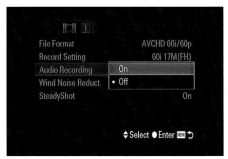

Figure 4-5: Don't forget to turn on audio recording (like I have).

Blowing in the wind

When shooting movies with sound outside, you may find that wind, even a gentle breeze, gets picked up by the microphone and recorded. To counteract some of that, ensure that the built-in wind attenuator is enabled:

1. **Press the Menu button.**
2. **Go to Movie Shooting menu 1.**
3. **Highlight Wind Noise Reduction, as shown in Figure 4-6, and press the enter button.**

4. Select On to filter out wind noise.

It's on by default. Choose Off to disable it. Maybe you're not recording audio, or you have a high-quality external mic with a good "dead cat" (wind screen) on it, or you plan on re-recording the audio later.

5. Press Menu to exit.

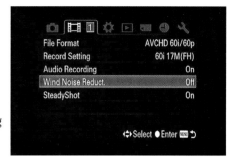

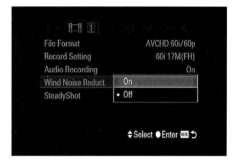

Figure 4-6: Turn on the wind filter to filter wind noise picked up by the microphone.

Connecting and using an external stereo microphone

If you want higher-quality audio, you should seriously consider buying and connecting an external stereo microphone. Although the internal stereo microphone is very good, it's just too close to the camera and the photographer. Any extraneous lens, camera, or photographer noise will be recorded.

If you want to mount a microphone on the Auto-Lock Accessory shoe, make sure you get one that is compatible with Sony's hardware. Not all camera manufacturers use the same type of shoe. More specifically, if a microphone says it's compatible with Canon and Nikon digital SLRs, it *will not be compatible* with the A65/A77 accessory shoe unless you buy additional hardware like the Seagull SC-5 hot shoe adapter to standard flash shoe.

Thankfully, Sony has just such a microphone: the ECM-ALST1 Alpha Compact Stereo Microphone. It will fit just fine.

1. Set up the microphone.

Depending on the microphone, mount the microphone on the camera, on a stand, pin it to a person's clothes, or use a microphone boom (like in the movies).

2. Pull open the rubber external microphone jack cover.

3. Plug the 3.5mm (1/8-inch) stereo microphone plug into the microphone jack.

You can tell a stereo cable from a monophonic microphone cable because there are three separate areas on the plug: the tip, ring, and sleeve. By convention, the tip and the ring carry the left and right audio channels respectively, while the sleeve carries the ground. See Figure 4-7.

4. Make sure you're set up to record audio by enabling audio recording.

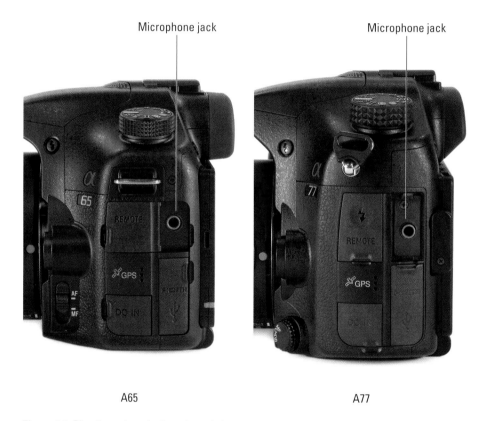

Microphone jack Microphone jack

A65 A77

Figure 4-7: Plug the external microphone in here.

When you get to shooting, consider adding these techniques to your repertoire:

- ✐ **Test:** Shoot a few test movies to check audio levels. You have to do this be ear. There are no fancy audio meters or gauges on the A65/A77. If you hear distortion or the sound is too loud, back the microphone away from the sound source, if possible, or tell them to be a bit quieter.

- ✐ **Put some distance between the camera and the microphone:** Your best bet to avoiding extra sounds is to use a stereo microphone mounted on a separate stand or boom, protected by a foam or furry wind shield. You'll be running a longer cord if so. Be careful not to trip over it.

Yelling, "Action!" Versus Saying "Cheese"

Technically, shooting movies isn't a challenge. You don't have to change modes or figure out the exposure. At the most basic level, you simply point the camera at your subject and press the Movie button. However, it's not all peaches and cream. You can't run around with your A65/A77 and act like a high-def Steadicam operator. You have to pay attention to the focus using a small 3-inch LCD monitor or viewfinder. You have to hope the camera doesn't overheat. The upcoming sections address the differences between shooting movies and still photos, and steps to follow to shoot relatively static versus dynamic movies.

Making the transition to movie-think

Before you begin, study these differences and similarities between shooting movies and taking still photos.

You can start recording a movie at any time, in any mode. Figure 4-8 is a frame from a movie I took out on the driveway as we were going out Trick or Treating. No setup. No prep-time. Just start shooting and have fun with it! The aperture and shutter speed are automatically adjusted. You can't control them once the filming starts.

Figure 4-8: Impromptu movies are fun!

Settings that apply to movies

There are several settings that are applied to the movie when you start shooting. If you're creative with them, you can set the camera up before you shoot the movie and use them to great effect. Even if you're not creative, use them for the same reason you would when taking a still photo. For example, you would use White Balance to make sure the colors are rendered correctly by the camera.

The settings that apply, assuming you're in a compatible shooting mode to begin with, follow:

- ✔ **ISO:** Crank up in low light. See Chapter 7 for more on ISO.

- ✔ **White balance:** You can set the White Balance yourself or choose Auto. Don't leave White Balance set to something funky like Cloudy if you're shooting outside on a sunny day. On the creative side, you can shoot movies with a White Balance that skews the colors dramatically. Be warned, though, that you can't undo this. For more information White Balance, turn to Chapter 8.

- ✔ **Creative Style:** Set the Creative Style to process your movies without having to use a computer. In particular, settings like Vivid (enhanced colors and contrast) and Black and White (no color) give you powerful creative options. Figure 4-9 shows a frame from a black and white movie I shot of an old movie camera. Using a Creative Style is a great way to make interesting movies. For more information on Creative Style, turn to Chapter 8.

Figure 4-9: Shooting in black and white saves a lot of editing time.

- ✔ **Exposure compensation:** If you're not happy with the exposure, use Exposure compensation to adjust it up or down. You can also use this creatively. Chapter 8 has more information on Exposure compensation.

- ✔ **AF area:** Set the AF area you want the camera to use when autofocusing. Wide (the default) is the automatic setting. With Zone, you choose between one of three general areas; the camera picks the specific AF area. Spot forces the camera to use the center AF area. Local lets you choose your own, even on the fly. Turn to Chapter 8 for more information on setting the AF area.

- **Metering mode:** This setting controls how the camera evaluates the scene's brightness. Multi-segment (the default) analyzes the entire scene. Center weighted uses the entire screen, but weighs the center more. Spot uses a small metering circle in the center. Center weighted and Spot work well when you're dealing with single subjects like people and not expansive landscapes. These modes will keep backlit subjects from being too dark. They will also work with front-lit subjects. Turn to Chapter 7 for more information on metering modes.

- **Face Detection and Object Tracking:** Enable these helpers to keep you in focus.

- **D-range optimizer:** Processes the movie to keep the brights and darks within range. See Chapter 7.

- **Lens Compensation:** Automatically correct lens characteristics like distortion and vignetting on the fly. More on this in Chapter 11.

- **Picture effect:** You can apply a Picture Effect (see Chapter 11) to the movie as you shoot it. Toy Camera is particularly cool, but they are all very interesting to experiment with.

- **Focus:** For more information on focusing, see Chapters 1 and 7. You have two ways to focus when shooting movies:

 - *Manual:* Of course, you can always change focus when you have set the camera to Manual focus.

 - *AF:* When set to AF, the camera continues to focus according to the AF area you have chosen. If you set AF area to Local, you can change the AF area during shooting.

Don't do this stuff

Do keep these don'ts in mind when you're shooting:

- **Make noise:** Be careful not to make noise when shooting. The internal stereo microphone will surely pick it up. It may even be picked up even by an external mic.

- **Crank the heat:** Heat is a major problem to avoid when shooting movies. So much so that there are copious warnings that shooting for a long time will raise the temperature of the camera high enough that it will turn off automatically. When the overheating warning light comes on, stop shooting the movie. It might help to turn off the camera and take an extended break, or put the camera in a cool, dry place.

Picking a Genre

These tips don't fit in the other categories, but are still helpful:

- ✔ **Short clips:** Shoot short clips instead of long takes. Delete the bad ones. Keep the good ones. Later, trim to specific scenes and combine into larger videos later.

- ✔ **Rerecord audio:** Record a scratch track while you're shooting the movie, but replace it with re-recorded audio in editing. Yes, that's a bit more complicated than normal, but it's possible with today's sophisticated editing programs and a little elbow grease. Unfortunately, I can't tell you exactly how to do this given the space constraints of a single bullet point in a small section in one chapter of this book.

- ✔ **Bloopers:** Everyone loves bloopers. Keep them and use them as DVD extras.

- ✔ **No audio:** Sometimes, no audio is better. Do you want people to hear you yelling at your kids as they fight over presents they just opened? Even if you record it, you may be better off using a music track.

- ✔ **Family get-togethers:** This just in from my wife. She says that using your camera to film family members during a family reunion would be a great idea. Have everyone drop by the camera, one at a time or with their immediate family unit, and tell who they are and how they are related to you.

Sitting still

The easiest type of movie to shoot with your A65/A77 is a movie under controlled conditions where you aren't running around worrying about tripping. Approach this type of movie differently than one you're moving around shooting. Consider the following.

Tripod

Use a tripod whenever possible when shooting movies that are stationary. If your subject is moving (but not enough to put you in the next section), you may need to shoot hand-held or get a nice pan/tilt tripod head that you can use to smoothly follow the action.

Lighting

Creative license notwithstanding, movies where you are giving a review, telling a story, or explaining something benefit from good lighting.

 ✔ Turn on lamps and overheads.

 ✔ Bring in extra lights.

 ✔ Open the curtains.

If outdoors, shoot with the sun behind or to the side of you. It should shine toward or across your subject.

Background

This may be the most challenging aspect of filming a movie of a stationary subject. Set your camera up to show off a pleasing area of your home, a nicely decorated wall, window (although that can mess with the exposure), or somewhere outside that looks like a good movie backdrop. Figure 4-10 shows a nice-looking fence that I tend to use when I want to photograph my family. In this frame, my two older boys are

Figure 4-10: Doctors who?

talking about dressing up as Doctor Who (the 11th and 10th from left to right) for Halloween.

You may be able to point the camera down at something. If so, a nice table or cloth will work. It doesn't have to be perfect. Keep it natural, but you may need to clean and position things in or out of frame to remove distractions or add interest.

Focus

Manual focus works fantastically when shooting static movies. Use the Zoom Magnifier feature to zoom in and nail it. Once you have your focus, don't move it. You'll be very pleased not to hear any auto focusing sounds when you play your movie back, and you will appreciate things not moving in and out of focus.

Wide-angle

When shooting general home movies inside, wide-angle lenses work well. They keep you from feeling claustrophobic and capture more action. If you are filming a single person, use a normal or zoomed in focal length (28mm or more).

Using a stunt double

Shooting movies with a digital SLR or SLT isn't like carrying around a small compact digital camera. It's heavier, has a longer lens, gets hotter, and is harder to keep in focus.

That doesn't mean it's impossible, but it has an entirely different feeling. It pays, therefore, to approach shooting dynamic scenes with the A65/A77 differently than you would a stationary movie.

Here are some ideas:

- **Use AF:** It can be very hard to keep a good manual focus on a moving subject, especially when you're also moving. Figure 4-11 shows my youngest running around as I try to focus on him. It's hard! If you don't want the focus wandering (the camera changes the AF area it wants to focus on), select Zone, Spot, or Local.

- **Use your lifelines:** Try using your camera's other focusing aids, such as object tracking and face detection.

- **Metering:** Use Multi segment or Center weighted metering when you and the subject are moving. If you're standing still (but not so still to make it a static setup), you can use Center weighted without too much trouble. Spot is hard to use unless you can keep the center of the frame zeroed in on the subject with precision.

Figure 4-11: He's quite fast.

- **Monopod:** You may be able to use a monopod (a tripod with only one leg) and shoot action movies, especially if you're standing on the sidelines.

- **Zoom:** When shooting action, go for it and zoom in, as shown in Figure 4-12. You may have to practice to get the hang of keeping people in the frame and in focus, but it will look better than a wide-angle shot of something really small running around a huge soccer field.

Figure 4-12: He's the center of attention at this range.

What's next?

If you're using Windows, Sony Picture Motion Browser has a few rudimentary movie editing options. Namely, you can trim movies from the beginning and from the end, and you can save individual movie frames as JPEGs. That might not sound like a lot of options, but isolating clips and saving them as new files means you can create other movies or projects. If your clip is long enough, you can save any number of smaller clips from it and create separate files to join again later. Edit out the parts you want to keep, and then work with them separately.

You can also export movies (to YouTube, among other places) and burn movies to disc. Included options are standard-def DVD, high-def DVD (a special AVCHD format), and Blu-Ray. The first time you burn a DVD with AVCHD movies, you must connect your camera to your computer with the supplied USB cable (because you have to sign in and download DVD-video add-on software from Sony later).

Sony doesn't have video editing or DVD burning software solutions for the Mac. I'm therefore pointing you in the direction of Apple's iMovie and iDVD, which are the least expensive and easiest ways to start creating movies and burning them to DVD using a Macintosh. iMovie and iDVD have many more features and capabilities than Sony's PMB. When creating DVDs, you can create sophisticated projects with menus, extras, text, photos, and more, or use the Magic iDVD or OneStep DVD options to automate the process. You can even preview the disc.

This Good News List doesn't mention anywhere near all the cool things about iMovie:

- Create and manage movie projects.
- Create complicated videos using separate clips.
- Apply special effects.

Point-and-Shoot Movie Making

Once all the preparations are made, the file format is set, you've decided whether or not to record audio, and you've thought through how to approach shooting the movie you want (static or stationary), it's time to shoot the movie.

Here's how in the short version. The explanations for each stop follow.

1. **Get everything ready.**

 If you want to shoot in Program Auto movie mode (which gives you control over metering, white balance, DRO, creative styles, Picture Effects, and exposure compensation), put the camera in one of the advanced exposure modes (P, A, S, M), or in Sweep Panorama, 3D Sweep Panorama, or Continuous Priority AE mode. If you're in anything else, the camera defaults to auto movie mode when you press the Movie button.

2. **Press the Movie button to start recording.**

 It's the shiny silver button with the red center. You can't miss it. See Figure 4-13.

3. **Adjust exposure.**

4. **Keep an eye on some important indicators.**

5. **Press the Movie button to stop recording.**

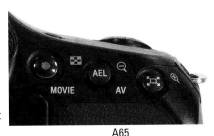

A65

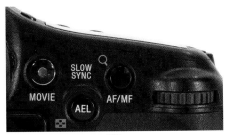

A77

Get everything ready

I said that, yes, but it's important. This includes the following:

Figure 4-13: You may have to reach for the Movie button with your thumb.

- Clean the lens.

- Set the camera's movie options.

- Set audio options.

- Set controls like white balance, focus mode, AF area, metering mode, and the like. Leave no stone unturned. If you forget something and then remember it 10 minutes into the movie, you're in a quandary. And that's putting it nicely to get past the editor.

- Mount the camera on a tripod (if desired).

- Get the lighting, background, and other location-specific aspects ready.

- Prepare your subjects, if necessary. In parent-speak, that means telling the kids to stand still, stop messing with your clothing, and saying, "No, you cannot go to the bathroom. No, you can't have juice!"

- Make sure you have a full battery. Have more than one if possible.

- Have an adequate supply of clean memory cards.

- Press AF to initiate autofocus and get it in the ballpark (it will have to focus again when you start shooting, but it will be close), or manually focus. If you're shooting a static scene and manually focusing, take advantage of the focus magnifier option to zoom in and get a perfect manual focus. (See Chapters 3 and 7 for more information on this feature.)

You know, you can just run out and shoot a movie if you want. All this prep work is only if you want it. If you'd rather be spontaneous, go for it!

Press the Movie button to record

When recording, the display looks like any other shooting display (see Chapter 1), as shown in Figure 4-14. The exceptions are that you won't see a histogram and the For viewfinder display is disabled. Press the Display button to cycle through the options. The main things to key on are:

✏ *Recording:* REC appears in red when you're recording.

✏ *Time remaining:* Shown in minutes beside the memory card in some display modes. How much recording time you have left.

✏ *Recording time:* Elapsed recording time.

✏ *Frame rate:* Shown at the top of some display modes. Reminds you of your frame rate.

✏ *Movie size:* Shown at the top in some display modes. A reminder of movie size and format: PS, FX, FH, 1080, or VGA. The latter two are MP4. The former three indicate AVCHD.

✏ *Remaining battery:* The amount of charge left in the battery as a percentage, compared to a full charge. Shown at the top in some display modes.

✏ *No Audio:* If you aren't recording audio, you will see an indicator. Keep an eye out for this. I've accidentally recorded movies without sound because I wasn't paying attention. The icon is shown at the top in some display modes.

✏ *Focus area:* If in AF, the current focus area shows green if you're in focus. If AF area is set to Zone or Local, you can change the focus zone/area by pressing the AF button on the A65. If using the A77, use the Function button to access AF areas unless you designate another button to serve as an AF Area button; see Chapter 11.) Press the up, down, left, or right buttons to change the zone/area. Press AF again to lock the new zone/area.

If you're using focus tracking or face detection, you'll see appropriate target or face detection frames (see Chapter 8) bouncing around the screen.

✏ *Focus indicator:* The green focus indicator lights up and stays steady if focus is good and not changing.

 • A solid green dot in the center of steady arcs: Focus is good and tracking.

- The green dot disappears but the arcs remain: The camera is trying to find the focus.

- Everything disappears and then the green dot flashes: The camera can't focus. Houston, you have a problem.

✔ *EV scale:* The current exposure compensation. If you press Display, the shooting functions are shown on either side of the screen. If you press Display again, everything disappears except the recording indicator, elapsed time, and the EV scale.

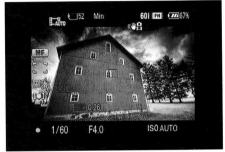

Auto

✔ *Exposure data:* The shutter speed, f-number, and ISO are displayed normally (even in graphic display). Whether shooting point-and-shoot movies or in a more advanced mode, this information isn't as useful as when taking still photographs. You can alter ISO in the middle of recording, however. When in Movie mode, the displayed details reflect your desired settings.

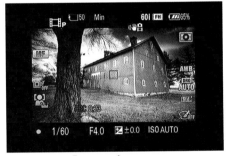

Program Auto

Figure 4-14 shows the monitor in Display All Information mode while shooting a movie in one of the automatic shooting modes versus the P movie mode (discussed later). Notice that several of the shooting functions are available. With practice, you'll be able to access and change functions between takes.

Figure 4-14: You can see quite a bit of information.

Adjust exposure

You can adjust exposure compensation while recording a movie. To do so, press the exposure button and rotate the main dial. Rotate the dial to the right to increase the exposure compensation. Rotate to the left to decrease the exposure compensation. The display changes to reflect what you're doing, and the amount of exposure compensation is also shown on the EV scale.

Keep track

Watch the following:

- Overheating warning indicator (and stop shooting if it comes on)
- Battery level
- Time elapsed
- Time remaining
- Focus

If you're manually focusing and moving, you'll have to focus on the fly. If you're using AF, make sure you're pointing at the right spot in the scene to focus on.

Stop recording

Relax and take a deep breath. Shooting a movie takes longer than shooting a photo. On average, many thousands of times longer. As a result, the concentration required can be very demanding.

Taking Creative Cinematic Control

The Movie button is available in every shooting mode. After making sure some settings are what you want them to be (ISO, white balance, creative style, and so forth), you're off. Press the Movie button to start shooting movies and press it again to stop. It's the essence of point-and-shoot movie making.

Movie modes

The A65/A77 has four movie modes that give you greater creative control. In essence, you decide exposure just like you would when shooting still photos.

However, there's a catch. When you take creative control, you lose the ability to autofocus in three of the four advanced movie modes: A, S, and M.

Here's a summary of the four modes:

✔ *P (Program Auto):* Like stills, you take manual control of the camera but leave exposure to the camera. You can't alter shutter speed or f-number in this mode. However, you keep autofocus and can control a host of shooting functions. When the camera is in an advanced exposure mode (P, A, S, or M), or in Sweep Panorama, 3D Sweep Panorama, or Continuous Priority AE mode, you record in this mode when you press the Movie button. It's sort of a hidden feature.

✔ *A (Aperture Priority):* Adjust the f-number to suit your artistic or practical desire. Larger numbers reduce the aperture size, resulting in larger depths of field; see Chapter 8. Smaller numbers enlarge the aperture, resulting in shallow depths of field. The bad news is that you must enter manual focus to use this mode.

✔ *S (Shutter Priority):* You can adjust the shutter speed. Faster shutter speeds make a smoother-looking movie, but need more light. If you're tracking moving objects or panning the camera, choose a fast shutter speed. The movie will be much smoother. Slower shutter speeds can feel jerky when you record them and they aren't as smooth-looking when you play them back. This mode also requires manual focus.

✔ *M (Manual Exposure):* In this mode, you can adjust both the aperture and the shutter speed. You can blur the background, and record a movie that tracks smoothly. You can't use autofocus in this mode either.

Okay, there's another catch. When you record a movie in an advanced mode, there's no way to recall what settings you used for the aperture or shutter speed. If you're expecting a huge EXIF data reservoir to track your movie settings (like you would with Raw and JPEG still photos), you'll be disappointed. Write your settings down (use a clapperboard or digital slate like Spielberg does), or always do everything the same. That way you won't have trouble remembering what you did.

Setting and recording in Movie mode

To shoot in an advanced movie mode, set up and prepare as you would a point-and-shoot movie. (That's code for *make sure to read the rest of the chapter to find important information.*) Whether you control the exposure or not, it's still a movie. However, if you're using a mode that requires manual focus, practice some.

I encourage you to turn on and become familiar with peaking, which is explained in Chapter 11. If it works with your subject, it will help you keep focus.

To record in any of the four advanced Movie modes, follow these steps:

1. **Set focus mode to Manual (unless you're going to shoot in P mode).**

 If you want to use P mode, keep the camera in autofocus.

2. **Set the mode dial to movie, as shown in Figure 4-15, and press enter.**

3. **Highlight a movie mode, as shown in Figure 4-16, and press enter.**

 You're almost ready to shoot, but don't get carried away and miss the next step.

4. **In A, S, or M modes, adjust the exposure.**

 Change the aperture, the shutter speed, or both as you would to shoot a still photo; see Chapter 7.

5. **Focus.**

 If using autofocus, you don't really need to do anything. The camera should focus automatically.

 - If you plan on using object tracking and it's not on, press the Function button to enable it.

 - If manually focusing, use the focus ring if the lens to focus on your subject.

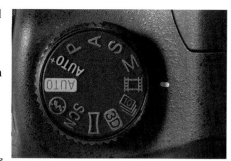

Figure 4-15: The advanced Movie mode on the A65.

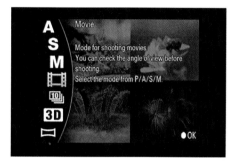

Figure 4-16: Selecting a specific movie mode.

- Be careful when selecting very large apertures (small f-numbers) in A or M modes, especially when you're shooting handheld. Longer focal lengths and close distances also reduce the depth of field, which can end up so narrow that it will be *pert-near* impossible to keep things in focus. That's why filmmakers make the big bucks. It's hard! See Chapter 8 for information on depth of field.

6. **Press the Movie button to start recording.**

7. **Press the Movie button to stop recording.**

Changing the movie mode

To change movie modes, follow these steps:

1. **Press the Function button.**

2. **Go to Movie mode, as shown in Figure 4-17, and press enter.**

3. **Select a different mode and press enter.**

 That's it. Changing movie modes is very simple.

Figure 4-17: Changing movie modes from the functions screen.

Enjoying the Show: Movie Playback

After you've shot a movie, you might want to play it back on the camera to preview them. This section shows you how to do just that. Before you get to it, you should know that Chapter 5 has a lot of information that relates to playing back photos and working with movies on your A65/A77. Before, during, or after you read this section, flip over and take a look.

If you aren't done shooting, though, don't spend too much time reviewing your movies in-camera. Not only does it use battery power, extensive movie playback raises the camera's internal temperature, which is a bad thing.

Watching movies

If you've just been recording movies, dive right in and press the Playback button — skip to the following steps. If you have been switching back and forth between shooting movies and stills, or have been playing back photos, you may have to change the View mode first.

Entering movie mode

To enter a movie playback mode, follow these steps:

1. **Press the Menu button and go to Playback menu 1.**

2. **Highlight View Mode and press the enter button.**

3. **Select either Folder View (MP4) or AVCHD View and press the enter button.**

 See Figure 4-18. You can view these two types of movies. You do, of course, have to have shot movies of that type to then view them.

 When you press enter, the image index appears.

4. **Select a movie from the image index, as shown in Figure 4-19, and press enter.**

 You're playing back a movie. Pick this up in the next series of steps. If you want to return to the image index, press the image index button. See Chapter 5 for more information on using the index.

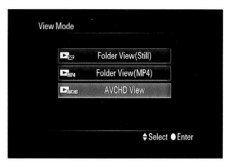

Figure 4-18: Choosing a movie mode.

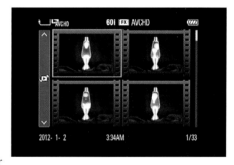

Figure 4-19: Setting the view takes you to the index.

Playing back movies

You don't always need to change the view mode to view movies — namely, if you've already done so and haven't taken a still photo, or a movie was the last thing you recorded.

To immediately start playback, follow these steps:

1. **Press the playback button.**

 You'll see the first frame of a movie, as in Figure 4-20. This may not be the only movie on the memory card. Use the left or right button to get to the movie you want to play back.

 You can also view more than one movie thumbnail at a time if you're using the image index. Press the Image Index button to view the index, as shown earlier.

Playback bar

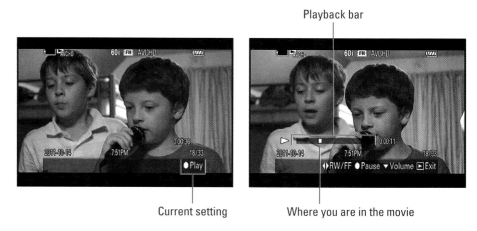

Current setting Where you are in the movie

Figure 4-20: The movie playback controls.

2. **Prepare for playback.**

Press Display to turn off the text overlay to focus solely on the movie. For an explanation of each piece of information, please see the following section in this chapter.

If you want to see all the information, press Display until the details appear.

3. **Press enter to begin playback.**

The display changes subtly to playback mode. You can see the playback bar and counter shown in Figure 4-20. Playback mode shows the current transport setting (rewind, fast forward, pause, and so forth). The playback bar shows you where you are in the movie. The counter shows the current playback position in terms of time: hours, then minutes, then seconds.

4. **To control movie playback, press the appropriate button.**

 - *RW:* Press the right button. Keep pressing it to increase the speed.

 - *FF:* Press the left button. Keep pressing it to increase the speed.

 - *Pause/Play:* Press the enter button to pause; press enter again to resume.

 - *Slow-forward:* Pause first, then rotate the control dial to the right. (One click is all you need to initiate slow-forward; it doesn't go frame by frame according to your spin.) Resist the urge to rotate the control dial to the left to stop slow-forward. You'll switch to slow-reverse if you do. Instead, press the enter button to pause.

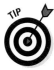

• *Slow-reverse:* Pause first, then rotate the control dial to the left.

• *Display:* Press the Display button to change the display during playback.

5. To control sound, press the down button.

Use the up or down buttons to adjust the level. If you don't want to miss playback, pause first, then set the sound level. If you need to hear the sound to adjust it, keep playing. When you press down, the other playback information is hidden and a volume slider appears, as shown in Figure 4-21.

Volume slider

When the movie is finished, the clip resets to the beginning. If you want to see it again, press

Figure 4-21: Adjusting the volume (as the boys sing to Guitar Hero).

the enter button. If you want to see another movie, press zoom out to see the image index or use the left or right buttons to scroll through the movies on your card.

Movie metadata

When the camera enters playback mode for movies, the screen shows you the first frame from a movie and several bits of information. This information shows when the movie isn't playing:

✔ *Memory card:* This icon shows that a memory card is inserted.

✔ *View mode:* Reminds you that you're seeing a movie (and what type).

✔ *Movie data:* The frame rate, size, and type of movie you're playing back.

✔ *Battery remaining:* The percentage of power left in the battery. If you plan on shooting more, keep tabs on this so you don't run out of power.

✔ *Recording date:* The year, month, and day that you shot the movie.

✔ *Recording time:* The time you recorded the movie.

✔ *Movie time:* The running length of the movie clip.

✔ *Movie number/total number of movies:* The number this movie is out of the total on the card.

Part II
Playing with Pixels

The 5th Wave — By Rich Tennant

DIGITAL PICTURE FRAMES

DPF1132cW
VGA LCD
RANDOM TRANSITIC

HI-DEF
TOUCH SCREEN
WIFI
MEMORY PLUS
BLUETOOTH

UDIO

"It's sad when you realize there are picture frames with more processing power than your home computer."

*p*hotography is about more than taking pictures. In particular, digital photography enables you to immediately confirm that the composition, focus, exposure, and color are what you want them to be. After that, rather than take film to be developed, you transfer the files from the camera's memory card to a computer. This part covers these important aspects of modern digital photography.

5

Getting More from Picture Playback

*P*laying back photos and movies on the camera is such a beneficial aspect of digital photography. It means that you can check the focus, color, composition, and exposure before you take the next photo. You can also rotate photos, protect or delete pictures and movies, set photos to automatically print (using a DPOF-compatible printer), and check each photo's histogram. Your A65/A77 playback features give you access to these powerful features. Which means, of course, another aspect of your camera that you can master.

Knowing What to Press

Familiarize yourself with Figure 5-1 before you get started, and use it later to jog your memory. This figure shows all the relevant playback buttons used in this chapter. Position the LCD monitor so that it's comfortable to see while you work the playback (and other) controls.

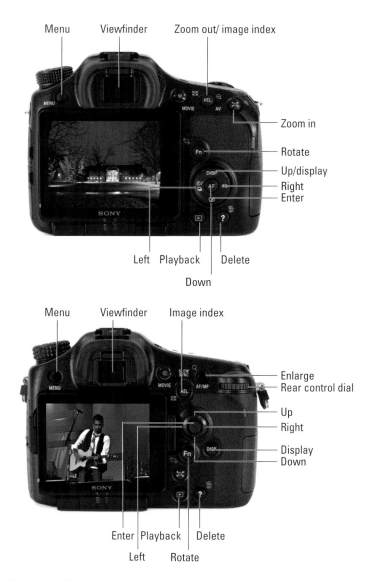

Figure 5-1: Playback central.

Both cameras share the ingenious electronic viewfinder. While you may not realize it at first, being able to look through the viewfinder, work the menus, and review photos is a fundamental transformation in how digital SLRs operate. This means you don't always have to take the camera away from your eye (should you be using the viewfinder) to look at the back of the camera.

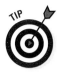

On bright days when the LCD is harder to see, the viewfinder makes a great playback backup.

Thank You Very Much-o Mr. Auto Review

You can review photos (not movies) immediately after you take them. That feature is called auto review, but it's disabled by default. You have good reasons to enable auto review but equally good reasons to leave it disabled. The test is this:

✔ **Yes indeedy doodly:** If you find yourself pressing the playback button every time you take a photo, whether to check focus, brightness, or cuteness, enable auto review.

✔ **No thanks:** If you have auto review enabled and find yourself continuously pressing the shutter button halfway to get back to taking photos, either reduce auto review time or turn it off. You can always press the playback button to review specific photos rather than all of them.

To enable auto review, follow these steps:

1. **Press the Menu button.**

 Figure 5-1 shows all the buttons used in this chapter.

2. **Go to Custom menu 2.**

3. **Highlight Auto Review and press enter.**

4. **Highlight a time and press enter.**

 The times, shown in Figure 5-2, are 2, 5, or 10 seconds. This is how long the camera shows the photo before returning to shooting. Choosing Off disables auto review.

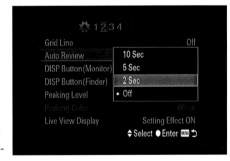

Figure 5-2: Enable and set auto review timing.

Setting the View à la Mode

Before you press the playback button and start reviewing what you've shot, I want to discuss an important A65/A77 playback option: View mode. It's central to how they play back photos and movies. View mode determines whether you see still photos, MP4 movies, or AVCHD movies when you press the playback button.

This method of playback (keeping things separate) keeps you focused. If you want to see still photos, you don't have to look at movies. If you want to see movies, you don't have to wade through hundreds of photos.

Most of the playback features work with both photos and movies, but not both at the same time. That means you have to choose one or the other. To make it more complicated, MP4 movies are handled separately than AVCHD movies. Once you choose, that choice is set until you change it or take a photo or shoot a movie in a format other than what you've set the View mode to. The fact that the camera changes to reflect what you're shooting is nice, but you have to realize that if you were in Still mode when you shot an AVCHD movie, the camera switched to AVCHD mode without telling you.

To change the View mode, follow these steps:

1. **Press the Menu button.**

2. **Go to Playback menu 1.**

3. **Highlight View mode and press enter.**

4. **Highlight an option:**

 • Folder View (Still)

 • Folder View (MP4)

 • AVCHD View

 These options are shown in Figure 5-3.

5. **Press the enter button to lock in the choice.**

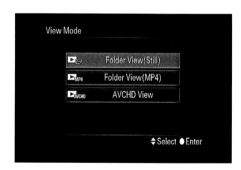

Figure 5-3: Select the type of files you want to play back.

The rest of this chapter lists playback features that work with still photos or movies. Choose what type of file you want to work with by following the steps in this section.

You can change the View mode during playback. Here's how:

1. **Press the playback button.**

2. **Press the image index button.**

3. **Press left to highlight the navigation bar.**

 The navigation bar is on the left side of the screen in Figure 5-4.

4. **Press enter.**

5. **Choose a new View mode.**

6. **Press enter to return to the image index.**

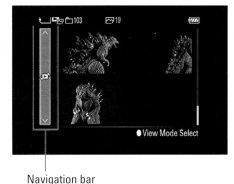

Navigation bar

Figure 5-4: Pay attention to the navigation bar; ignore the moving monster.

The mode you choose affects what you can and can't do while playing back files. For example, if you choose AVCHD mode, you can't delete still photos. Likewise, you can't configure and start a slide show unless you're in Still photo mode. Because options change according to your choices, several of the steps in following sections refer back to this section and ask that you check to make sure you're in the right mode. If you aren't, you may not see the same options. For example, if you're playing back movies, the rotate button is rendered useless.

Playing Back Photos (and Lots More)

This section has a lot of information, from initiating photo playback to viewing an image index, zooming in and out, panning to and fro, rotating, protecting, and setting the print order. Get right to it.

Playback basics

Follow these easy steps to play back photos or movies:

1. **Set the View mode.**

 You can read how to set it in this chapter's "Setting the View à la Mode."

 This step is optional if you haven't changed the mode or shot any movies and want to look at still photos. The camera comes set up to view photos as opposed to movies. However, once you start switching or press the Movie button, plan to change the mode first or be prepared to change it when you're in playback.

2. **Press the playback button.**

 Each photo is shown, one at a time, on the LCD monitor. Check out Figure 5-5. You also can see it in the viewfinder.

3. **(Optional) Rotate, zoom in, zoom out, or pan photos; play movies; or delete photos or movies.**

 In other words, there's a lot more you can do with photos than simply look at them. If you're reviewing movies, you can play or delete them. Movie playback is covered in Chapter 4.

Figure 5-5: Images in the LCD monitor during playback may appear closer than they are.

4. **If you're looking at a normal (not 3D) panorama, press enter to automatically scroll.**

 Press enter again to pause. See Figure 5-6. Press playback to return to normal viewing.

5. **Press the left or right arrow buttons to go forward or back one photo.**

 Alternatively, you can spin the main dial to advance or retreat.

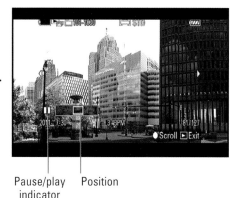

Pause/play Position
indicator

Figure 5-6: Scrolling, scrolling, scrolling . . . a panorama.

6. **(Optional) To switch the recording data display, press the Display button.**

 Pressing Display changes the type of information you see when the photo or movie is playing back. More on this later.

7. **To stop playback, press the playback button.**

 Alternatively, you can press the shutter button halfway to return to shooting or press the Menu button to enter the menu system.

Displaying the image index

It is sometimes helpful to see several thumbnails of photos or movies. That helps you quickly scan different shots and choose the one you want. You can also do tasks (like select files to delete, print, or protect) more quickly from the image index.

Configuring the index (A65)

The A77's index shows four thumbnails; you can't change that. To change the image index on the A65, follow these steps:

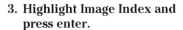

1. **Press the Menu button.**

2. **Go to Playback menu 1.**

3. **Highlight Image Index and press enter.**

 Your two options are shown in Figure 5-7.

4. **Highlight the number of photos you want displayed on a single page and press enter.**

 Choose between 4 and 9 images. Both are shown in Figure 5-8.

 At this point, you've configured the index and need not review any photos or movies. However, the index is automatically shown. Press the playback button or press the shutter halfway to get back to other business.

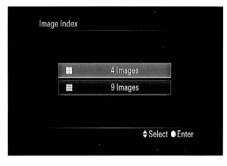

Figure 5-7: Configuring the image index.

Using the index

Using the index is a snap. Here's how:

1. **Press the playback button to enter playback mode.**

 You'll see photos or movies in full screen. Don't panic. It works this way.

2. **Press the image index button when the photo is shown full screen.**

 Now you'll see the index.

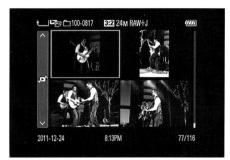

4 images

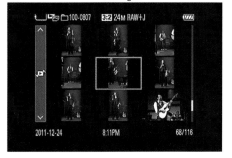

9 images

Figure 5-8: Choose the size that works for you.

3. **Move around the index and choose a photo or movie.**

Currently selected photo

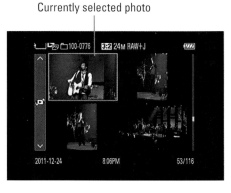

Use the up, down, left, or right buttons to move between photos. An orange box surrounds the currently selected photo or movie, as shown in Figure 5-9. To view a photo or movie full screen, highlight it and press enter. To return to the index, press the image index button.

Figure 5-9: The photo you have selected is outlined.

You can change the folder you're in (see Chapter 10 for more information about folders). A navigational tab is on the left. Highlight it and press up or down to change folders, or press enter to change the View mode. The folder number at the top of the screen changes. See Figure 5-10.

4. **Press the shutter halfway to return to shooting.**

Folder number changes

Number of photos or movies in folder

Still photo icon

Folder number changes

Number of photos or movies in folder

Still photo icon

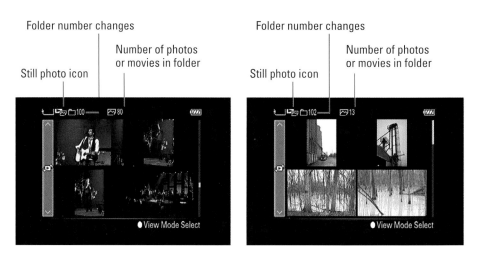

Figure 5-10: Switching folders.

Zooming and panning

Zooming in, also known as enlarging, is really helpful when you're reviewing photos. Getting close lets you see if pictures are in focus, whether details are visible, or if the photo is perfectly framed. *Panning,* or moving the view (whether from side to side or up and down), helps you see the specific area

of the photo you want once you've zoomed in. The following sections provide some zooming and panning pointers. Figure 5-1 points out the zoom in and zoom out buttons on the A65 and the enlarge button and rear control dial on the A77.

Zoom in

The button you press to zoom in depends on your model:

- ✒ **A65:** Press the zoom-in button. Keep pressing it to increase the magnification.
- ✒ **A77:** Press the enlarge button and spin the rear control dial to the right.

Normal

Figure 5-11 shows the normal view and the final zoom level. Figure 5-12 gives you mid-zoom labels. Arrows along the four sides show that you can pan in those directions. If there's no arrow, you've reached the edge. Look at the thumbnail at the bottom left; a tiny red rectangle indicates your current view.

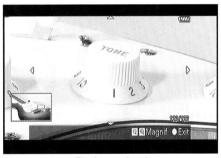

Final zoom level

Figure 5-11: Strato-zooming.

You can zoom in and compare several photos to each other at the same magnification. To do so, follow these steps:

1. **Press the playback button.**

2. **Use the left or right button to find the first photo you want to view.**

3. **Press the appropriate button depending on your model.**

 A65: Keep pressing zoom in to increase the magnification.

 A77: Press the enlarge button and zoom in with the rear control dial.

4. **Press the left or right buttons to the spot in the photo you want to compare.**

Pan arrows

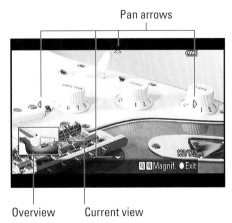

Overview Current view

Figure 5-12: Pan every which way.

5. Spin the main dial to switch back and forth between photos.

Figure 5-13 compares two photos with different lighting.

Zoom out

By *zoom out,* I mean zooming out of a photo you've already zoomed in on. If you zoom out of a photo that hasn't been magnified, the image index shows up. To zoom out:

✔ **A65:** Press the zoom out button.

✔ **A77:** Rotate the rear control dial to the left.

When you first zoom in, you really zoom in. If you want something less drastic, zoom in and then zoom out to reach the desired view.

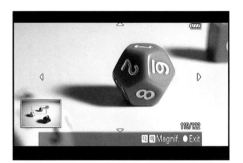

Figure 5-13: Comparing lighting effects on a green die.

Pan

Use the left, right, up, or down arrow buttons to pan. Use the arrow buttons as you zoom to move around the photo or pan afterward — your choice. Press and hold any of the arrows to speed up the action. You don't have to press and release and press and release each step.

Normal

To return to normal playback, press the playback button.

Rotating photos

Pictures have an up and a down to them based on how you hold the camera. If you hold the camera horizontally, the photos are in *landscape orientation.* If you hold it vertically, the photos are in *portrait orientation.* That can be confusing because the two terms, portrait and landscape, have other very specific photography-related connotations to them. Namely, when you take a portrait of someone or photograph a landscape.

The camera knows how it is being held and flags each photo with the appropriate orientation. This information is stored in the photo's properties and is used to automatically rotate it in the camera and by software that reads that flag.

You can, however, turn off automatic rotation. I know what you're thinking. Why in the world would you ever want to turn it off? I can think of at least one very practical reason: Vertical photos are automatically rotated when you play back. The photo is right-side up, but it gets shrunk to fit on the monitor. It looks much smaller than an unrotated photo. If you don't automatically rotate, you may have to turn your head or the camera, but the photos are much larger.

To turn off automatic image rotation during playback, follow along:

1. **Press the Menu button.**

 Figure 5-1 shows all the buttons used in this chapter.

2. **Go to Playback menu 2.**

3. **Choose Playback Display and press enter.**

4. **Choose one of the options:**

 - **Auto Rotate**

 - **Manually Rotate** (This option's disabled when the camera's connected to an HDTV.)

Regardless of the ifs (you're in Auto Rotate mode and the camera didn't sense the orientation correctly), whens (you're in Manual Rotate mode and want to rotate the photo), or whys (maybe you like rotating photos upside down to flag them for some purpose), follow these steps if you want to rotate a photo yourself:

1. **Press the playback button and go to the photo you want to rotate.**

 Figure 5-14 first shows a running fountain photographed during the Golden Hour. Auto rotate has been turned off for this example.

2. **Press the rotate button.**

 Rotate mode activates, as shown in Figure 5-14. Press the left or right buttons to move between photos if you need to.

Original

First 90 degrees

Second 90 degrees

Figure 5-14: Manually rotating a photo.

3. Press the enter button once to rotate the photo 90 degrees counter-clockwise.

The first 90-degree turn is shown in Figure 5-14. Each time you press the enter button, the photo moves another 90 degrees. So, if a picture is upside down and you want it right-side up, press enter twice. The photo plays back this way even if you turn off the camera.

4. Press the left or right buttons to scroll through the photos in the current folder.

Follow the instructions in Step 3 to rotate more photos.

5. Press playback to return to Playback mode.

Protecting photos and movies

Protect photos and movies that you don't want to accidentally delete from your memory card. You can also protect files that you want to flag for one reason or another. Think of it as a sneaky way to tag photos in your camera.

First, set the View mode to Still Images or Movies, depending on what you want to protect. The option is in Playback menu 1, shown earlier. Afterwards, protect your photos and movies by following these steps:

1. Press the Menu button.

Figure 5-1 shows all the buttons used in this chapter.

2. Go to Playback menu 1.

3. Highlight Protect and press enter.

4. Select an option:

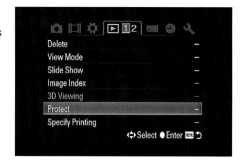

- *Multiple Images* protects one or more photos/ movies. If you choose this option (see Figure 5-15), continue to the next step.

- *Cancel All Images/Movies (MP4)/AVCHD* cancels the protected status on *all* your photos or movies, depending on the view mode you're in. If you choose this option, highlight it press the enter button. You're done.

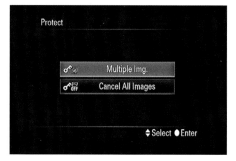

Figure 5-15: Protecting photos.

**5. Press the enter button to pro-
tect the displayed file.**

A small check box shows your
action; see Figure 5-16. If the box
is empty, the file is unprotected.
If it has an orange check, the
file is protected. Press enter to
toggle back and forth.

A small white key shows up
in the top of the display data
during playback to indicate
previously protected files.

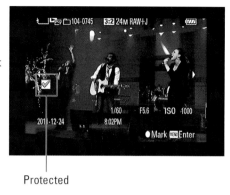

Protected

Figure 5-16: Marking a photo for protection.

**6. Press the left or right buttons
to scroll.**

Protect photos/movies as you did in Step 6. To unprotect photos/
movies, follow the same steps, making sure to clear the checkbox.

7. Press Menu to quit.

8. Highlight Enter and press the enter button.

With that, you've saved the status of all the photos or movies you have
protected.

You can also protect and unprotect files when viewing the image index.
Here's how:

1. Follow Steps 1 through 4.

You'll see a full-screen image.

2. Press the image index button.

The image index opens, as
shown in Figure 5-17. Each
photo has a small protect check-
box in the lower-left corner of
its thumbnail.

**3. Go to photos or movies you
want to protect or unprotect.**

They will have an orange box
around them.

Figure 5-17: Check photos to mark for
protection.

4. **Press enter to check or uncheck the protect box.**

 To protect everything in a folder, highlight the tab on the left and press enter; a check appears in the box in the tab. That marks all the photos. To unprotect everything, remove the check in the tab.

5. **Press Menu to quit.**

6. **Highlight OK and press the enter button.**

 You're done.

DPOF a doo-wop printing

If you have a printer that's compatible with Digital Print Order Format (DPOF), you can specify which photos to print, in what quantity, and whether to put the date on them.

You tag photos with DPOF data just like you would when you're protecting them. Here's how:

1. **Press the Menu button.**

 Figure 5-1 shows all the buttons used in this chapter.

2. **Go to Playback menu 1.**

3. **Select Specify Printing, as shown in Figure 5-18, and press enter.**

 A Specify Printing screen appears. If all the options look the way you want them to, there's no need to change anything. Skip Step 5.

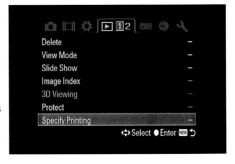

Figure 5-18: Specifying DPOF printing.

4. **(Optional) Highlight an option and press enter; then choose a setting and press enter.**

 You can change these DPOF setup options:

 - *DPOF Setup: Multiple Images* is the correct mode if you want to specify DPOF on selected photos.

 - *DPOF Setup: Cancel All* clears DPOF data from all photos. Use this after you've printed and are done.

 - *Date Imprint* puts the date on the photo. Choose On or Off.

5. Highlight Enter and press the enter button to continue.

- *If DPOF setup was set to Multiple Images,* continue to the next step.

- *If DPOF setup was set to Cancel All,* confirm your decision by highlighting Enter, then press the enter button. You're done.

6. Select photos you want to print and press enter.

Like protecting photos, a white checkbox is on the left side of the screen. This box indicates whether the photo is in the print list. Press enter to toggle an orange check on (to print) or off (to remove). See Figure 5-19. A print icon also appears at the bottom left and shows you how many total photos you have marked to print.

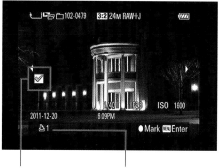

Selected to print Number of photos to print

Figure 5-19: Flagging a photo to print a copy.

You can only print one copy of each photo, and they must be JPEGs.

Press the image index button to select photos to print from the image index, as shown in Figure 5-20. Check or uncheck the boxes by pressing the enter button.

7. Press Menu to quit.

8. Highlight OK and press enter to save.

If you press Cancel, you return to Specify Printing mode. To stop the entire operation without saving anything, press the playback button.

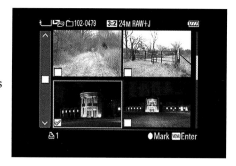

Figure 5-20: Marking DPOF print images from the index.

Decoding Picture Data

When you play back photos, you can change how the display looks and what type of information is shown by pressing the Display button. Keep pressing it to cycle through the three display modes shown in Figure 5-21:

- ✔ **With Recording Data**

- ✔ **Histogram**

- ✔ **No Recording Data** (The photo appears by its lonesome, with no additional information.)

With Recording Data display

Yes, the default display has a goofy name. Important recording data such as the file name, folder, remaining battery, date taken, and so forth are displayed at the same time as the photo. It gets a little cluttered at times. If you can't see the information clearly on the LCD screen, look through the viewfinder.

The display called With Recording Data has the best of both worlds, as shown in Figure 5-22. The photo is shown full screen and several bits of information help you remember what happened:

- ✔ **Memory card indicator:** Memory Stick Pro Duo and SDHC cards have an icon that looks like a small memory card. Eye-Fi cards display an Eye-Fi status indicator.

- ✔ **View mode:** A small icon that shows the current View mode. All three have a miniature playback button. A small photo that looks like a mountain landscape means still photos. MP4 and AVCHD have text labels.

With recording data

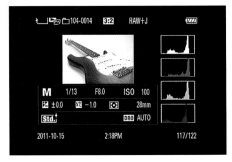

Histogram

No recording data

Figure 5-21: Press the Display button to cycle the displays.

- **Folder/file name:**
 Three digits before
 the dash indicate
 the folder that the
 photo's stored in.
 The last four digits
 (after the dash) are
 the file number.

- **Photo aspect
 ratio, size and
 quality:** Pretty
 self-explanatory.

- **Protection and
 printing status,
 plus battery level:**
 A key appears if
 the photo is pro-
 tected. If the photo
 is part of a DPOF
 print run, DPOF is
 displayed. Finally,
 the battery level
 reminds you that
 power is precious.

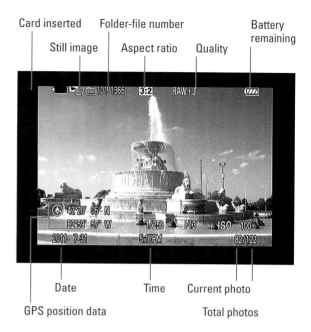

Card inserted Folder-file number Battery remaining
Still image Aspect ratio Quality

Date Time Current photo
GPS position data Total photos

Figure 5-22: This display balances the photo and a wealth of information.

- **GPS location information:** If you took the photo with GPS enabled, the latitude and longitude are displayed.

- **Auto HDR:** An Auto HDR indicator appears above the ISO to remind you that you shot the photo you're looking at using Auto HDR drive mode.

- **Shutter speed, aperture, ISO:** The exposure settings are shown. Chapter 7 explains the settings in more detail.

- **Date and time:** The year, month, day, and time that you took the photo are displayed.

- **Photo number/total photos:** Displayed in the bottom right, this fractional number shows you two things: the current photo number and the total number of photos on the memory card.

- **Scroll:** If the photo is a panorama, you're reminded that you can press the enter button to automatically scroll. This reminder doesn't show up in other display modes, although automatic scrolling still works.

Histogram display

This display shrinks the photo to make room for lots of metadata and a *histogram* (a graph of the photo's brightness). In addition, pixels blink if they're at the minimum or maximum brightness. See Chapter 10 for more on histograms. Figure 5-23 gives you an overview of the display. Figures 5-24 through 5-26 break down what's on each row.

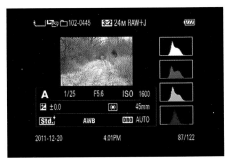

Figure 5-23: This display features histograms.

Letting Go of Bad Photos and Movies

You don't have to leave bad photos or movies on your memory card. They take up space on the card and, if you leave them on during the transfer process, they will take up space on your computer. Delete the bad ones. Keep the good ones.

One word of caution: When you delete a photo or movie from your memory card, it's gone. Chances are, you can't recover it. If you're afraid of deleting good photos or movies, protect them as shown earlier in this chapter. You can't delete protected photos.

Deleting a single file

You have a few ways to delete a single photo or movie. First, if you have auto review set up when you take photos, follow these steps:

1. **Press the Delete button during auto review if you don't like the photo you just took.**

Exposure mode Aperture

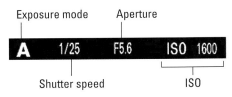

Shutter speed ISO

Figure 5-24: Row 1 has basic exposure information.

Exposure compensation Metering mode

Flash compensation Lens focal length
displayed only when set

Figure 5-25: Row 2 has compensation information, metering, and focal length.

Creative style White balance

Picture style shown D-range optimizer
when present

Figure 5-26: Row 3 has style, white balance, and DRO information.

2. **Highlight Delete to confirm your choice, as shown in Figure 5-27.**

 Highlight Cancel if you've changed your mind and want to keep the picture.

3. **Press enter to delete the photo.**

To delete a photo or movie (make sure to enter the right view mode) while playing it back, follow these steps:

Figure 5-27: Deleting blurry kids.

1. **Press the Delete button.**

2. **Choose Delete.**

3. **Press enter to delete the photo.**

If you are viewing the index, highlight a photo and press delete. Confirm and press enter.

Deleting more than one photo or movie

Even good photographers take bad photos, especially if they're rapidly moving and shooting. The great thing about digital photography is that you don't have to hold back. Shoot, shoot, and shoot. If you get a handful of great photos out of a session, keep them and delete the rest. The same thing applies to movies. Here's how to delete more than one photo from your memory card.

Enter the correct View mode.

1. **Press the Menu button.**

 Figure 5-1 shows all the buttons used in this chapter.

2. **Go to Playback menu 1.**

3. **Highlight Delete and press enter.**

4. **Select the Multiple Images option and press enter.**

5. **Use the left and right arrows to view the photos you want to delete.**

 An empty check box appears on the left side of the photo. Don't confuse this with protecting or printing photos.

6. **Press enter to mark for deletion.**

 Photos that you've marked to delete have an orange check in the box, as shown in Figure 5-28. They aren't deleted immediately. You can review and mark photos until you press the Menu button.

7. **Return to Step 5 and keep marking photos until you're done.**

 If you like, you can press the image index button and select photos from their thumbnails, as shown in Figure 5-29. Press enter to mark highlighted photos with a check for deletion. Highlight the tab on the left and press enter if you want to delete all the photos in the folder.

8. **Press the Menu button to finish marking photos.**

9. **Select Delete.**

10. **Press enter to delete the photos.**

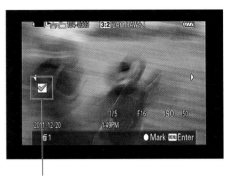

Marked to delete

Figure 5-28: Preparing to delete a photo.

Figure 5-29: Delete batches of photos quickly from the index.

Deleting all the photos in a folder

You can delete all the photos in a folder:

1. **Make sure the folder from which you want to delete is the currently selected folder; see Figure 5-30.**

 You can use the Select REC Folder option in Memory Card Tool menu 1 to select an existing folder.

Figure 5-30: Confirm the folder to delete first.

If you have more than one still image folder on the card, you should confirm that it's chosen (or select a new one). You can easily do this from the image index. Look at the top line, which has the folder number you are currently viewing. If it isn't the folder you want to delete, press the left button to highlight the tab on the left, then press up or down to change folders.

2. **Go to the Playback menu 1 and set View mode to Still.**

 You can delete MP4 movies by folder as well. Change the View mode to Folder View (MP4) if that's the case.

3. **Press the Menu button.**

 Figure 5-1 shows all the buttons used in this chapter.

4. **Go to Playback menu 1.**

5. **Highlight Delete.**

6. **Choose All in Folder, as shown in Figure 5-31.**

7. **Confirm by selecting Delete.**

 If this isn't the folder you want to delete, select Cancel, press the enter button, return to Memory Card Tool menu 1, and choose Recording Folder.

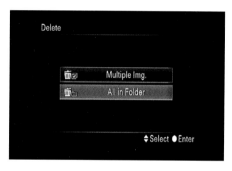

Figure 5-31: Deleting everything in the folder.

Deleting all movies

You can delete movies just like photos. The thing to remember is that you have to be in the appropriate View mode to delete MP4 or AVCHD movies. The Delete dialog box in Playback menu 1 changes based on your mode.

MP4 movies are organized and thereby deleted by folder. AVCHD movies are organized differently. You can only choose to delete them all, as shown in Figure 5-32.

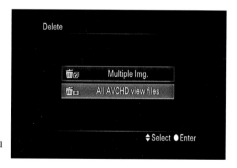

Figure 5-32: Deleting AVCHD movies.

Setting Up Slide Shows

Slide show is a fancy, old-fashioned name for automatic playback. The camera shows you the photos you have identified by certain criteria. That way you don't have to constantly press the arrow buttons to go to the next photo. It's a great finger saver.

You can only set up and launch a slide show from Folder View (Still) View mode. Otherwise, the Slide Show menu will be grayed out.

1. **Press the Menu button.**

 Figure 5-1 shows all the buttons used in this chapter.

2. **Go to Playback menu 1 and choose Slide Show.**

3. **Press the enter button.**

 An options screen like the one in Figure 5-33 appears.

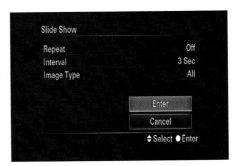

4. **(Optional) Use the up button to select an option and press the enter button.**

 Highlight the value of your choice and press the enter button.

 Options for still photos:

 • *Repeat:* Whether to repeat the slide show, once it finishes. Options are On or Off (default).

 • *Interval:* How long to display each photo. Options are 1, 3, 5, 10, or 30 seconds. The default is 3 seconds.

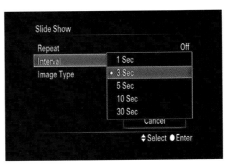

 • *Image Type:* Whether to play all or 3D photos only. Options are All (default) or Display 3D Only. The latter option only works if the camera's connected to a 3D-compatible TV.

Figure 5-33: Setting up options for photos.

5. Highlight enter and press enter to start the show.

Or highlight Cancel to opt out altogether.

While the slide show runs, you'll see some information over what's being shown. Still photos display the information as shown in Figure 5-34.

2011-12-24 7:51PM 19/127

◀▶Back/Next ●Exit

Figure 5-34: A slide show in action.

- Press the Display button to toggle the information on or off.

- To skip ahead or back, press the left or right buttons.

- To cancel the show, press enter.

Viewing Playback on an HDTV

If you have an HD TV (or computer monitor) with an HDMI input, you can connect your A65/A77 to it and look at photos (singly or as slide shows) and movies (one at a time) on the TV instead of the 3-inch LCD monitor on the back of the camera.

Being compatible

If you have a Sony PhotoTV HD-compatible device or 3D-compatible TV, you're in for more fun. The PhotoTV HD excels at displaying the high-quality photos you've taken with your A65/A77. Sony has optimized it (when connected to a camera) to be able to display the colors, tones, and resolution of photos. If you connect your camera to a 3D TV, you can play back 3D Sweep Panoramas. On other TVs, they look normal.

Talk to a salesperson before you buy so you can confirm the specifications of the TV you're interested in.

That's the good news. The iffy news is this:

- ✔ **If you have an older HD TV,** your HDMI input may be out of reach on the backside of the TV. If that's the case, you'll probably have to crawl, shimmy, shake, and wiggle to be able to access it.

- ✔ **If your set only has one HDMI input port** and it's already connected to your cable or satellite box, you'll have to disconnect your cable service from the HDMI port to connect the camera. It's possible (unfortunately, I know from experience), but not very convenient.

HDMI cable

The HDMI cable you need to connect your camera to your TV doesn't come with your camera. It probably didn't come with your TV, either. While it would be nice if it were included, you get to choose the color, length, and brand yourself. Think ahead and pick one up before you really need it.

Before you walk into an electronics store or visit an online retailer, make sure of what you need. The terminal on your camera is an *HDMI mini terminal*. It's smaller than a standard Type A HDMI terminal. It's smaller size makes it possible to fit it on the side of your camera. Your TV probably requires the large Type A HDMI connector, but you should confirm that prior to purchasing a cable. Figure 5-35 shows both ends of the HDMI cable I use. The Type C mini connector that fits in the A65/A77

Figure 5-35: HDMI connectors side by side.

is on the left and the larger Type A HDMI connector that fits in my HDTV is on the right. There is one smaller type of HDMI connector, called the Type D micro connector.

Connecting camera to TV

Once you have your HDMI cable, follow these steps to connect your camera to an HD TV:

1. **Turn everything off.**

 This protects the sensitive electronics in the TV and your camera. It also makes sure the video system activates after the connection is made.

2. **Open the rubber terminal cover labeled HDMI on the left side of your camera.**

 Beneath it you'll see two terminals, as shown in Figure 5-36. The HDMI terminal is the one you want. It's above the USB terminal and is conveniently labeled HDMI Out (in very tiny letters).

3. **Connect the small end of an HDMI cable to the HDMI terminal on your camera.**

 Be careful to insert the end of the cable straight into the receptacle. Do not twist, turn, or force the end into the camera.

4. **Connect the other end of the HDMI cable to your television.**

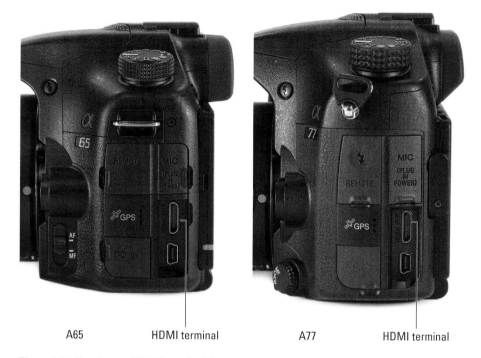

A65 HDMI terminal A77 HDMI terminal

Figure 5-36: Use the top (HDMI) terminal, Luke.

5. **Turn on the TV.**

6. **Switch TV input to the HDMI port.**

 You'll have to look at your TV manual to figure this one out, but if you lost that long ago, try pressing your remote's Input button and scrolling through the choices, looking for HDMI.

7. **Turn on your camera.**

 The LCD on the back of the camera doesn't turn on because the camera is routing the signal to the TV through the HDMI Out port.

8. **View photos in playback or slide show, zoom in and out, protect, delete, or switch to viewing movies for playback.**

 In other words, go to town! Figure 5-1 shows all the buttons you use to do all these wonderful actions.

 If your TV supports Bravia Sync, you can use the TV remote to control the camera. Once you've connected everything and turned on the TV and camera, press the Sync Menu button on the TV remote.

6

Setting Up Shop at Home

*T*aking photos with your A65/A77 is the obvious part of digital photography. Take pictures. Critique yourself. Take more pictures. Repeat and rinse. In fact, most of this book is dedicated to that aspect of using your camera. However: This chapter focuses on a different, but very important, aspect of digital photography. You become your own photo lab. I explain how to *transfer* (or download) files from your camera or memory card to a computer, as well as how to manage and edit your work.

While this chapter shows you the ropes, it can't possibly cover every contingency and every possible application. There are just too many! As such, it focuses on introducing you to the software Sony distributes with your camera. You'll know what's available, what it does, the basics of how to use it, and where you might want to look for other software.

Getting the Party Started

The good news is that if you're a Windows user, everything you need to transfer your photo files, view and organize them, and then edit, print, and share them with the world comes in the same box that your camera came in. You don't have to go to a store or get online to buy anything else.

Sony's Picture Motion Browser is for Windows only. You have to use a third-party application if you want to edit your JPEG photos or videos. Sony recommends using iPhoto to work with JPEGs and iMovie to work with your movies.

Sony software

The Sony software CD that shipped with your A65/A77 camera comes with some very helpful applications. The first two are compatible with Windows and Macintosh.

- **Image Data Lightbox SR** is mainly a photo viewing program. See Figure 6-1. Use this program if you need to compare several shots against each other, rate them, sort, possibly send Raw photos to Image Data Converter SR, and choose the best ones to print or share.

- **Image Data Converter SR** is Sony's Raw editor and converter. It has lots of Raw editing tools. Most of the editing tools are disabled when you load JPEGs. If you're an advanced user who wants to process Raw photos, you will get a lot of mileage out of Image Data Converter SR. The latest version of the Image Data Converter dropped SR from the name and incorporated much of the functionality of Image Data Lightbox SR.

Figure 6-1: Image Data Lightbox SR acts like a lightbox.

✔ **Picture Motion Browser (PMB)** automatically imports photos and videos from your camera, memory card, or disc. Use PMB to view, manage, print, and share your photos (and movies). PMB also has JPEG editing tools (in fact, more than Image Data Converter SR). Picture Motion Browser isn't compatible with Macintosh computers.

Other photo editors and organizers

The software that Sony ships with your camera is functional and you paid for it when you bought your camera. However, those applications aren't the only ones around, nor are they necessarily the best. You can look into alternatives. The main options are discussed here.

✔ **Adobe Photoshop Elements,** for Macintosh and Windows, is a toned-down version of Photoshop that's much less expensive and easier to use. Check out www.adobe.com.

✔ **Adobe Photoshop Lightroom,** for both Macintosh and Windows, is an amazing program that professional photographers use to organize their collections and develop their Raw photos. Go online at www.adobe.com.

✔ **Adobe Photoshop**, also for Windows and Macintosh, is the gold standard photo editor. It is enormously powerful but costly. It doesn't organize photos like Lightroom, but can process Raw files with Adobe Camera Raw.

If all you want to do is brighten a few photos and print them out, or play with panoramas, Photoshop is decidedly overkill. Photoshop Elements is Adobe's simpler and cheaper photo editor. Go to www.adobe.com.

✔ **Apple iPhoto** is for Macintosh only. The components of iLife (iPhoto, iMovie, iDVD, and Garage Band) perfectly complement your A65/A77. Visit www.apple.com.

✔ **Apple Aperture,** for Macintosh only, it isn't a graphics program. Expect to be able to organize, rate, edit, and process every photo you take. Check it out at www.apple.com.

✔ **Corel PaintShop Pro** is for Windows only. There's quite a bit to play with and have fun with here. PaintShop Pro Ultimate has additional goodies. Go to www.corel.com.

Video software

Some of these programs are professional-level applications and downright expensive. I included them so you know what's available and can compare. Shop around. Compare applications with the features you need. The best way to save money is to avoid paying for things you don't need. Within a general category, price isn't always the best gauge of quality.

- ✐ **Adobe Premier Elements** (Macintosh and Windows) is Adobe's entry-level video editing software. Visit www.adobe.com.

- ✐ **Adobe Premier Pro** (Macintosh and Windows) is Adobe's pro-level video editing software. Visit www.adobe.com.

- ✐ **Apple iMovie** (Macintosh only) comes standard on most Macintosh computers. For Mac users who don't have access to Sony PMB, this is the best, cheapest way to do something with the movies you shoot with your camera. Visit www.apple.com.

- ✐ **Corel VideoStudio** (Windows only) has several video editing applications to choose from. VideoStudio Express is an inexpensive alternative to Sony's PMB. Visit www.corel.com.

- ✐ **Pinnacle** (Windows only), a division of Avid, offers reasonably priced HD video-editing solutions. Studio HD is the entry-level product. Visit www.pinnaclesys.com.

Transferring Photos and Movies to Your Computer

Transferring (also known as *downloading*) photos and movies to your computer is a very simple process. You have several methods to choose from, though, which can make it seem more complicated than it is. Each method uses a different approach to hook things up and may require hardware that you don't have. Each approach also has its own pros and cons.

- ✐ **Direct USB connection:** Setting up a direct connection between your camera and computer (see Figure 6-2 for an example) is the most straightforward and easiest method. *Upside:* The only thing you need, besides your camera, is the USB cable that was provided and came in the same box as the camera.

 Don't use any USB cord that isn't exactly compatible with your computer and camera. Also, don't force a cable into a terminal.

Downsides:

- Your camera has to be on. If your battery is low and you have no backup, recharge the battery a bit so your camera won't turn off in the middle of a transfer.

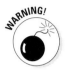

- When you put your camera on a table and connect it to a computer with a cord that can be snagged, tripped on, pulled, or yanked (by you, your kids, your cats, or your dogs), you risk pulling the camera off the table. That will ruin your day.

✔ **External USB card reader:** External USB card readers take the camera out of the transfer equation. The reader plugs into your computer, as shown in Figure 6-3. You feed a memory card into it and it handles the transfer. *Upsides:* You don't have to use your camera's battery and you don't have to worry about running out in the middle of the transfer. You aren't endangering your camera. Also, if the card reader goes bad or you break it, you can replace it quickly and cheaply.

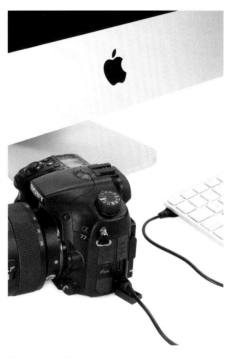

Figure 6-2: Take care to secure your camera when it is connected to a computer.

Downsides:

- You need a card reader for each type of memory card you have (for example, the A65/A77 can use either Memory Stick PRO Duo or SD cards, and other cameras may use different types), or buy one that

Figure 6-3: Card readers that support different card types are very helpful.

supports multiple card types. That is requires you to think ahead to buy the right equipment to support your photography.

- They can litter your desktop or fall off , forcing you to get on your hands and knees and look behind the computer to retrieve it.

- If you have multiple computers to transfer files to, you must either buy more card readers or walk the one you have back and forth.

✔ **Built-in card reader:** Some computers and printers have built-in card readers. New iMac desktop computers, MacBook Air, and MacBook Pro notebooks have built-in SD card readers that are compatible with your A65/A77 SDHC memory cards. If you own a Windows computer, it might have come with an internal card reader (our new HP laptop has a convenient SD card reader in front). If not, you can (if you don't want to, contact a local computer nerd) install an internal card reader. *Upsides:* They aren't as slippery as portable card readers sometimes are, and can't fall off your desk. You also won't forget to take it with you (should you be using a laptop).

Downsides:

- Internal card readers aren't portable (unless you're using a portable computer).

- Internal card readers aren't as easy to upgrade or repair as the type you plug in.

✔ **Wireless memory card technology:** Eye-Fi (`www.eye.fi`) wirelessly transfers photos and movies from your camera to your computer. *Upsides:* It's portable, doesn't tie you down, doesn't require additional hardware (beyond the memory card), is cool, and effectively gives you an unlimited amount of storage while you shoot.

Downsides:

- Eye-Fi cards use your camera's battery to transfer, are slower than the other methods, and require that you be in a wireless network for everything to operate.

- Software installation, setup, and configuration are required.

- You must buy the right type of card.

- Not all Eye-Fi cards transfer Raw photos.

- Using Eye-Fi locks you into the Eye-Fi Center, which is software that enables Eye-Fi. It organizes your photos much like Sony's PMB. For more information on setting up an Eye-Fi card, turn to Chapter 11.

Sony recommends minimum system requirements to connect your camera to the computer with the supplied USB cable. Also, Sony lists detailed system requirements to run their software. If you bought your computer before 2005, check with Sony's support pages (www.sony.com) to see if they have plans to support your system. If all else fails, if your computer can use a card reader, you'll be able to transfer photo to it, whether or not Sony lists your OS as supported.

Making a direct connection

To make a direct connection between your A65/A77 and computer, follow these steps:

1. **Power up your computer and camera.**

2. **Check the camera's battery level.**

 If your battery is above 10 percent, you probably have enough battery power.

 If your battery power is low before you connect your camera to your computer, take the battery out and recharge it. If you have a backup battery that's already charged, simply swap them.

 Alternatively, if you have the AC-PW10AM AC adapter, just plug the camera into a wall outlet. You'll have to buy the adapter separately. If you shoot a lot of photos in a studio (at home or elsewhere), this is a good accessory to pick up.

3. **Connect the larger end of the USB cable to your computer.**

 You may want to connect the USB cable to the back of your computer and leave it plugged in. In which case, secure the cable to the desk so it doesn't fall off when not in use. In this scenario, the cable is always connected to the computer.

4. **Connect the small end of the supplied USB cable to your A65/A77 USB port, shown in Figure 6-4.**

 The first time you make this connection, your computer may take a moment to introduce itself to the camera and vice versa.

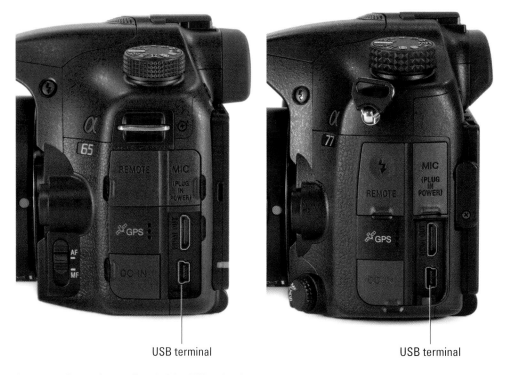

USB terminal USB terminal

Figure 6-4: Insert the small end of the USB cable into the bottom port.

Using a card reader

If you prefer to use a card reader to transfer your photos and videos, follow these steps:

1. **Power up your computer.**

2. **Connect the card reader, if necessary, to the computer, using the correct USB cable.**

 If your card reader is always plugged in, or you're using a device with a built-in reader, you can ignore this step.

3. **Remove the memory card from your A65/A77, as shown in Figure 6-5.**

 If necessary, turn off the power to save battery power.

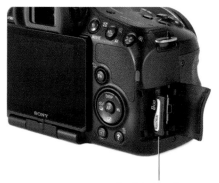

Push in to release,
then pull out

Figure 6-5: Be gentle when extracting the card. It isn't brain surgery, but darn close.

4. Insert it into the correct slot in your card reader.

Make sure you know which side of the card goes up. If using a card reader that supports more than one type of card, always insert the card into the correct slot for its type. Some card readers with multiple slots have helpful labels that keep the confusion to a minimum.

Importing files using Picture Motion Browser

This section only applies to Windows-based computers. Macintosh users can use iPhoto or transfer photos manually.

To import files using PMB, follow these steps:

1. Follow the steps in this chapter's "Making a direct connection" section.

The Import Media Files to PMB dialog box appears.

You can change the import method here. Click Change to open another dialog box and choose a setting:

- Import all Media Files
- Import Only Media Files That Have Not Been Imported
- Select Media Files to Import

Check the Delete Imported Media Files from the Device or Media box if you want PMB to get rid of the files after transfer. This saves you from having to delete them using the camera.

If this dialog box doesn't appear, run PMB, select Tools⟹Settings, and choose the Import tab. Make sure the Import with PMB When a Device Is Connected option is checked. Close the dialog box by selecting OK and reconnect your camera or reinsert a memory card.

2. Select Import.

A new dialog box appears, as shown in Figure 6-6. Click the Stop button if you want to call off the dogs.

When the transfer is complete, you can see the folder and files you've just imported. PMB looks for faces in pictures and creates expanded thumbnails for movies. You can turn this off within PMB by choosing Tools⟹Settings. Then choose the Content Analysis tab.

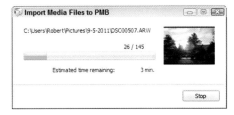

Figure 6-6: Progress bars are just cool.

Manually transferring photos and MP4 videos

You should be able to transfer your photos and videos to a computer yourself. This skill keeps you up and running when you don't have the right Sony software installed, can't install it (Macs, for the time being), are moving or changing computers, or are using someone else's machine.

Follow these steps:

1. **Connect your camera to your computer or insert your media card.**

 If you're connecting your camera to the computer, use the steps in the section named "Making a direct connection" earlier in this chapter. If you're using a card reader, follow the "Using with a card reader" steps.

 On a Mac, double-click the camera/drive icon.

 If an automated transfer program pops up, cancel it.

2. **Find the folders you want to copy.**

 Pay attention to just these folders: DCIM and MP_ROOT. Ignore everything else. To find your photos, look for something like DCIM\101MSDCF or DCIM\10210913. To find your MP4 movies, look for something like this: MP_ROOT/100ANV01.

3. **Drag and drop the folders to your hard drive.**

 Sony doesn't recommend manually copying AVCHD movies. Use PMB Import tool or another HD-aware video editing package if you're using Windows. Mac users should use iMovie to transfer AVCHD movies.

4. **Rename and reorganize as you see fit.**

 For example, you can name the folder according to the date of the latest photo or movie, the date you're transferring, or the camera name and date.

5. **Turn off your camera or remove the card from the reader.**

 On a Mac: Drag the camera or drive folder to the Trash.

Printing and Sharing

Printing high-quality photos in the comfort of your own home, apartment, room, or recreational vehicle has never been easier. Seriously. If you bought a fancy all-in-one printer, scanner, faxer, with wet bar and hot towel dispenser, you're set. If you bought an entry-level color ink jet printer that has no bells and whistles and cost less than $100, you're still set. If you don't have a printer, you can still take as many JPEGs as you want down to your local Super-Mega-Mart and print then out at a kiosk.

It's just downright hard *not to* get good prints nowadays.

If you're a stickler for the highest possible quality, take your photos to a professional print shop and have them printed out on large, high-quality paper using commercial-grade printers.

Regardless of the method you use, you should pay attention to a few things. They're discussed next.

Resolution

Measured in dots per inch (dpi) or centimeter, resolution is a measure of how many pixels you will print per inch or centimeter. Printing an image at 300 dpi is considered high quality. When you change the resolution (this depends on the software you are using), the pixels don't change. They are not resized. You're simply telling the printer to print more or less of them per inch.

Given the number of megapixels the A65 and A77 sport, you aren't going to have to worry about resolution, even with the smallest-sized photos you can take, unless you plan on making very large prints.

Paper size

Even when you can't change the resolution directly in software, you can always change the paper size. This indirectly changes the resolution. Printing on smaller paper squeezes the same number of pixels (up to the capabilities of the printer) into a smaller sized area. Printing on larger paper stretches those pixels out. Chapter 2 has the pixel dimensions for every sized photo you can take with your camera and tells you the largest paper you can use and still have a 300dpi printout.

Format

When printing at home, you can print using whatever software you want, and therefore use whatever format your software is compatible with. That might include Raw photos, TIFFs, Photoshop files, or JPEGs, to name a few. When printing at kiosks, you will normally have to use JPEGs. If printing commercially, contact the print shop you want to use and ask them what file format you should send them. Remember, JPEG compression can introduce artifacts in your photos. They will not be visible unless you print very large photos, however.

Working with JPEGs

Go ahead and delete those hopelessly overexposed, noisy, or embarrassing photos. You know — the ones that you'll never want to show off to your friends and family. Use the Delete button on the back of the camera to send such pictures back from whence they came before they take over your computer. You don't need to waste time with them. This section shows how to use some of the tools in Sony's Picture Motion Browser (PMB) and Apple's iPhoto to spruce up your already-pretty-good-but-something-may-be-slightly-off JPEGs.

Sony Picture Motion Browser (PMB) and Apple iPhoto are the simplest, least expensive ways to do some minor photo retouching. Both organize your photos and have a suite of effective JPEG-only editing tools. Neither are hard to figure out, and both are pretty good at what they do. The following sections introduce the basics of working with files in Sony PMB and Apple iPhoto.

They call it Picture Motion Browser

PMB lets you import, organize, and edit photos and videos. Unlike the other two applications that come with your camera (Image Data Lightbox SR and Image Data Converter, both of which are summarized in the Sony Software section in this chapter), PMB can edit JPEGs.

Here, then, are some tasks you'll need to do quite often.

Launching PMB

The fastest way to launch PMB is to double-click the PMB icon. The program starts in your last view, whether Calendar or Index. On the other hand, you can start the program with PMB Launcher, which presents you with the task-based dialog box. Select View from the list of options on the left and then choose either Calendar or Index View to run the program.

De-cluttering

If you shoot Raw+JPEG, PBM shows both thumbnails in both Calendar and Index views. This makes it hard to navigate and figure out which photo you want to edit.

When you have both file formats for photos and want to see the JPEGs only in PMB, choose View➪Show JPEG for Raw+JPEG.

Using Calendar view

The Calendar view organizes your collection by date. Figure 6-7 shows an entire year. The Calendar is located on the left side of the screen and works like you might expect. Click a year or month to see the calendar appear in the main window. Dates with photo thumbnails have pictures of movies associated with them. Click a date to see the photos you took on that date, based on their EXIF data. Use the vertical scroll bar to the right, if present, to browse up and down.

Figure 6-7: Organizing by date with Calendar view.

Working in Index view

The Index view (see Figure 6-8) organizes by import folder rather than by date. A folder hierarchy appears on the left in this view. Click a folder name to show the photos and movies in the folder, as well as any subfolders. Folders with hollow triangles beside them indicate they can be expanded.

Figure 6-8: Index view organizes by folder.

Click the triangle to view the subfolders. Select the folder to view only the photos within that folder (and any potential sub-subfolders). Black triangles show folders that you can collapse. Click to reverse the process.

Previewing photos

In PMB, Preview is where you edit your JPEG photos. It's not the most obvious name. To enter Preview mode, double-click a photo or choose Manipulate⇨Edit⇨Preview menu. A series of buttons should appear on the

right side of the screen in the Edit Palette. Thumbnails are on the left side of the screen. Click a thumbnail to change the photo shown in the Preview area. If you've made any changes and haven't saved the photo, you'll be prompted to Save, Save As, Do Not Save, or Cancel when you try to switch to a new photo.

Using the Edit Palette

The Edit Palette has buttons you'll use to spruce photos up your photos. The buttons are also available under the Media Control menu when you're in Preview mode.

- ✔ **Reveal the Edit Palette** by clicking the Show Edit Palette button in the bottom-right corner of the window. The buttons are this chapter's main subject.

- ✔ **Cancel edits** by pressing Reset, providing you haven't saved your changes yet. Pressing Reset also resets the view.

- ✔ **To preserve your edits**, click Save or Save As buttons at the bottom of the Edit Palette.

PMB offers the following editing tools:

- ✔ **Red-Eye Reduction:** When people's eyes glow in photos like they came up from the underworld, you've got a problem with red-eye. Use this tool to remove it.

- ✔ **Crop Image:** Even professional photographers *crop* their photos. Cropping in PMB is the digital equivalent of taking a pair of scissors or a paper cutter and trimming the photo down and keeping only what you want.

- ✔ **Insert Date:** When film cameras ruled the earth, some superimposed the date the photo was taken on the negative, which appeared on the print when it was developed.

 You can replicate this in PMB by putting the date onto a corner of the photo.

- ✔ **Autocorrect:** I'm a big fan of automatic corrections. However, it's hard to predict whether Autocorrect will work wonders or not. Try using it, but don't think you have to accept the results. You may be able to tweak the brightness, contrast, or color yourself and do a better job, or do nothing and have a better looking photo than Autocorrect would do.

- ✔ **Brightness:** Performing subtle adjustments to brightness and contrast can make a world of difference for many photos. Take a good photo and make it better. That's fun! It's also possible to rescue some photos with more severe brightness and contrast problems.

- **Saturation:** *Color saturation* is a way of describing color intensity, from none (which is a shade of gray) to full strength.

- **Tone Curve:** The Tone Curve is probably the nerdiest photo-tweaking tool in PMB. Despite that, it has its strengths. With it, you can alter a photo's brightness and contrast as a whole and by color channel. See what I mean? Nerdy.

- **Sharpness:** Sharpening doesn't work for very blurry or out of focus photos. If a photo is a bit *soft* (not in sharp focus), try sharpening it.

Zooming

You can zoom in to inspect details as you browse in Preview mode, or after you select an editing button. Some functions, like red-eye reduction, kick you back to the original view, which means that you may have to zoom back in.

- **To zoom in or out,** use the Preview slider. Drag the slider left or right, click somewhere along the line, or click the plus or minus magnifiers.

- **To see the entire photo,** click the Fit to Window icon (shown in Figure 10-4). Or, right-click in the Preview window and select Actual Size or Fit to Window.

Panning

To pan around a photo that you've zoomed in on, click and drag in the Preview window. This works (mostly) whether you've selected an adjustment or not. However, there are two exceptions: Red-Eye Reduction and Crop Image. When you're using those edits, you can't pan with the mouse. You must use the horizontal and vertical scrollbars to the bottom and right of the image.

Saving your work

Use the Save or Save As buttons at the bottom of the Edit Palette to save the adjustments you've made to your photos.

Choosing Save overwrites the original photo, which means that your changes are made, whether you like them or not. You get one warning, which you can (inexplicably) turn off. Unless you have a backup or the Raw file (in addition to the JPEG you're editing), overwriting the original locks in your changes forever. If that's okay with you, then don't worry about it. If not, *always have a backup file or use Save As.*

Choosing Save As lets you save a copy of the JPEG with a new name. Although, technically, repeatedly saving a JPEG file will degrade it, you'd have to save your JPEGs many times to make a practical difference. I stopped at about 15, compared the before and after photos, and saw no difference.

iPhoto a go-go

Apple iPhoto is a powerful little photo organizing and editing application that lets you edit JPEGs on your Macintosh.

Working with events and photos

When you first start iPhoto, you import photos into the iPhoto Library. Photos are collected into events, which are sorted by the date of the earliest picture. Events aren't limited to a single date. One event could span a year or more.

- ✓ **To browse though large thumbnails of events,** click Events. That option is in the Library section on the left.

- ✓ **To open an event,** double-click it. It expands to take up the screen and shows you thumbnails of all the photos associated with it, as shown in Figure 6-9.

- ✓ **To return to the Events view,** click All Events.

Figure 6-9: Expanding an event.

- ✓ **To name an event,** click its name. When the title changes to a text entry box, type a new one.

- ✓ **To see a list of events,** rather than large thumbnails, click Photo (from the Library list on the left). Events are smaller but show more information. Click the triangle beside the event name to expand or collapse each event. This shows an event's thumbnails.

Throughout all this, you can access the helpful tools at the bottom of the screen.

Viewing individual photos

To see an individual photo, open the event. Double-click the thumbnail of the photo you want to see larger. Click the photo to return to thumbnails.

Editing photos

If you're currently viewing the photo in large form, simply click Edit. Otherwise, follow along:

1. **Click the photo thumbnail.**

2. **Click the Edit button at the bottom of the screen.**

iPhoto has a complete set of JPEG and Raw editing tools. They are:

- **Rotate:** This tool rotates photos that may not be oriented correctly.

- **Enhance:** This is iPhoto's version of Autocorrect.

- **Fix Red-Eye:** Take the red out with Red-Eye.

- **Straighten:** If your photo is a bit out kilter, straighten it. Drag the Straighten slider to the left or right to angle the photo one way or the other. Look for things that should be straight or level and use them as a guide. Line them up with the yellow guides.

- **Crop:** Cropping a photo is like taking a pair of scissors and lopping off the parts you don't want.

- **Retouch:** Retouch lets you remove blemishes from people's faces and other marks, like dust spots from your lens, buts, or other unsightly spots. It's easy to use. Select Retouch when in Edit mode and then click on the blemish you want to remove. Presto! It'll disappear. If not, try adjusting the brush side upwards to cover it (what happens is that the brush pulls in material around it and copies it over the center). If the brush is too large and you're bringing in material that doesn't match the area around the spot, reduce it.

- **Effects:** Select Effect to show six brightness and color effects and nine preset special effects that you can apply to your photos. The presets range from B & W (black and white), Sepia (aged and yellow), and Antique (aged with a different tint), to Matte, Vignette, and Edge Blur.

- **Adjust:** This is a powerful tool that lets you tweak several of the photo's parameters: Exposure, Contrast, Highlights, Shadows, Saturation, Temperature, Tint, Sharpness, and Noise.

Working in Full Screen mode

To enter Full Screen mode (seen in Figure 6-10), select View➪Full Screen or click the Full Screen button at the bottom of the screen. The Full Screen mode lays out differently than normal windowed mode. The event's thumbnails now appear in a strip at the bottom of the screen. If they disappear, move your mouse to the top of the screen to bring them (and the menu) back. The editing and viewing controls are also at the bottom of the screen. When you're done working in Full Screen, press Esc.

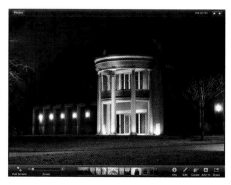

Figure 6-10: Moving up to Full Screen.

Saving

You don't have the option to save photos in iPhoto. They're automatically saved when you move on to another photo. You can, however, choose to Revert to original when in Edit more.

Your only other file options are to duplicate (Photos➪Duplicate) or export (File➪Export) the photo. Duplicate keeps the new file in iPhoto and places it in the same event. Export saves the file to your system.

Working with Raw Files

If you save the Raw file format, you're taking on additional responsibility for your photos. Yes, that is daunting. But if you can use a computer and your camera, you can figure out how to work with your Raw photos. To review the differences between Raw and JPEGs, take a moment and check out Chapter 2.

Ultimately you just have to decide whether using Raw files is worth it in terms of time and discernable photo quality.

You have several ways to convert Raw files into something like a JPEG (to put on your Facebook page, for example). All the methods use a program that can view, edit, and convert Raw files. Check out the section titled "Other photo editors and organizers" earlier in this chapter. However, Sony Image Data Converter SR is the easiest approach. It comes on the CD that came with your camera. You've already paid for it and for any upgrades Sony makes available.

To process Raw files in Image Data Converter (if you're using an earlier version, it's called Image Data Converter SR and it has no View mode), follow these steps:

1. **Download the photos to your computer.**

2. **Start Image Data Converter.**

3. **Select a file to edit.**

 If you're in Edit mode, Choose File⇨Open.

 If you're in View mode, double-click a file to open it in Edit mode.

 If Image Data Converter SR is installed and the .arw files are correctly associated with it, you can double-click any .arw file to open it in Image Data Converter SR.

4. **(Optional) Adjust the image using the controls in the palettes.**

 The palettes are on the right side of the program window. Click the triangle or double-click the palette name. (Brightness is chosen in Figure 6-11.) Double-click the title bar of the floating palette to dock it. Click the control to the right of the name to toggle between floating and docked.

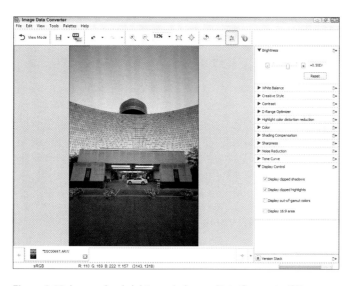

Figure 6-11: Increasing brightness in Image Data Converter SR.

5. **Save your photo as Raw or as another format.**

 - *Raw:* Click the Save or Save As icons on the toolbar. Your adjustments are applied and saved, but not permanently.

 - *Another Format (JPEG or TIFF):* To save your Raw file as a JPEG or TIFF, click the Output icon on the toolbar. You can't edit the product as a Raw file thereafter.

6. **If outputting a JPEG or TIFF, choose your file options.**

 You have more to decide when you save as a JPEG or TIFF. The important options are:

 - *File Name (PC)/Export As (Mac)*

 - *Save as Type (PC)/File Type (Mac)*

 - *Compression:* Only applies if you've selected JPEG as a file type. Compression levels range from 1 (high quality) to 4 (high compression).

 - *Color Space:* Read more on color space in Chapter 8.

 - *Bit Depth:* If you're saving a TIFF, choose 8 bits per color channel or 16 bits per color channel.

 - *Portion to Save:* Click to crop or rotate.

 - *Width and Height:* Changing these values resizes the output file to the dimensions you enter.

7. **Choose the folder where you want to save the file.**

8. **Click Save to save the file.**

 A progress box shows you the status of the save. It disappears when the work is done.

9. **Close the Raw file.**

 If you made any changes to the Raw file, you're asked to save it. The problem is, you can't change the name or location if you click Yes when it asks you. If you want those options, click Cancel and save the file yourself. Otherwise, click Yes to save and overwrite the Raw file. Select No to close the file without keeping the changes.

 If you don't want to save your Raw files but do want to keep the settings, choose Edit↪Image Processing Settings↪Save. You can apply them to other Raw images whenever you want.

Part III
Expressing Your Creativity

The 5th Wave By Rich Tennant

"I've got the red-eye reduction, I'm just seeing if there's a button that'll fix your hair."

*I*n the advanced exposure modes, you take control of the settings that affect depth of field, motion, noise level, lighting, color, and style. Not only that, you choose flash, autofocus, and metering modes, as well as control other advanced features.

7

Making Exposure and Flash Decisions

In This Chapter

▷ Using advanced exposure modes

▷ Working with ISO

▷ Locking down exposure

▷ Using advanced dynamic range features

▷ Working with the built-in flash

1 remember the days when I started learning about my camera's advanced exposure modes. I looked at several sources and took plenty of notes. (I still have them in a Notepad file.) I read about exposure, aperture, shutter speed, and ISO, and in the end I was still left wondering how I was supposed to decide what to do? That's what this chapter is about: giving you enough information about exposure and how your A65/A77 works to choose the exposure control effects, and side effects, that work for you. I want to share some of the answers that I was looking for.

Making Big Decisions

Your job is to control *how much* light makes it into the camera and *how* you allow it to enter (quickly or slowly, among other things). As you decide the "how" part, you can express a good deal of creativity. Each exposure tool has its own effects and side effects. You can make these creative decisions on your own when you're working in the advanced exposure modes.

When taken as a whole, the camera's auto exposure system determines the total amount of light necessary to take each photo. Even in Manual mode, the camera suggests what the proper exposure is.

My advice is to trust the camera to work out how much light it needs. On the whole, it does a great job. When it doesn't, the tools in this chapter correct that. In the meantime, your task is to decide on the exposure settings that yield the side effects that match your creative or practical desires.

Describing the exposure controls

Whether you use them for "how" or "how much," your camera has only three exposure controls: aperture, shutter speed, and ISO.

Aperture

Very generally, an *aperture* is an opening. In photography, an aperture is the area of the lens that allows light to pass through and continue into the camera.

- ✓ Larger apertures let in more light per unit of time. Larger apertures produce photos with a very shallow depth of field. See Chapter 8.

- ✓ Smaller apertures let in less light over the same time. Smaller apertures keep things in focus better by producing comparably deeper depths of field.

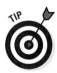

Think of aperture as a depth-of-field knob. Turn it one way and depth of field increases. Turn it the other way and it decreases.

Shutter speed

Your camera's *focal plane shutter* (the electronic front curtain shutter discussed in Chapter 11 notwithstanding) blocks light and keeps the sensor in the dark until you press the shutter button. The focal plan shutter is just in front of the sensor and behind the mirror, as shown in Figure 7-1. When you press the shutter button, the shutter opens to let light through for a discrete amount of time (unless you are in Bulb mode), and then closes. The elapsed time that the shutter is open is called the *shutter speed*.

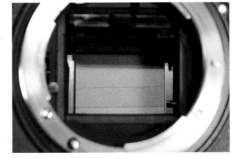

Figure 7-1: If you look carefully, you can see the leaves of the shutter.

 ✔ Fast shutter speeds capture and freeze moving objects.

 ✔ Slow shutter speeds blur moving objects like water or lights.

Think of shutter speed as a blur knob. Turn it one way and you minimize or eliminate motion blur. Turn it the other way and you allow it. The exception is when you're shooting a motionless subject with the camera mounted on a tripod. In this situation, you have pretty much eliminated this side effect.

ISO

Technically, *ISO* doesn't directly control light flow like shutter speed and aperture. Rather, ISO (also known as ISO sensitivity) controls the camera's sensitivity to light. This alters how much light you need to gather over a certain amount of time, and thus the exposure.

You can think of ISO as the camera's volume knob. Setting a high ISO means the camera gathers less light. You can adjust a digital camera's ISO sensitivity between each shot.

Increased ISO levels generate more noise than low ISO levels.

Making creative decisions

Creatively, first decide what effect you want (see the following subsections), and then choose the advanced exposure mode that allows you to control it. Those modes, explained in more detail later, include P (Program Auto), A (Aperture priority), S (Shutter priority), and M (Manual).

Rule out Program Auto because it doesn't allow you to alter the aperture or shutter speed. Although Manual mode is always an option, Aperture and Shutter priority modes are the most convenient. They allow you direct control over the exposure control of your choice while handling the other exposure elements automatically.

Depth of field

The *depth of field* (DOF) in a photo is the area that appears to be sharply in focus. The areas outside this area are out of focus. Call that the *bokeh*. Although DOF also depends on other factors (such as the distance to the subject and the lens' focal length), the aperture is the only exposure control that affects DOF.

You want a shallow depth of field when shooting

- ✔ Portraits
- ✔ Some action shots
- ✔ Close-ups

A nice bokeh separates the subject from the rest of the photo and makes it the center of attention. Figure 7-2 illustrates the creative use of depth of field in a portrait of my son. Notice that the background is pleasingly out of focus. That's on purpose and made possible in part by an f-number of f/5.6. If you look closely, you can see that his far shoulder is out of the depth of field.

On the other hand, you want a deep depth of field when shooting

- ✔ Landscapes
- ✔ Cityscapes
- ✔ Landmarks
- ✔ When you want everything to be in focus

You can safely follow these aperture guidelines:

Figure 7-2: Shallow depths of field make portraits look even better.

- ✔ Large apertures are those with an f-number of 5.6 and below. (Smaller f-numbers have larger apertures.) Use these f-numbers when you want to limit the depth of field at normal distances. Bigger apertures admit more light (increasing the exposure).

- ✔ Good general-purpose apertures range from f/8 to f/11. When shooting close-ups, they have shallow depth of fields. At standard distances they have what you would call a *normal* depth of field. At long distances (landscape), they produce very large depths of field.

✔ Small apertures are those with an f-number of f/16 and above. Use them when you want a reasonable depth of field for macro work and very large depths of field at other distances. Smaller apertures admit less light.

Depth of field is also covered in Chapter 8.

Blur

Movement — yours or the subject's — causes motion blur. To minimize this type of blur, increase the shutter speed. The shutter speed you need to used depends on the speed of the subject and the relative direction of motion.

You can safely follow these shutter speed guidelines:

✔ Use slow shutter speeds (how slow depends on the subject's speed) to intentionally blur movement. Figure 7-3 shows two views of a fountain in downtown Detroit. The shot that froze the water (no pun intended) was taken at 1/80 second. The example where the water looks misty and ethereal (the blur I was after) was taken at 1.0 second. To capture motion blur without camera shake at slow shutter speeds (1/30 second and longer), stabilize the camera on a tripod or some other support.

✔ Shutter speeds around 1/250 second capture people moving around and being active without blur. That includes kids and pets. If your subject is moving faster, use a shorter shutter speed (unless you want the blur).

1/80 second 1 second

Figure 7-3: Shutter speeds can be creative at both ends of the spectrum.

✔ To produce sharp sports and action shots, increase the shutter speed to between 1/250 and 1/500 second.

✔ Racing and other very fast activities might require 1/1000, 1/2000, or 1/4000 second shutter speeds to freeze the action. Figure 7-4 shows two of my boys playing football; I shot the photo at 1/2000 second.

You may run into problems when you want to shoot with a very fast shutter speed but need to use the flash. The Flash Sync speed for the A65 is 1/160 second. That's not blazingly fast. If you need to use a faster shutter speed, invest in an external flash and mount it on the accessory shoe. You can then use the flash's high-speed sync feature (enabled from the flash, not the camera). For example, the Sony HVL-F58AM and HVL-F43AM flash both support high-speed sync up to the faster camera shutter speed. In this case, that's 1/4000 second. The A77's sync speed is 1/250 second, which is marginally faster, but not that much more capable. Consider picking up an external flash to use faster shutter speeds.

Figure 7-4: Capture action with fast shutter speeds.

Noise

Because noise is often an undesirable effect, this creative goal is usually expressed as a negative. In other words, your goal is probably to minimize all possible noise, or perhaps limit it to a certain level. On the other hand, you may have no other way to take a photo in dim light sans flash other than to raise the ISO. In these cases, the necessity of getting the right exposure will override your desire to limit the noise level in the photo.

The A65/A77 have impressive ISO ranges, starting at ISO 50 (A77) or ISO 100 (A65) and reaching to ISO 16000. Auto ISO in P, A, and S modes works from ISO 100 (both cameras) to ISO 1600. Limiting ISO is one of the most challenging aspects of digital photography. However, having access to ISO 16000 feels miraculous because it gives you the ability to take pictures that are normally impossible.

Figure 7-5 shows the conundrum: You have access to high ISOs but pay for it in noise. I took this basketball shot in a dimly lit gym. I wanted a fast shutter speed to capture the action (1/500 second). Unfortunately, my lens was limited. The camera was in Shutter priority mode chose and chose f-number f/6.3. The ISO was 12800, resulting in quite a bit of visible noise. You can soothe the noisy beast somewhat with software, but at the cost of some sharpness.

When controlling the noise level is your creative goal, ISO is your most important exposure control. You can safely follow these shutter speed guidelines:

- Generally speaking, use ISO 50 (A77)/100 (A65) when outside in the daylight.

- If necessary, go to ISO 400 when shooting action.

- Inside, ISO values go through the roof, even when using a wide aperture and slow shutter speed. It's darker than you think in there!

Figure 7-5: High ISO can be a double-edged sword.

On the other hand, noise *can* look like film grain, especially when you take a black and white. Your mileage, however, may vary.

You don't get something for nothing. Every exposure decision you make affects the other two exposure controls. For example, if you reduce the aperture to increase the depth of field, that lets in less light. You may need to offset that by using a longer shutter speed or higher ISO.

Shooting in different conditions

Sometimes the practical necessity of getting the right exposure takes precedence over any artistic goals. You may find this true in these extreme conditions:

- **Low light:** ISO tends to make up the difference in low light, and is why the A65/A77 is such a good low-light camera. Both have high maximum ISOs (16000) and good noise levels well up into that range.

- **Bright light:** The A65 has a maximum shutter speed of 1/4000 second. That's fast, but it may not be fast enough in very bright conditions when you have a wide aperture. Your only alternative to reducing the exposure at that point is to use an ND filter, which is like putting a pair of sunglasses on the camera. The A77's maximum shutter speed is 1/8000, which is twice as fast as the A65. That's good, but you should remember that the difference between 1/4000 and 1/8000 second is only a stop's worth of exposure, which isn't all that much.

- **Movement:** If you or your subject are moving and you want a clear photo, you have to dial in a fast shutter speed. It's essentially impossible to shoot a fast subject with a very small aperture at low ISOs in anything other than very bright conditions. This means that you should increase the aperture and raise the ISO, if necessary.

Dialing in Advanced Exposure Modes

Your A65/A77 has four advanced exposure modes:

- P (Program Auto)
- A (Aperture priority)
- S (Shutter priority)
- M (Manual)

These modes give you much more control over the camera than the basic shooting modes. In the end, though, they have the same purpose: to enable you to take the photos you want of the subjects that you choose.

You have to know how the exposure controls work to get the creative outcome you want with advanced exposure modes. For example, if you want action shots, you have to know that requires a fast shutter speed. You must know that two modes let you set the shutter speed yourself: Shutter Priority and Manual. You then have to choose the mode and enter the exposure settings yourself. Yikes. That's why these modes are covered more in Chapters 7 and 9. See Figure 7-6.

The advanced exposure modes offer fewer choices, but they're more powerful. See Table 7-1.

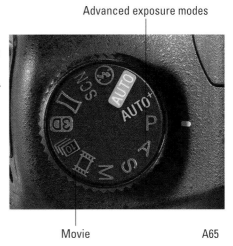

Advanced exposure modes

Movie A65

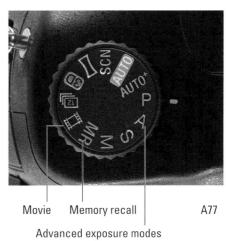

Movie Memory recall A77
Advanced exposure modes

Figure 7-6: The advanced exposure modes give you much more control.

Table 7-1	Advanced Exposure Modes	
Icon	*Mode Name*	*Description*
P	Program Auto	The camera is set on automatic exposure, but you retain control over settings like ISO, Creative Style, and so forth. In other words, you keep some of the creative control while the camera handles the exposure.
A	Aperture priority	You set the aperture and the camera determines the other settings needed to arrive at the proper exposure. Good for portraits, landscapes, and close-ups.
S	Shutter speed priority	The same as Aperture priority, only you set the shutter speed instead of the aperture. Good for sports, action, and when you are moving.
M	Manual exposure	You take total control of the camera and make all the exposure and function decisions.
MR	Memory Recall (A77 only)	The A77 has a special Memory recall mode, which allows you to store and retrieve up to three camera configurations. This is covered in Chapter 11.

Using Program Auto

Program Auto is a first step towards total manual control. Turn the mode dial to P and press the Display button to see all the powerful shooting functions that are hidden from you in the basic exposure modes. These include ISO, metering mode, flash compensation, white balance, D-range optimization, and creative style. See Figure 7-7.

However — and this is a big however — you don't have any more control over aperture or shutter speed than you did in the basic modes. In Program Auto mode you can't make creative depth-of-field decisions or skew the camera's shutter speed toward crisp action or fuzzy water shots.

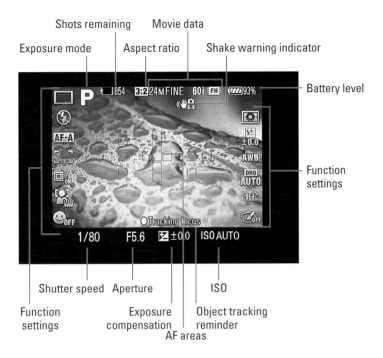

Shots remaining Movie data

Exposure mode Aspect ratio Shake warning indicator

Battery level

Function settings

Shutter speed Aperture ISO

Function settings Exposure compensation Object tracking reminder

AF areas

Figure 7-7: Enough shooting functions to satisfy the hardcore enthusiast.

Program Auto is valuable if you don't need to control the aperture or shutter speed, but you're ready to exercise more control over the shooting functions. To use Program Auto mode, follow these steps:

1. **Set the mode dial to P, as shown in Figure 7-8.**

2. **Press the Function button and review the shooting functions.**

 Make sure things like the metering mode, AF mode, flash, and Creative Style are set correctly.

 It stinks to start shooting and then realize something was incorrectly set.

3. **Press the shutter button halfway to autofocus and meter.**

 If manually focusing, do so now.

4. **Press the shutter button fully to take the photo.**

5. **(Optional) Review your photo.**

 If necessary, press the playback button to review your photo. Look for over- or underexposed areas. If things look off, adjust the metering method or use exposure correction to adjust the exposure.

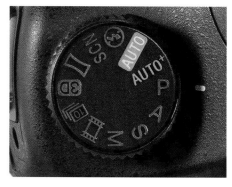

A65

Using Aperture priority mode

In Aperture priority mode, your primary decision is choosing the aperture. The camera sets the shutter speed (and possibly the ISO if you've left it on Auto).

Most people use Aperture priority mode to shoot portraits, landscapes, and close-ups because it gives you creative control over the depth of field. To use Aperture priority mode, follow these steps:

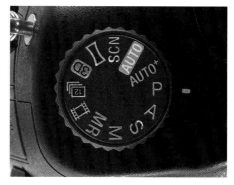

A77

Figure 7-8: P stands for Program Auto.

1. **Set the mode dial to A, as shown in Figure 7-9.**

2. **Press the Function button and review the shooting functions.**

3. **Spin the control dial to set the aperture.**

 This is the big deal; the reason you're in Aperture priority mode. Have fun and enjoy it! Choose aperture (through the f-number) based on your creative desires.

 Spin the Control dial left to decrease the f-number, or right to increase it. The shutter speed dynamically adjusts to account for the size of the aperture and make the exposure work.

 Remember, lower f-numbers, such as f/5.6, increase the size of the aperture and higher numbers, such as f/22, decrease it.

4. **Press the shutter button halfway to autofocus and meter.**

 Or manually focus.

5. **Press the shutter button fully to take the photo.**

6. **(Optional) Review your photo.**

 If necessary, press the playback button. Look for over- or underexposed areas. If things look off, adjust the metering method or use exposure correction to adjust the exposure.

Using Shutter speed priority mode

Shutter speed priority is just like Aperture priority, but you've isolated shutter speed (not aperture).

Use Shutter priority for sports, action, and when you're moving. Follow these steps:

1. **Set the mode dial to S, as shown in Figure 7-10.**

2. **Press the Function button and review the shooting functions.**

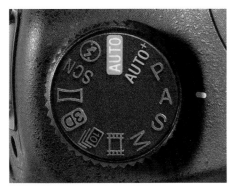

A65

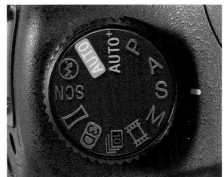

A65

A77

A77

Figure 7-9: A is for Aperture priority.

Figure 7-10: S stands for Shutter speed priority.

3. **Spin the control dial to set the shutter speed.**

 Set the shutter speed according to your creative desires and the necessity of capturing action. Spin the control dial left to increase the time (slower shutter speeds), or right to decrease it (faster shutter speeds). The f-number adjusts to compensate.

4. **Press the shutter button halfway to autofocus and meter.**

 Or manually focus.

5. **Press the shutter button fully to take the photo.**

6. **(Optional) Review your photo.**

 If necessary, press the playback button. Look for over- or underexposed areas. If things look off, adjust the metering method or use exposure correction to adjust the exposure.

Taking total control with Manual exposure mode

In Manual exposure mode, you have total control of the camera. Although the camera indicates what the correct exposure is, you have to set the aperture, shutter speed, and ISO to make it happen. The EV scale changes as you make aperture and shutter speed adjustments. The standard value pointer moves to the left or right, depending on whether you're decreasing or increasing the exposure.

A65

To use Manual exposure mode, follow these steps:

1. **Set the mode dial to M, as shown in Figure 7-11.**

2. **Press the Function button to review the shooting functions and set the ISO.**

 You can't put ISO on Auto when you're in Manual mode. Set your ISO to the noise level that you're willing to live with now, recognizing that you may have to increase it later. ISO 50 (A77) /ISO 100 (A65) is the lowest.

A77

Figure 7-11: Manual mode is the camera's most advanced mode.

3. **Press the shutter button halfway to meter, then release.**

 I think it's helpful to have an idea of what settings will work in Manual mode before you start spinning the dials. Metering now puts that data in the camera. You'll see the EV scale adjust to your inputs.

4. **Set the shutter speed.**

 For the A65: Spin the control dial left to increase the time (slower shutter speeds), or right to decrease it (faster shutter speeds). As you spin the dial, the EV scale changes to read the current exposure.

 For the A77: Depending on how you've set up the camera (see the Control Dial Setup option in Custom menu 4), spin the front or rear control dial. The camera assigns shutter speed to the front dial by default when you're in Manual mode.

5. **Adjust the aperture.**

 For the A65: Press *and hold* the Exposure button and spin the control dial to adjust the aperture. Spin it left to decrease the f-number; spin it right to increase it.

 For the A77: Depending on how you've set up the camera (see the Control Dial Setup option in Custom menu 4), spin the front or rear control dial. The camera assigns an f-number to the rear dial by default when you're in Manual mode.

6. **Confirm the exposure.**

 If you want to shoot the exposure that the camera suggests, set the combination of shutter speed and aperture so the Standard value reads 0EV. If the caret moves to the left, the exposure is less than the camera's calculated optimum exposure. If the caret moves to the right, the camera thinks you will overexpose the photo. When the caret is centered, the exposure controls will produce a photo at 0.0EV.

 If you risk underexposing the photo and can't adjust the shutter speed or aperture any further to let in more light, increase the ISO.

7. **Press the shutter button halfway to autofocus.**

 Or manually focus.

8. **Press the shutter button fully to take the photo.**

9. **Review your photo.**

 If necessary, press the playback button. Look for over- or underexposed areas. If things look off, adjust the shutter speed, aperture, or ISO. You can't use exposure correction in Manual mode.

Hi Ho, Hi Ho, to ISO You Go

Even though ISO doesn't have its own advanced exposure mode, try to control it as you would aperture and shutter speed. ISO is so important a contributor to exposure that you should elevate it to first-tier status, even if most of the time you're trying to limit it.

Selecting an ISO

In the automatic shooting modes, your ISO is largely set for you. In advanced exposure modes, you can set the ISO to a specific value. In all but Manual mode, you can also leave it on Auto.

To select an ISO, follow these steps:

1. Press the ISO button.

This calls up the ISO screen shown in Figure 7-12. The figure shows the A77's ISO screen, which has more low-ISO options.

You can also access ISO anytime from the shooting function screen by pressing the Function button.

Figure 7-12: Remember, ISO is about sensortivity.

2. Highlight the ISO you want.

Use the up or down buttons, or spin the control dial.

When in P, A, or S modes, selecting Auto gives partial control over ISO to the camera. It chooses values up to ISO 1600 automatically, but doesn't go past ISO 1600. If you need more than that, you have to select it yourself. Also, if Image Quality is set to Standard, Fine, or Extra Fine (in other words, JPEGs only), ISO Auto is an option (which automatically goes up to ISO 6400). See the next section for more information on this feature.

Don't confuse Auto with ISO Auto. The top option on the ISO display, ISO Auto, is multi-frame noise reduction. (It might show a number, in which case it is still the multi-frame noise-reduction ISO.) Auto, the next option, is the automatic mode where the camera chooses the ISO for you.

3. Press the enter button to exit.

Or press the Function button to get to the shooting display.

Using multi-frame noise reduction

Multi-frame noise reduction is a fairly interesting option that shoots several images, combines them, and then spits out a single, low-noise photo. Use it when you're shooting a still subject and need a higher ISO and want a single JPEG (not Raw) with a low noise level.

To use multi-frame noise reduction, follow these steps:

1. **Press the Menu button and go to Still Shooting menu 1.**

2. **Change Image Quality to Extra Fine (A77), Fine or Standard; then press the enter button.**

3. **Press the ISO button.**

4. **Highlight ISO (the top option).**

5. **Press the right and down buttons to select an ISO sensitivity.**

 Pressing right highlights the ISO bar at the bottom of the display. When active, you can press up or down to scroll through the settings. Go backward by pressing the up button or keep pressing down if you're like Hamm in *Toy Story 2* and you "gotta go around the horn."

 Your options are:

 - *Auto:* Leave it on Auto to let the camera choose the ISO sensitivity.

 - *ISO 100 through 12800:* This range is within your camera's normal ISO sensitivity range.

 - *ISO 25600:* That's right, you can choose an ISO sensitivity beyond the single-shot range of your camera. That is awesome.

6. **Press enter to lock in your settings.**

7. **Compose the shot, meter, and so forth.**

8. **Press and hold the shutter button until the shooting stops.**

 The camera will fire off several shots. Do your best to hold steady.

9. **Release the shutter button and review the photo.**

 Figure 7-13 shows a direct comparison between ISO 100, ISO 16000, and ISO 25600 with multi-frame noise reduction enabled. I used ambient lighting and corrected the white balance afterwards. As you can see from the close-ups, ISO 100 looks very good. Both shots with high ISO levels have a lot of noise, but the multi-frame noise reduction produces a noticeably better photo.

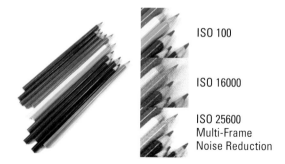

ISO 100

ISO 16000

ISO 25600
Multi-Frame
Noise Reduction

Figure 7-13: Comparing ISO performance.

Metering Methodology

Measuring the amount of light in a scene is called *metering*. The camera senses direct light as well as reflected light, determines the intensity, and calculates the exposure. Strong light, such as the sun, is very intense. Weak or low light, such as a dark room, is not.

Most scenes are a combination of strong and weak light, and can be very complex. As such, it's helpful to know how to use two of the A65/A77 tools:

- ✔ Different metering modes
- ✔ Histogram

Meter types

The A65/A77 has three distinct metering modes that let you adjust to different lighting conditions.

Multi-segment

Multi-segment metering is the default. The mode separates the scene into areas and then evaluates the exposure based on everything in the frame. No area is left out. See Figure 7-14.

Use multi-segment metering unless you have a reason to change it. It's the best mode for general photography.

Center weighted

Although this mode takes into account light intensity across the entire frame, as the name suggests, it gives greater importance to the center of the frame. Figure 7-14 also illustrates the center-weighted method.

 Use center-weighted mode on bright areas that you want to keep from blowing out. In other words, if you're shooting a high-contrast scene and want to preserve details in the high-lights, switch to center-weighted mode, point the camera at the bright area, meter, recompose, and take the photo. Center-weighted metering also works for dark subjects that are larger in the frame. You can expose mostly for them if you choose this mode.

Spot

Spot mode (also in Figure 7-14) is a special type of metering that evaluates the brightness in the spot metering circle in the middle of the frame. It leaves out all else.

 Use spot mode in high-contrast scenes to make sure your subject (and not the background) isn't over- or underexposed. Good examples are when someone is in front of windows, with their back to the sun, or other objects are in shadow against

Figure 7-14: Three distinct metering modes exist.

a bright background. Center the object you want metered under the spot metering circle, press the shutter button halfway, and recompose. Use the AEL button to lock in the exposure.

By using spot mode, you've decided that you're willing to accept a certain amount of blown highlights. In other words, you may not get a good exposure as a whole and ensure that your subjects are bright. To be honest, there may be no other way to take the photo.

Changing metering mode

To change the metering mode, follow these steps:

1. **Set the mode dial to an appropriate mode.**

 You can change metering mode in P, A, S, M, Panorama, 3D Sweep Panorama, Continuous Advance Priority AE, and Movie modes.

2. **Press the Function button.**

3. **Highlight Metering Mode and press the enter button.**

4. **Highlight a new mode.**

5. **Press enter to return to shooting.**

 Or press the Function button to return to the shooting function display.

Now, in case you're wondering, this actually *does* work. Figure 7-15 shows three shots of my son outside.

- ✔ In the first shot, I used multi-segment metering. The bright sky and reflections off the tree and other background objects dominate the scene, pushing up the exposure. He looks too dark.

- ✔ In the second, I used center-weighted metering. This tells the camera to pay more attention to what's in the middle than on the edges, which is a good description of the problem with the first shot. The result is *much*

Figure 7-15: Seeing the metering modes in action.

better. He's lit as if I used the flash (I didn't). That's because his face played a more important role in determining the exposure.

- ✔ In the last shot, I used spot metering. I located him under the spot metering circle in the viewfinder. Although he looks very good, the overall photo comes close to being too bright. That's because the edges weren't considered when the camera evaluated the exposure.

Using the Histogram

If you want to stay on top of your scene's brightness before you shoot, use the histogram display. This histogram is similar to the luminance histogram that you can see in Playback mode, but with one big difference: This histogram is live. As a result, you can change the exposure using exposure correction.

Press Display until you see the histogram. If you don't see it after cycling through all the displays, you may have turned it off. See Chapter 10 to see how to make sure the histogram display is available.

Locking the Exposure

When you're working with high-contrast scenes, it's often useful to lock the exposure into the camera. This lets you point and meter a specific area, then use that for the overall exposure. The AEL (auto exposure lock) button is shown in Figure 7-16.

To use auto exposure lock (AE lock), follow these steps:

1. **Choose an exposure mode that allows AE lock.**

 Trick step! You can use AE lock in any exposure mode, including the basic exposure modes. The only mode where it doesn't make sense is Manual exposure mode, although you can still press the button.

2. **(Optional) Change to spot metering mode.**

 This more precisely identifies the spot in the scene that you want to lock the exposure on. Use the other metering modes if you're turned one direction and need to shoot with the same exposure in another, such as when you're shooting a panorama.

A65

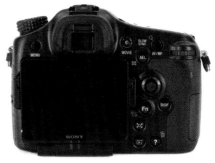

A77

Figure 7-16: Press and hold AEL to lock exposure.

3. **Make sure you can see the area you want to meter.**

 In other words, focus.

4. **Press and hold the AEL button.**

 The AE lock mark appears, as shown in Figure 7-17.

5. **While pressing the AEL button, press the shutter button halfway to focus.**

6. **Press the shutter button fully to take the photo.**

 To take more photos with the same exposure, keep holding the AEL button. Recompose, focus, and keep shooting.

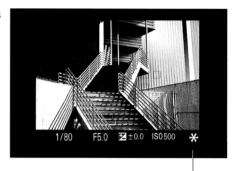

AE Lock indicator

Figure 7-17: Press and hold AEL to lock exposure.

Using Exposure Compensation

Sometimes the camera gets the exposure right, but the photo just doesn't look like you want it to. Your eyes are the ultimate judge. Whether for aesthetic or artistic reasons, use exposure compensation to dial in exposure corrections when you aren't in Manual mode.

Before you use exposure compensation, take a few test photos and review them by pressing the playback button. Zoom in to look closely at the bright and dark areas, and see whether you need to tone down or brighten up the image. Then follow these steps:

1. **Enter a compatible exposure mode.**

 You can use exposure compensation in P, A, S, Panorama, 3D Sweep Panorama, Continuous Advance Priority AE, and Movie , modes.

2. **Press the shutter button halfway to meter the scene, then release.**

 If you're in autofocus, this step also focuses.

3. **Press the exposure button, shown in Figure 7-18.**

 Despite what your instincts may tell you, you *don't* have to hold the exposure button down.

Exposure button Exposure button

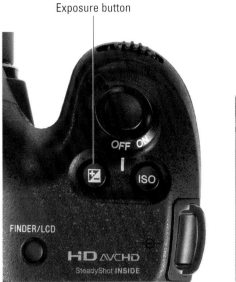 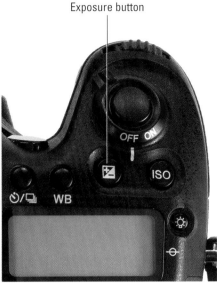

Figure 7-18: Press the exposure button to enable exposure compensation.

4. **Rotate the control dial to increase or decrease the exposure.**

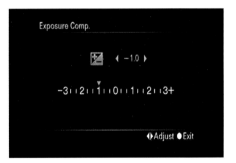

 - Turn the control dial to the left to decrease the exposure (darken the image). The compensation amount is a negative orange number above the EV index, as shown in Figure 7-19.

 - Turn the control dial to the right to increase the exposure (lighten the image). The compensation amount is a positive orange number above the EV index.

Figure 7-19: The EV index shows the amount of compensation you've dialed in.

With the A77, you can change which dial you want to spin. Go to the Dial Exposure Compensation option on Custom menu 4.

Each click of the control dial changes the compensation amount by a third of an EV, up to +/- 3.0EV (A65) or +/- 5.0EV (A77).

5. **Press the shutter button halfway to meter again and focus.**

6. **Press the shutter button fully to take the photo.**

Dynamic Range or Bust

The world is a pretty dynamic place. The sun is an incredibly bright light source, and shadows are great at hiding things. When you put them together in the same photo, the camera has to choose between making one look good over the other. This dynamism has created the current enthusiasm with high dynamic range (HDR) photography and spurred developments such as the D-range optimizer.

Processing photos with the D-range optimizer

The D-range optimizer (DRO) produces JPEGs with more balanced highlights and shadows. Although the D-range optimizer automatically applies when you're shooting in many of the basic shooting modes, you can disable (or configure) it when you're working in an advanced exposure mode.

To change the D-range optimizer settings, follow these steps:

1. **Select a compatible exposure mode.**

 The D-range optimizer works with P, A, S, M, Continuous Advance Priority AE, and Movie modes.

 In other modes, the DRO is either fixed to off (in Sweep Panorama, 3D Sweep Panorama, the Sunset, Night Scene, Night Portrait, or Hand-held Twilight scenes, when using multi-frame noise reduction, or when using picture effects) or fixed to Auto (in Auto mode or the other scenes in Scene Selection). Yeouch.

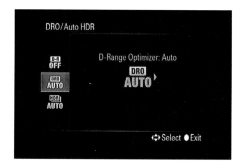

2. **Press the Function button.**

3. **Highlight DRO/Auto HDR and press enter.**

 The DRO/Auto HDR screen opens. To turn off the D-range optimizer, highlight DRO Off. I discuss the other option, HDR Auto, in the next section.

4. **Highlight DRO Auto, as shown in Figure 7-20.**

 Auto is the default camera setting. If you're satisfied, press the enter button and stop here. If you want to select a strength, continue.

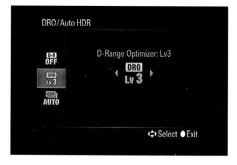

Figure 7-20: Accessing DRO levels.

5. **Use the left or right buttons to set the DRO level (see Figure 7-20), then press enter.**

 The D-range optimizer has six processing levels. Choose anything from Lv1 (weak) to Lv5 (strong).

6. **Frame, meter, and take your photos.**

7. **Review them to see if the highlights and shadows are processed to suit your taste.**

DRO off

Figure 7-21 shows a scene shot with and without the D-range optimizer. It was a bright afternoon with an extreme range of highlights (the sky and lake beyond) and shadows (trees in silhouette and shadows on the ground).

The difference between Off and Lv3 is pretty dramatic. In the latter, details on the trees in the foreground are visible and the shadows on the grass are not too dark. The sky isn't brighter. Overall, the photo lacks a bit of contrast, but you can fix that with software.

DRO Lv3

Figure 7-21: The D-range optimizer processes only JPEG files.

DRO Bracketing (A77)

Only the A77 offers DRO bracketing, which takes one photo and processes it three times. You end up with three JPEGs, each with a different DRO setting. To shoot DRO brackets, follow these steps:

1. **Enter a compatible shooting mode, as described earlier.**

2. **Press the Drive button and select DRO Bracket.**

3. **Select a range and press enter.**

 If you select Lo, the camera uses Lv1, Lv2, and Lv3. If you select Hi, the sequence is Lv1, Lv3, and Lv5.

4. **Focus, meter, and take the shot.**

You don't get Raw files with DRO. If you want to create your own brackets and experiment with DRO settings, launch Image Data Converter SR and process your Raw files yourself. See Chapter 6 for more about that.

Using Auto HDR

Auto HDR is another way to deal with high-contrast scenes that have a large dynamic range. Rather than shoot a single photo and process it differently (as in the case of D-range optimizer), Auto HDR shoots several photos with different settings and merges them into a single shot.

To use Auto HDR, follow these steps:

1. **Press the Menu button and go to Still Shooting menu 1.**

2. **Set Image Quality to Extra Fine (A77), Fine, or Standard.**

3. **Select a compatible exposure mode.**

 Auto HDR works only in P, A, S, or M modes.

4. **Press the Function button, highlight DRO/Auto HDR, and press enter.**

 This displays the DRO/Auto HDR screen.

5. **Use the up or down buttons to select HDR Auto.**

6. **Use the left or right buttons to set the HDR level.**

 You can leave it on Auto if you like. The camera handles all the details for you. Otherwise, select one of six exposure levels, ranging from 1.0EV to 6.0EV. When shooting HDR, the smaller differences capture a smaller dynamic range. On the other hand, the HDR image will look more realistic.

7. **Compose the scene.**

8. **Press the shutter button to start the process.**

There's no need to hold down the shutter button. The camera shoots continuously, regardless. As with other multi-exposure techniques, try to remain still and keep the camera steady as it shoots. If necessary, get a tripod.

Figure 7-22 shows the difference Auto HDR can make. In this scene (a gorgeous suspension bridge for foot traffic at sunset), the sky is light and the foreground is in shadow. It's a nice photo, but Auto HDR can bring out detail in the foreground. The key is remembering to use it. It isn't an after-the-fact software trick. I shot this example with a 6EV exposure-level difference.

Auto HDR off

Auto HDR 6EV

Figure 7-22: Auto HDR only works when you have the image quality set to Extra Fine (A77), Fine, or Standard.

Exposure bracketing and HDR photography

Although now primarily for HDR photography, auto exposure bracketing (AEB) began years ago on film cameras. Getting the right exposure was much trickier then, and you couldn't immediately play the photo back to inspect it. Shooting exposure brackets covered your exposure bases. You could take three photos and chose the best one when you developed the film. You can use it the same way today, but more people use bracketing for HDR photography.

Chapter 9 has a more extensive section on shooting HDR. This section shows the exposure bracketing feature.

To shoot auto exposure brackets, follow these steps:

1. **Enter an appropriate exposure mode.**

 Exposure bracketing works only in P, A, S, or M modes.

2. **Press the Drive button.**

3. **Select Bracket: Continuous or Bracket: Single.**

 Continuous bracketing means you have to press and hold the shutter button until the photos stop. Single bracket means that you must take each photo separately.

4. **Use the left or right button to select bracketing details.**

 The A65 lets you choose a step distance of 0.3 or 0.5EV. The larger step (0.5EV) shoots brackets that cover a larger dynamic range and are best suited for HDR. Choose the smaller step if you're covering your exposure bases.

 On the A77, you can shoot three or five brackets with a step size of 0.3, 0.5, or 0.7EV, or three exposures separated by either 2.0 or 3.0EV.

 Choose 5 brackets if the scene has high contrast. Shooting more brackets captures a wider range of light, which lets you process a smoother, less artificial image.

5. **Frame and focus.**

6. **Press the shutter button to start shooting.**

 You have to hold down the shutter button when you're shooting continuous exposure brackets. The A65/A77 is fast enough to shoot brackets handheld, but if the shutter speed is slow, you may need to use a tripod.

 If shooting single brackets, press the shutter button fully once to photograph each bracket.

 The camera normally takes the photos in this order: spot on, under, and then over. If using the A77, you can change this to under, spot on, and over with the Bracket order option in Setup menu 4.

7. **Transfer your photos to a computer.**

8. **Process the brackets in HDR software or choose the best single exposure.**

This part of the process is covered briefly in Chapter 9. Figure 7-23 presents a final image taken with an EV difference of 0.7EV. The statue is of James Scott and is on Belle Isle, within view of Detroit.

Controlling the Built-in Flash

Using the flash in an advanced exposure mode doesn't have to be frightening. Armed with the information in this section, you can start shooting good flash photography in no time.

Setting the flash control method

Figure 7-23: The Architect in HDR.

Because the flash contributes so much to the exposure, there has to be a way to integrate it with the exposure settings. Enter flash control.

Flash control comes in three types:

✔ **ADI flash** is the best, most accurate flash control method. Advanced Distance Integration takes into account the distance from the camera to the subject, as well as other metering information. This method is supposed to prevent harsh reflections. ADI flash only works with lenses that provide distance information to the camera (which includes all Sony lenses).

Using any sort of flash diffuser, bounce flash, ND filter, or macro lens will throw off ADI flash. Switch to pre-flash TTL on those cases.

✔ **Pre-flash TTL** is the next best thing to ADI. Through the Lens (TTL) flash uses pre-flash metering to figure out how strong the flash should fire. Because pre-flash TTL doesn't use distance information, it's more likely to create strong reflections off close subjects.

✔ **Manual flash** (A77) lets you set the strength of the flash from the Power Ratio option in Custom menu 2. See Chapter 11 for more information about using the flash in manual mode.

Setting advanced flash modes

The basic flash options — Flash Off, Auto Flash, and Fill-Flash (see Chapter 3) — aren't available in the advanced exposure modes (P, A, S, or M), or in Continuous Advance Priority AE or Movie modes.

When you're in those modes, you keep the built-in flash closed to turn off the flash; raise the flash to enable it. There is no Auto Flash equivalent in the advanced exposure modes.

Advanced flash modes

The more advanced flash modes follow:

✔ **Slow Sync** tries to balance the light between the foreground and background better than normal flash. You can't enable Slow Sync from a menu on the A77. Use the Slow Sync button instead, as described in the following section.

✔ **Rear Sync**, also known as Rear Curtain or 2nd Curtain, freezes moving objects at the end of their movement rather than flashing first.

✔ **Wireless** enables the built-in flash to act as a wireless master. Set up your compatible wireless slave flash unit off the camera and have fun with different setups and lighting effects. Chapter 11 has a section on shooting wireless flash if you want more information.

Setting flash mode

To set the flash mode, follow these steps:

1. **Press the Function button.**

2. **Highlight Flash Mode and press the enter button.**

3. **Use the up or down buttons to select a flash mode.**

4. **Press the enter button to exit.**

 Or press the Function button to return to the shooting function.

The A77 can shoot Slow Sync, but the mode doesn't show up in the shooting functions along with the other flash modes. The A77 has a slow sync button. Press and hold the slow sync button to shoot using Slow Sync.

Using the built-in flash

Using the built-in flash is surprisingly easy, but I want to put this section in as a shout-out to the guys at United Flash Button Operators Local 523. See Chapter 2 for more information and tips for working with flash.

To use the flash, follow these steps:

1. **Press the flash pop-up button shown in Figure 7-24.**

 The flash pops up, as shown in Figure 7-25.

2. **Press the Function button and review the Flash mode.**

 Make sure it's what you want. Select Fill-Flash for normal flash use.

3. **Compose and take the photo.**

4. **Review the shot.**

 If the flash looks too weak or too strong, consider adjusting its strength, as described in the next section.

Adjusting the flash strength

You know, sometimes firing off the flash at full strength makes things — especially people — look harshly lit. Plus, it casts obnoxious shadows. On the other hand, you may be in a large room with your subject farther away; you may need more flash strength

Flash pop-up button

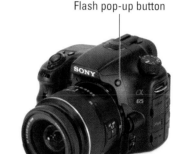

Figure 7-24: Push this button . . .

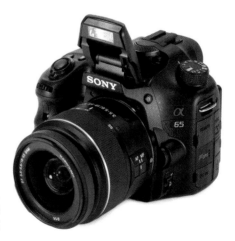

Figure 7-25: . . . to make this happen.

than the camera wants to give you. Flash compensation can help you in both of these situations.

To adjust the flash's strength, follow these steps:

1. **Enter a compatible shooting mode.**

 Flash compensation works in P, A, S, M, and Continuous Advance Priority AE.

2. **Press the Function button to call up the shooting functions.**

3. **Highlight Flash Compensation and press the enter button.**

4. **Decrease or increase the flash compensation.**

 Spin the control dial to the left to decrease flash compensation. Spin it right to increase flash compensation. Press the left or right buttons to decrease or increase. Negative numbers (measured in EV) decrease the strength of the flash. Positive numbers increase the strength of the flash. See Figure 7-26.

5. **Press the enter button to return to shooting.**

 Or press the Function button to go back to the shooting function display.

Trying flash compensation

Try flash compensation when you take a photo and the flash is too bright (like 0.0EV in Figure 7-27). I dialed back the flash strength by -1.0EV and took another shot. Awesome.

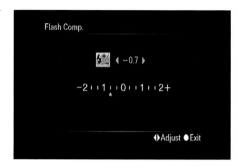

Figure 7-26: Dialing in flash compensation.

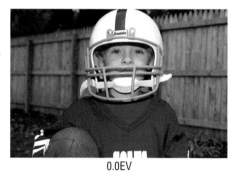

0.0EV

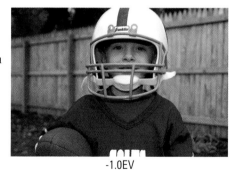

-1.0EV

Figure 7-27: In this case, the softer flash resulted in a much better photo.

Do you want a fantastic (albeit advanced) reason to use flash compensation? You can treat the built-in flash as if it has a manual mode (and in essence, manually shoot with an effect similar to Slow Sync).

Here's how:

1. **Choose M on the mode dial.**

2. **Meter the scene by pressing the shutter button halfway.**

3. **Set ISO, aperture, and shutter speed to expose the background nicely.**

 Look carefully at the scene on the monitor or through the viewfinder. If the background is too dark, change the exposure controls to brighten it. If the background's too light, reduce the exposure.

 Make sure you have a shutter speed that's fast enough so you can hold the camera without shaking.

4. **Take a test shot and review it.**

 Look to see if the background is nice and the exposure is correct. If not, go back to Step 3 and make adjustments.

5. **Press the flash button.**

6. **Fire a test shot with your subject in view.**

 Ignore what the EV scale says. This shot serves as the baseline flash-strength shot. You will surely need to adjust it.

7. **Review the photo to evaluate the foreground exposure.**

 If it's too strong, reduce flash compensation. If it isn't strong enough, increase it.

8. **Pat yourself on the back and take the final photo.**

 If the exposure looks nicely balanced, you have the information you need to take flash photos in this situation with brighter backgrounds and nicely lit, natural-looking subjects. Unless the lighting or your distance to the subject changes dramatically, you can keep taking photos without changing any of the controls.

Flash bracketing

Bracketing is clearly a priority with the A65/A77. Because it means taking three separate photos with different exposure settings, flash bracketing is more like exposure bracketing than white balance or DRO bracketing. In this case, the difference is flash strength.

Flash bracketing uses the same procedures as exposure bracketing (see the section on exposure bracketing earlier). There are, however, two main differences:

- **Pop the flash:** Press the Drive button and choose exposure bracketing, but then pop the flash. The camera knows to change the amount of light the flash provides instead of changing the exposure settings.

- **Single shots:** Regardless of whether you've chosen Continuous or Single Bracketing, you have to press the shutter button for each photo of a flash bracket. This gives the flash a chance to recharge.

Designing with Focus and Color

*P*hotography is a whole lot of fun for so many different reasons. By using focus and color, you can create photos that match your ever-expanding vision. In this chapter you see how to use different aspects of the A65/A77's autofocus and how to shrink or expand a shot's depth of field. You read about light and how it affects the appearance of photos, as well has how to correct that by setting the white balance. You delve into Creative Styles, which are processing options built right into your camera. Finally, you read about color space, which are color profiles embedded into JPEGs that tell things how to display the colors correctly.

That's a lot. It's fun. It's important. When you begin to experiment with focus and color, you expand your horizons as a photographer into new and exciting territory. Have fun!

Getting Autofocus to Behave

Autofocus can sometimes act like an unruly puppy. You have to be able to control it to get the most out of it. Don't let the technical nature of these sections scare you off. It can be a bit dry sometimes. However, there's no substitute for being able to focus on

what you want. To ensure that you get what you want out of autofocus, you must know about the different options and how to use them.

Chapter 11 has more information on some of the brainier autofocus functions that only the A77 has.

Understanding AF indicators

Your camera tells you what's happening as it focuses. Look for the AF indicator in the bottom left display, as shown in Figure 8-1, in addition to the green AF area indicators (which tell you focus is confirmed in those areas). The focus indicator at the bottom left of the screen signifies the current focus status. Check out Table 8-1.

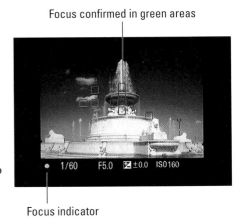

Focus confirmed in green areas

Focus indicator

Figure 8-1: The green dot and green squares tell you that auto focus has been successful.

Table 8-1	Autofocus Indicators	
Icon	*What It Means*	*Explanation*
●	Focused and ready	Lit, steady, and accompanied by a beep. The areas used to focus turn green; others disappear. Face detection frames in focus are green. You're good to shoot.
((●))	Focused and tracking	Lit and steady. Arcs appear around it. Focus is confirmed, but not locked. No beep, but the AF area turns green and follows the target as long as the camera has it locked. You're good to shoot.
()	Tracking but not focused	The indicator isn't on but the arcs are lit. The camera is trying to focus on a moving subject. You can't take a photo until the camera focuses.
—	Focus failure	Flashing (or absent) green light means the camera can't focus. You can't take a photo. Release the shutter button and try again.

Changing Autofocus mode

When your subject has as much get-up-and-go as my three boys, the AF system has to constantly update the focus. But you don't need to constantly update the focus for a potted plant. It's not going anywhere. In fact, if the AF system keeps trying to refocus on it, it might lock on one part for a moment and then choose a different part. You don't want that.

AF modes

Autofocus modes to the rescue. The autofocus system has two modes for different types of subject behavior, and it has a smart mode that can figure things out on its own. Change among them to keep up to speed with what you're shooting. Table 8-2 explains the modes.

Table 8-2	Autofocus Modes	
Mode Name	*Explanation*	*Best Use*
Single-shot AF (AF-S)	Focus is locked when you keep the shutter button pressed halfway. If you release the shutter button, the camera refocuses when you press it again. Focus also locks when you press the AF button.	Still shots, close-ups, portraits, and landscapes
Continuous AF (AF-C)	Focused when you press the shutter button halfway; keeps updating focus. Focus-lock doesn't work in AF-C mode when you use the shutter button. Switch to AF-A, AF-C, or Manual focus if you need to lock the focus.	Sports and action
Automatic AF (AF-A)	Switches between AF-S and AF-C, depending on motion.	General-purpose

The default AF mode for the advanced still photo exposure modes is Automatic AF (Movie is Continuous AF). You have to change it yourself if you want to use a different mode. The mode varies when you're in a basic shooting mode. For example, when you set Scene to Sports Action, the mode is automatically set to AF-C. However, for Auto mode the setting's AF-A.

Changing AF modes

To change the A65's AF mode, follow these steps:

1. **Press the Function button.**

2. **Highlight AF mode and press the enter button.**

3. **Use the up or down buttons to select the AF mode.**

 Choose between AF-S, AF-C, or AF-A.

4. **Press the enter button to exit.**

To change AF modes on the A77, change the focus mode dial. (It's on the front of the camera beneath the lens release button.) Choose between M (manual), AF-C, AF-A, or AF-S.

Selecting AF areas

It can be frustrating when you want the camera to focus on one part of the scene and it somehow feels compelled to focus on another. You can stop that by changing how the camera decides on which AF area to use. You can go so far as to have the camera focus on one of 15 (A65) or 19 (A77) areas.

Table 8-3 reveals the focus area modes. Astute readers (that means you) will recognize that there is no difference between choosing Spot and using Local with the center AF area selected. Figure 8-2 compares the different areas.

Table 8-3	AF Modes	
Name	*Description*	*Best Use*
Wide	The camera chooses an AF area and uses it to focus.	Best all-around AF area (unless you're getting bad results).
Zone	You activate a zone (left, center, or right) and then the camera chooses a specific AF area within the zone when focusing.	Very good for many purposes. You have more control than Wide mode but aren't locked to a single AF area, like you are in Spot and Local.
Spot	Locks the AF area to the center area. Spot is great for shots where your subject will reliably be in the center of the frame.	Static close-ups, some action shots. (Focus on the player under the center AF area; Spot keeps the other players from stealing the AF when they're closer.)
Local	Your subject can be in a number of places in the frame and good focus can be had. The A77 has more zones to choose from (19 total: 8 linear, 11 cross) than the A65 (15 total: 12 linear, 3 cross).	Precise control over which of the AF areas the camera uses. Keep the camera from focusing on part of the frame. (Shooting through a fence is an example. Choose an AF area on your subject, not the fence.)

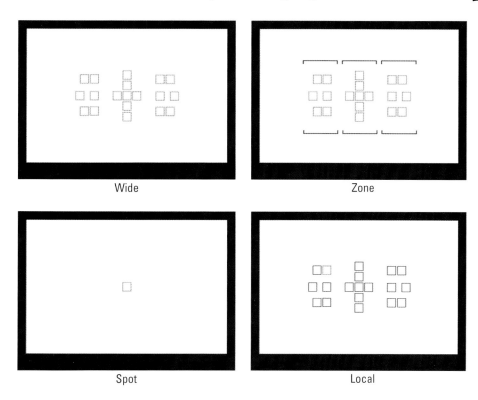

Figure 8-2: Comparing the four different focus area modes on the A77.

To change the AF area, follow these steps:

1. **Press the Function button.**
2. **Highlight AF area and press the enter button.**
3. **Use the up or down buttons to select the AF area of your choice.**

 Choose between Wide, Zone, Spot, or Local.
4. **Press the enter button to exit.**

5. If you chose Local or Zone, choose a specific AF area.

- *You're using Local:* The AF area setup screen appears like the one labeled Local in Figure 8-3. Use the left, right, up, or down buttons to choose a different AF area. The selected area is a bright orange box.

- *You're using Zone:* Select one of the three zones. (See Figure 8-3 again, which shows the A65's areas.)

Go back to the Local area or Zone setup screen later by pressing the AF button. In Wide and Spot modes, the AF button autofocuses.

6. Focus and shoot.

- *You're using Wide:* Point and shoot.

- *You're using Zone:* Place the subject within the region you selected and press the Shutter button halfway to focus.

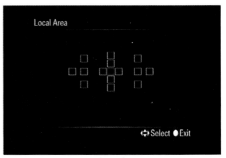

Local

Zone

Figure 8-3: Selecting a specific AF area or zone.

- *You're using Spot:* Place the subject under the center AF area and press the Shutter button halfway to focus.

- *You're using Local:* Make sure you have selected the AF area you want, place the subject under the AF area and press the Shutter button halfway to focus. If necessary, change the AF area and try again.

Locking on target

If you want to creatively compose your shots and ensure the camera focuses on what you want it to, use focus-lock. Traditionally, this happens when you're taking someone's portrait. You focus on them, lock it down, and then recompose the shot so they aren't in the exact center of the photo.

Cross versus linear AF points

Although they look the same in the camera displays, the A65 and A77 have two types of AF sensors (and hence, AF areas): linear and cross. Linear sensors are oriented either vertically or horizontally. They're most effective at achieving autofocus along their orientation. If edge details in the scene aren't aligned with them, the sensor may not be able to focus. Therefore, each camera has a mixture of differently oriented linear AF sensors. Not all are oriented in the same direction.

Cross sensors are essentially two linear sensors placed at the same spot, oriented 90 degrees to each other. One is horizontal and the other is vertical. Since they cover both directions, cross sensors are much better at detecting the details that make autofocus possible.

As mentioned earlier, the A65 has 15 total AF areas, of which 3 are cross sensors. The A77 has 19 total, of which 11 are cross sensors. That means the A77 should have an easier time achieving autofocus. It should also perform better shooting moving targets and in low light.

Regardless of the camera you use, try choosing a cross sensor as your AF area when shooting in Local area mode to maximize AF performance.

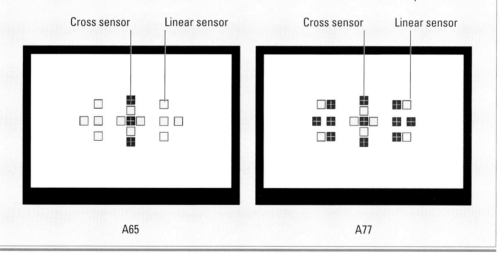

A65 A77

Pictures look better when things are balanced by the Rule of Thirds. Divide the photo into a three-by-three grid and place faces (and other subjects) along lines or at intersections.

Focus-lock doesn't work with AF-C. The feature works best when these you have a shallow depth of field resulting from any of these three scenarios:

- ✔ You've got a wide open aperture.
- ✔ You're close to the subject.
- ✔ You're zoomed in.

To use focus-lock, follow these steps:

1. **Press the Function button (A65) or check your focus mode switch (A77) to make sure you're in AF-S or AF-A mode.**

 A65: If the option to change the AF mode is grayed out (and you're not in a basic shooting mode), you're in Manual focus.

2. **Put the subject under an AF area.**

3. **Press the shutter button *halfway;* hold it there when focus is established.**

 This establishes the autofocus and meters. You'll see one or more green AF boxes light up and you'll hear a beep (unless you've turned that off): success!

 If you have trouble using the shutter button to lock the focus, try using the AF button instead. (Turn off Object Tracking first; it uses the AF button by default.) Press it now and hold it to lock the focus. In Step 5, while still holding the AF button in, press the shutter button halfway to meter, wait a moment, then press it fully to take the photo.

4. **Frame the photo.**

 This is the magic of focus-lock. While the shutter button is held halfway, the camera won't re-focus. You can compose the shot any way you wish and know that your subject is still in focus. Figure 8-4 shows my off-center but focused subject.

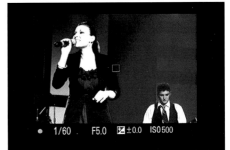

1/60 . F5.0 ☒±0.0 ISO500

Figure 8-4: Lock the focus and recompose your shot.

 You can't get away with everything, however. If you move closer or farther away from your subject and take the photo, it will be out of focus whether you locked it or not.

5. **Press the shutter button fully to take the photo.**

 Alternatively, use AF areas and select an off-center focus area. That may work better than focus-lock when the camera is on a tripod.

Using the focus magnifier

Sometimes it helps to magnify your view so you can check the focus before taking the photo. You can use focus magnifier

 ✔ As you manually focus to dial in the best focus possible.

 ✔ After you auto focus to double-check the clarity of the autofocus.

It works best when the camera is mounted on a tripod. There's very little point in magnifying the scene to check the precise focus if you're going to be moving around.

Although peaking and the focus magnifier aren't related, peaking is useful when you're manually focusing and using the focus magnifier. Chapter 10 has more information on peaking.

Enabling focus magnifier

The focus magnifier doesn't have a dedicated button and is off by default, which means you have to enable it first and assign it to a button. The best button to use is the Smart Teleconverter button, although it is not the only button that you can use.

Here's how to get the focus magnifier working:

1. **Press the Menu button.**

2. **Go to Custom menu 3.**

3. **Highlight Smart Teleconverter Button and press the enter button.**

4. **Select Focus Magnifier.**

 If it's already on and you want to turn it off, select Smart Teleconverter.

5. **Press the enter button.**

If you want to use another button, see Chapter 10 for more information on changing button functions. See Chapter 11 for more info on the smart tele-converter function.

Using focus magnifier

If you turn on focus magnifier in this way, the smart teleconverter button becomes a focus magnifier button when you're shooting. Here's how you use it:

1. **If using autofocus, press the shutter halfway to establish focus.**

 The focus magnifier works a little differently if you're using autofocus. The point is to zoom in and check the focus. You can't do anything about it, though, when zoomed in. If you press another button, the view returns to normal. You can change the AF area or switch to manual focus.

 Note: If you're focusing manually, start at Step 2.

2. **When you're ready, press the focus magnifier (smart teleconverter) button.**

 An orange frame is superimposed on the scene, as shown in Figure 8-5. The frame is the area you'll see when you press the zoom magnifier button again. I chose a sparse setting and positioned a single block back and to the left so you can see how powerful the focus magnifier is. From a distance, the block is small. You'd have little chance of successfully manually focusing on it.

Figure 8-5: Positioning the magnification frame.

3. **Use the up, down, left, and right buttons to move the frame where you want to see close up.**

4. **Press the focus magnifier (smart teleconverter) button again.**

 The image gets bigger on the LCD or in the viewfinder, as shown in Figure 8-6. Pressing the focus magnifier button again (this is the third time) increases the magnification again. Pressing the button a fourth time cycles back to the normal view, without the frame.

Figure 8-6: Zooming in.

5. **If manually focusing, adjust the focus to perfection.**

 I'm not cheating, per se, but I focused both photos in Figure 8-6 so you could see the results of the magnification better. Yours might be blurrier and won't sharpen up until this step.

6. **Press the shutter button to take the photo.**

 The view goes back to normal just before the shutter activates.

Tracking objects

Tracking a moving object and keeping it in focus can be pretty stinking hard, even with continuous autofocus and the best equipment. Luckily, the A65/A77 has a special focus mode called Object Tracking. It's very easy to use. Here's how:

1. **Choose a compatible shooting mode.**

 Valid modes are Auto, Auto+, Flash Off (A65), Scene Selection (except Hand-held Twilight), P, A, S, M, and Movie. Also, you can't use the smart teleconverter or be in Manual focus mode.

2. **Press Display to get to a display mode that has a helpful reminder.**

 - *Viewfinder:* Graphic, Display All Information.
 - *Monitor:* Graphic, Display All Information, For Viewfinder.

 Object tracking will work in any display, but you get a helpful tracking focus reminder in those displays. See Chapter 10 for more information about how to enable this display if you've somehow removed it from the rotation.

3. **When you're ready to start, press enter.**

 For A65 users, enter is the center of the control button. For A77 users, enter is the center of the multi-selector.

 You'll see a target frame, as shown in Figure 8-7.

4. **Center the target frame over the subject.**

 You have to physically point the camera to do this. Don't use the arrow buttons.

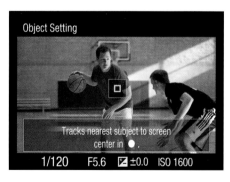

Figure 8-7: Preparing to track moving objects.

5. **Press enter to start tracking.**

The camera tracks the subject. The target frame, which becomes a double frame, moves with it. See Figure 8-8. If you have a good track, the double rectangle is white until you have established focus (in the next step), when it turns green. Otherwise, it is gray.

To cancel tracking, press enter.

If the camera has problems tracking the subject, the subject may be: moving too fast, too small or too large, not have enough contrast between the subject and the background, be too dimly lit, be on a Tuesday, and somewhere the light changed.

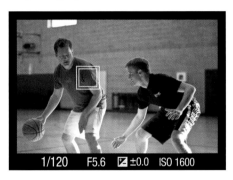

Figure 8-8: Stay on target.

Tracking stops when the subject moves out of the scene. If you're tracking a face (a moving person), the camera picks it back up and tracks it again when the person returns to the frame.

When the subject is in focus, the white rectangle automatically turns green; see Figure 8-9. One or more smaller AF areas may turn green if they come into focus.

6. **Press the shutter button fully to take the photo.**

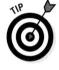

If the camera has trouble focusing, press the shutter button halfway to focus normally. Although the manual says nothing about it, this practice occasionally works.

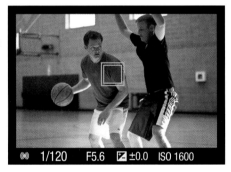

Figure 8-9: Locked on and ready to shoot.

Putting it all together

Getting good results with the autofocus system isn't hard, especially when you understand what all the modes do. Table 8-4 shows the combinations of settings that I suggest, depending on the circumstance.

Table 8-4	Suggested Mode Combinations	
Mode	*Best Use*	*Explanation*
AF-A, Wide AF, or Zone area	General purpose. Wide AF is best when your main subject isn't behind something that may grab the focus. Choose Spot or Local if the camera needs help identifying the specific subject you want from other competing objects in the scene.	Point and shoot.
AF-S, Local AF, and focus magnifier (if necessary)	For still subjects. Consider using focus magnifier, which is most effective when you're using a tripod with an inanimate subject.	Gives the most control over the autofocus system. AF-S allows focus lock, if necessary. Local AF lets you choose the AF area to use.
AF-C, your choice of AF area, or Zone area	For moving subjects.	Tracks the target. The AF area is optional. Wide AF area works if your subject is isolated or in front of everything else. Choose Zone if you are able to keep the subject in a general areas of the frame. Choose Local or Spot AF if the camera can't figure out which soccer player you want to focus on. Place the moving subject under the AF area when focusing.
Object Tracking	For moving subjects.	Greatly simplifies tracking a moving target. You identify it and the camera tracks it. Can't be used in all conditions or shooting modes.

Controlling Depth of Field

Depth of field is a complicated name that refers to a photographic effect that is very simple. It is the depth of the area that looks like it's in focus. Depth of field is an astounding, important creative component of photography. On one hand, you can have the camera take photos where most everything looks like it's in focus. Landscapes are a good example. On the other hand, you can take pictures where only a thin slice of the photo is sharp. Portraits and close-ups are good examples of this. Everything in front of and everything behind what you've focused on gets blurred — but it's not a *bad* out of focus. Depending on the lens, this area (called the *bokeh*) can be incredibly beautiful.

Figure 8-10: Focusing on the nearest object.

Figures 8-10 through 8-12 illustrate not only how thin you can make the depth of field, but that you can move it back and forth.

Figure 8-11: The depth of field is about a single-cat wide.

✔ In Figure 8-10, focus is on the black and white cat. The wooden cat to the right isn't that far away, but it's out of the depth of field. Despite this, you can make out some details of the wooden cat. The elephant in the background is almost unrecognizable.

✔ Focus is on the wooden cat in Figure 8-11. The black and white cat is now partially blurred. Remember, something can be *in front of* your prime subject and be out of the depth of field. The elephant looks like an elephant now.

Figure 8-12: Managing the depth of field by focusing on the farthest object.

✔ In Figure 8-12, the elephant looks clear but the cats are blurred. Depth of field powerfully directs your attention.

Affecting DOF

Chapter 7 talks about these DOF elements in detail. You can control three main factors that affect depth of field:

- ✔ **Aperture:** Very simply, the larger the aperture in the lens, the shallower the depth of field will be. Conversely, the smaller the aperture, the deeper the depth of field will be.

- ✔ **Focal length:** The longer the focal length, the shallower the depth of field. By comparison, shorter focal lengths create wider depths of field.

- ✔ **Distance:** Distance is the factor that everyone forgets about. When you're close to the subject, the depth of field is smaller than when you are far away.

Working with DOF

Here are some pointers for working with depth of field:

- ✔ **Use basic shooting modes:** Several of the modes optimize the camera's settings to produce either a shallow or deep depth of field. Choose the one that matches your creative vision:

 - *Shallow depth of field:* Portrait, close-up

 - *Deep depth of field:* Landscape

 See Chapter 7 for more about depth of field.

- ✔ **Or use advanced exposure modes:** Choose Manual or Aperture priority modes to gain maximum control over the depth of field.

- ✔ **Shallow and artistic:** If you're in Aperture priority mode, open the aperture up (use a low f-number) and let the camera set the shutter speed and ISO. Step close and zoom in to the subject to make the depth of field even shallower.

- ✔ **Go deep:** Set Aperture priority mode and close the aperture down (between f/8 and f/22). Use a wider-angle lens (28mm or less) and step back from the subject.

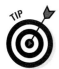

Previewing the depth of field

If you want to preview the depth of field, focus and press the preview button shown in Figure 8-13.

Believe it or not, when you look through the viewfinder or at the LCD, you often don't see what the photo will look like when you press the shutter button.

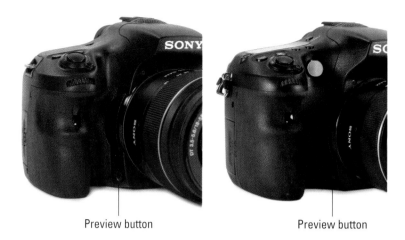

Preview button Preview button

Figure 8-13: The preview button is right under the lens.

Try this experiment to see the aperture in action (and see firsthand why you need a preview button in the first place):

1. Choose Aperture priority mode and set the aperture to something ridiculously small, like f/32.

2. Set the focal length of the 18–55mm or 16–50mm lens (or whatever you have) to around 35mm.

3. Turn the camera around and point it at your face so you can see the aperture.

4. Press the shutter button halfway so the camera meters and focuses.

5. Wait a moment.

6. As you carefully look at the lens, press the shutter button fully.

 You'll see the aperture shrink to f/32 and the camera will take the picture. The aperture stays wide open when you frame and focus your shot (see the Open label in Figure 8-14) so as much light as possible makes it into the camera for you to see. When you take the picture, the aperture shrinks according to the f-number you have it set at (see the Contracting label in Figure 8-14). That's why you don't see the same thing *before* versus after.

The effect is essentially one-way, though. What I mean is that if you have the aperture opened up as large as possible, the "before you take the photo aperture" is close to or the same as what it will be when you take the photo. In that case, what you see before you take the photo is close to what you will see in the actual photo. The lens quickly sets the aperture to the value that you (or the camera, if it's in an automatic mode) have set, which enables you to evaluate the actual depth of field. Some noise may show up in the display in dim lighting. As the aperture shrinks, the camera brightens the image so you can see what's going on. The result is noise.

Open

Contracting

Figure 8-14: The aperture changes to the actual f-number when you shoot.

Shedding Light on White Balance

Just when you thought it couldn't get any more complicated, it does. I won't blame you for completely ignoring this section if you want to. Leave the White Balance setting on Auto and control other aspects of your camera. When you need or want to start adjusting your white balance, come back here.

Brain, meet conundrum: Light and color get all tangled together. If a pure white light reflects off a white shirt, the shirt looks white. If a yellow light reflects off the same shirt, the shirt looks white to your eyes, but isn't. It's closer to yellow. Your brain works it out so things look the way they should. If they don't, you probably don't even notice it. These aren't the droids you're looking for. Your mind plays Jedi tricks on you. A white shirt, then, isn't always white. Sometimes it is bluer or greener or yellower, depending on the light. But your eyes see it, and in collusion with your brain, quite happily report, "That's a white shirt!" So it *looks the same to you,* but isn't.

Taking your color temperature

Light has a temperature, but it's not what you think. Scientists have decided that a light's *color temperature* is the surface temperature an idealized light bulb reaches when emitting light of that color. Light is energy, after all, and the light bulb heats up. (The light bulb is far more complicated that I am letting on, but my wife has prohibited me from trying to explain it. I'll just say that it's called a *black body* and it's pretend.) Someone who was probably wearing a white lab coat went to a lot of trouble and measured the color temperatures of a range of lights. The figure in this sidebar shows how they stack up, from low to high.

Notice that each color temperature is related to a temperature and has a color. That makes sense. The temperature is measured in degrees Kelvin. Hot colors are blue. Mid-range colors are light blue, white, and yellowish. Cooler colors are red. The colors are the opposite of what you would expect. We tend to think in terms of *red hot* and *cool blue*. So then, color temperature is a way of describing light. You can use the actual temperature in degrees Kelvin (or K), or name the type of light.

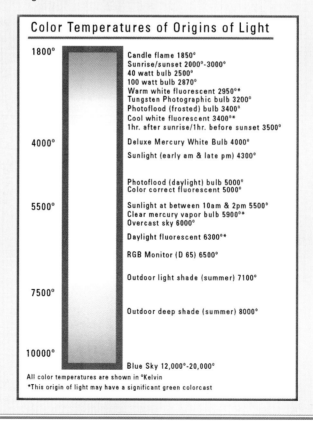

Color Temperatures of Origins of Light

1800°	Candle flame 1850° Sunrise/sunset 2000°-3000° 40 watt bulb 2500° 100 watt bulb 2870° Warm white fluorescent 2950°* Tungsten Photographic bulb 3200° Photoflood (frosted) bulb 3400° Cool white fluorescent 3400°* 1hr. after sunrise/1hr. before sunset 3500°
4000°	Deluxe Mercury White Bulb 4000° Sunlight (early am & late pm) 4300°
	Photoflood (daylight) bulb 5000° Color correct fluorescent 5000°
5500°	Sunlight at between 10am & 2pm 5500° Clear mercury vapor bulb 5900°* Overcast sky 6000°
	Daylight fluorescent 6300°*
	RGB Monitor (D 65) 6500°
	Outdoor light shade (summer) 7100°
7500°	
	Outdoor deep shade (summer) 8000°
10000°	
	Blue Sky 12,000°-20,000°

All color temperatures are shown in °Kelvin
*This origin of light may have a significant green colorcast

Your camera, for better or worse, doesn't act that way. (If it does, you should investigate it for other signs of consciousness.) Your A65/A77 might see an off-white shirt or a dingy yellow shirt. You get a dingy dose of reality when you look at your photo and see a white shirt looking very yellow. Change white balance to adjust the camera's reaction to light of different color temperatures so that the photo it records is closer to what you see with your eyes and what you expect with your mind.

Changing the white balance

Thankfully, changing the white balance on your A65/A77 is easier than reading about the science behind it. The trick is identifying the scene's actual light and setting white balance reflect that. Going from one bad setting to another isn't going to do you any good. Table 8-5 shows white balance settings.

Table 8-5		White Balance Settings
Icon	*Setting Option*	*Explanation*
AWB	AWB	Auto. The camera tries to automatically identify the light source and correct the color.
☀	Daylight	Bright light from the sun. At noon, daylight is very white and shouldn't cast any color on objects.
🏠	Shade	Bluer light than direct sunlight.
☁	Cloudy	Similar to the Shade setting.
💡	Incandescent	Bulbs with glowing filaments. These tend to be reddish, although soft white incandescent bulbs are very yellow.
▭	Fluorescent	Fluorescent lights glow with a greenish tint.
▭ –1	Fluorescent: Warm White	A fluorescent light with a warm, yellowish tint.

(continued)

Table 8-5 (continued)

Icon	Setting Option	Explanation
0	Fluorescent: Cool White	A fluorescent light that is nearly white.
+1	Fluorescent: Day White	A fluorescent light with a blue tint.
+2	Fluorescent: Daylight	A fluorescent light with a bit more blue than Day White.
WB	Flash	Use this setting if the flash is the main light source.
—	Color Temperature/ Color Filter	Color Temperature lets you choose a specific temperature. Check a light's package for color temperature. You can apply a combination of G (green), M (magenta), B (blue), or A (amber) color filters. G and M are paired, as are B and A. Choose one from either pair and strengthen by up to seven steps.
—	Color Filter	Some color casts go from green to magenta. Apply a green (G) or magenta (M) filter. Add magenta if the scene looks green, and vice versa.
	Custom	Choose Custom to set white balance to a previously measured color temperature; choose Set to record it. See the following section in this chapter.

To change the white balance, follow these steps:

1. **Select a compatible mode.**

 You can control white balance when in P, A, S, M, Sweep Panorama, 3D Sweep Panorama, Continuous Advance Priority AE, and Movie modes.

2. **Press the white balance button.**

 The White Balance screen appears.

3. **Highlight a white balance setting.**

See Figure 8-15 for an example. Your choices are explained in Table 8-5.

4. **Press enter to go back to shooting. Press the right button to make manual adjustments.**

5. **Use the directional controls to fine-tune the white balance.**

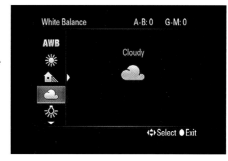

Figure 8-15: Selecting a white balance setting.

- *You chose Color Temperature/Color Filter:* Enter a new color temperature using up or down buttons. Press right again to continue to the color filter stage, which works like step 6.

- *You chose anything other than Color Temperature/ Color Filter:* The White Balance Adjustment screen appears, as shown in Figure 8-16. (Custom Setup is explained in the next section.)

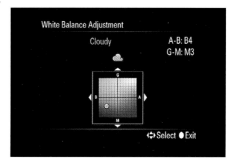

Figure 8-16: Fine-tuning white balance.

You can change the white balance the following two ways. You can adjust each setting by up to seven steps. The overall adjustment is displayed graphically as well as numerically.

- *Color temperature:* Displayed on the horizontal axis as B (blue) and amber (A). Adjust toward one or another using the left or right buttons. Go left to balance a scene that looks too yellow; go right to reduce blues.

- *Color filter:* Displayed on the vertical axis as G (green) and M (magenta). Adjust toward one or another using the up or down buttons. Go up to add green or remove magenta; go down to do the opposite.

 Which dial(s) you use depends on which camera you are using:

- A65: The front control dial moves the setting up or down.

- A77: Use both control dials to make adjustments. The front dial controls the vertical and the rear dial controls the horizontal.

6. **Press enter to exit.**

Creating a custom white balance setting

Creating a custom white balance setting is a good idea if you're working with JPEGs but not with Raw files. (It's easy to correct color imbalances in Raw files during processing.) Once the JPEG is created and saved by the camera, however, color problems are harder to solve without affecting other aspects of the photo.

The truth is, setting a custom white balance isn't a bad idea anytime you're working in a location where you plan on taking lots of photos. Yes, even if you're saving Raw files (in addition to or in place of JPEGs). You'll save yourself a lot of processing time by getting the white balance right the first time.

It's pretty easy to do. Here's how:

1. **Select a compatible mode.**

 You can set a custom white balance in P, A, S, M, Sweep Panorama, 3D Sweep Panorama, Continuous Advance Priority AE, and Movie modes.

2. **Press the white balance button.**

3. **Highlight Custom Setup, as shown in Figure 8-17.**

 Don't confuse this with Custom, which is right above it. That option puts you in a display similar to the White Balance Adjustment screen.

4. **Press the enter button.**

 The camera is ready, as in Figure 8-18.

5. **Frame the scene to fill the center AF area with something white.**

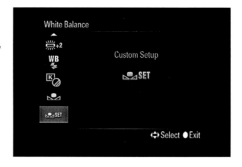

Figure 8-17: Preparing to set a custom white balance.

 Don't worry how it looks. You aren't going to submit this photo to *National Geographic.*

6. **Press the shutter button fully.**

 You will hear the shutter opening and closing, and a moment later the measured color temperature and color filter appear. See Figure 8-18.

7. Press the enter button (A65) or select a register number and press the enter button (A77).

White balance is set to the custom value you just measured. The A77 can save up to three settings. The A65 can save only the last measured value.

8. Take your pictures.

The camera holds onto the white balance setting until you change the setting. To recall this setting, choose Custom White Balance setting (rather than setting it).

Camera ready

Shooting white balance brackets

If you're not sure about the correct white balance and want to be able to choose from a few options, rather than shooting them one at a time, try shooting *white balance brackets.* You take one photo and the camera puts in all the work of processing the photo three times: two with different white balances, and one with the white balance you chose.

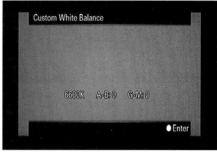
Measured color temperature

Figure 8-18: Have something white handy to measure with.

Here's how it works:

1. Select a compatible shooting mode.

You can shoot white balance brackets in P, A, S, or M.

2. Select a white balance that you think matches the scene.

You can choose Auto if you like, but then you have no idea where the camera is starting from.

3. Press the drive button.

4. Press the up or down buttons to highlight White Balance Bracket.

5. Press the left or right buttons to select Lo or High.

The camera can change the color temperature by a little or a lot, depending on which you choose.

6. Press enter to return to shooting.

7. Focus, frame, and shoot.

The camera takes one photo and processes it with three different temperatures, saving the result as three JPEG files. Figure 8-19 shows a result. In this example you can see three distinctly different outcomes. One is blue, one is natural-looking, and one is yellow. You may see three different shades, depending on your white balance setting and the lighting. The point is, you can go into it without knowing the perfect white balance setting. The camera gives you a few options to choose from.

Figure 8-19: Process three; choose the best one.

Using Creative Styles

Creative styles are a type of in-camera processing option. I love them because they make it possible to creatively push photos in different directions without having to be a photo-retouching expert. Figure 8-20 shows four of the more obviously different creative styles applied to a scene involving a pineapple we recently bought, a sponge I had laying around, a sand dollar, a few small vases my wife loves, and a fish I carved when I was a boy. Table 8-6 summarizes all of the creative styles.

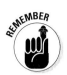

Creative styles are available in all the advanced exposure modes (P, A, S, and M), as well as in Sweep Panorama, 3D Sweep Panorama, Continuous Advance Exposure AE, and Movie modes. The processing is applied to the Raw data and saved as a JPEG.

Table 8-6		Creative Styles
Name	*Model*	*Description*
Standard	A65/A77	Your basic photo. Optimized for good all-round appearance. Not bad at all.
Vivid	A65/A77	Increases the saturation and contrast to add pop.
Portrait	A65/A77	Presents people in softer light by reducing sharpness.
Landscape	A65/A77	Elevates saturation, contrast, and sharpness.
Sunset	A65/A77	Use when you're shooting into or in the sunset. This style emphasizes the red-orange colors.
Black & White	A65/A77	Desaturates the image to present a classic black and white photo.
Neutral	A77	Toned down compared to standard. Use if you plan on processing with software.
Clear	A77	Captures transparent colors in bright areas. Good for lights.
Deep	A77	Colorful and solid.
Light	A77	Bright and airy.
Night Scene	A77	Tones down contrast to make night scenes more realistic.
Autumn leaves	A77	Saturates reds and yellows.
Sepia	A77	Applies an old-school tint to a black and white photo.

Standard

Vivid

Black & White

Sepia

Figure 8-20: Who lives in a pineapple under the sea?

Selecting a style

Selecting a creative style is easy. Here's how you do it:

1. **Enter an appropriate shooting mode.**

 You can use creative styles in the following modes: P, A, S, M, Sweep Panorama, 3D Sweep Panorama, Continuous Advance Exposure AE, and Movie.

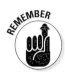

 You can't use a creative style *and* a picture effect at the same time. When you choose a picture effect, the creative style is automatically set to Standard. See Chapter 11 for picture effects information.

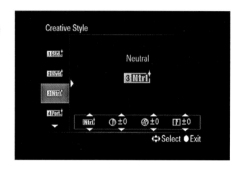

Figure 8-21: We've got style, yes we do.

2. **Press the Function button.**

3. **Highlight Creative Style and press the enter button.**

4. **Press up or down to select a style on the left. See Figure 8-21.**

 Or spin the control dial.

 A77 users: You have access to more styles than the A65, but you're still limited to six active styles in the list on the left side of the screen. To change which styles are listed, highlight the style you want to swap out and press right with the multi-selector; see Figure 8-22. Additional styles become active at the bottom of the screen, next to the contrast, saturation, and sharpness parameters. Scroll up and down to select the replacement (see Figure 8-22). Press enter to exit.

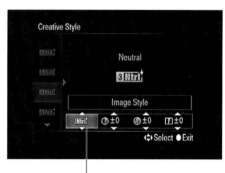

Additional style

5. **Press the enter button to lock the change in and return to shooting.**

 Press the Function button to go back to the function display and make more changes.

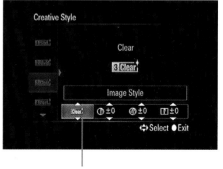

Additional style

Figure 8-22: Swapping out a style on the A77.

Fine-tuning style

When you're selecting a creative style, keep these moves in mind:

⮕ Press the right button to go to the three parameters. A77 users: The three parameters are beside the extra styles. Don't get confused by this. Contrast, the first tweakable parameter, is the second item from the left. A65 users will simply see the three parameters: contrast, saturation, and sharpness.

⮕ Press up or down to increase or decrease the setting, up to three steps.

⮕ Press right or left to switch between the parameters.

⮕ Press the enter button to return to shooting.

Figure 8-23: Customizing individual style parameters is for serious control freaks.

You can alter a style when you select it, as shown in Figure 8-23. A creative style has three tweakable parameters.

Contrast

Increasing contrast strengthens the difference between shadows and highlights in a photo. (Think bright, sunny day with deep shadows.) Decreasing contrast reduces this distinction, resulting in a mid-tone–heavy photo. (Think foggy day with no shadows.)

⮕ To increase a photo's overall impact, increase contrast. Be careful of increasing it so much that you turn highlights white and shadows black. In that case, you lose precious detail.

⮕ To mellow or age a photo, decrease contrast. Try decreasing contrast when shooting a naturally high-contrast scene. This rescues details that might be lost.

Saturation

Increasing saturation strengthens the colors. (Turn up the heat, baby.) Decreasing saturation removes the color from a photo, subduing it.

- ✔ To mimic an aged color photo, decrease saturation.
- ✔ To add pizzazz, increase saturation.

Sharpness

As a whole, sharpness adjustments aren't as visible as the other two unless you zoom in or enlarge the photo. Chapter 10 has a few examples of photos with increased sharpness.

- ✔ Increase sharpness to add definition to a photo.
- ✔ Decrease sharpness to reduce definition.

Color Space Wars: sRGB versus Adobe RGB

Lots has been written about the differences between the sRGB and Adobe RGB color spaces and which one you should assign to photos. To be honest, it's mostly a bunch of hooey.

Choose sRGB and don't worry about it. Check out the sidebar if you need a bit more convincing (or you're the really curious type).

Ultimately, you have to choose between color spaces based on this criteria:

- ✔ **Compatibility:** sRGB is compatible with everything you'll likely view, edit, or print your photos on.
- ✔ **Range:** AdobeRGB defines a wider color space and is technically better than sRGB, but there's no guarantee you'll ever be able to see it reproduced.

It breaks my heart to tell you this, because if there was ever someone who wanted things to work "right," it's me, but you should choose sRGB and feel good about it. The relative difference isn't so large that you throw up when you see an sRGB-defined photo. You've been seeing them for years. (If you shoot Raw photos, ignore all this until you decide to process and save your file as a TIFF or JPEG. Then you have to assign a color profile. Choose wisely.)

RGB wars

Being able to choose a color space is like giving you the option of choosing between putting a DVD disc in a DVD player or a Blu-ray disc in a DVD player. The DVD will work, despite being technically inferior to the Blu-ray disc, but the Blu-ray disc won't work. So, whatcha going to choose? The DVD. Still not convinced? Okay, I'll keep going.

Your eyes, to put it mildly, can perceive an incredibly large number of colors. By itself, that's no big deal. By charting those colors on a two-dimensional graph known as a CIE x,y Chromaticity Chart (see the figure) you see reds, greens, blues, and the colors that connect them (at one luminosity; it is actually far more complicated than this). This is the big enchilada. It's the most we can see.

When you introduce computers and other digital devices, however, it gets messy. There have to be ways to map the world's colors into a system that can be read and understood not by humans, but by the technologies that we use. (That's a sly way of defining a *color space*.) That way, when you photograph a red banner, it looks red on the back of the camera or computer monitor. A color space translates between color data in a photo and the device you're looking at to produce the colors that you expect.

Here's the problem: sRGB and AdobeRGB are both inadequate to the task at hand. Neither can describe the entire color space that we can see with our eyes (in fact, none that we have invented to so far). The accompanying figure illustrates this. Each color space is a subset of the total color space that we can see.

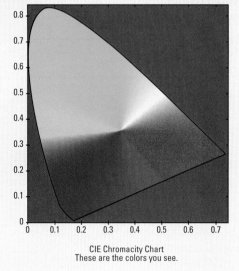

CIE Chromacity Chart
These are the colors you see.

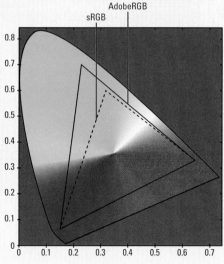

These are the colors each
color space can represent.

Now, it infuriates people who want things perfect that sRGB does a worse job of defining colors than AdobeRGB. It does. There's no contest when you look at the chart. However, due to the mysterious way the world works, sRGB has become the de facto color space standard. It's ubiquitous. In fact, what makes it so powerful is that devices that have no color management capabilities at all assume everything is defined in sRGB and reproduce sRGB photos perfectly.

The problem with using AdobeRGB is that you can't guarantee that any device you send your photo to will reproduce the colors that have been assigned correctly. When you see JPEGs with embedded AdobeRGB color spaces on web browsers that *don't* read the color space or render it correctly look odd (at best) and possibly really goofy.

Despite everything I've said, I encourage you to experiment with color space if you want. To change the color space, follow these steps:

1. **Press the Menu button.**

 Interestingly enough, you can change the Color Space in any shooting mode.

2. **Go to Still Shooting menu 2.**

3. **Highlight Color Space and press the enter button.**

4. **Use the up or down buttons to select an option.**

5. **Press the enter button to make the change.**

Cooking Up Picture-Perfect Recipes

In This Chapter

- Shooting great portraits
- Capturing breathtaking landscapes
- Freezing sports and action
- Shooting close-ups
- Trying out High Dynamic Range (HDR) photography

The more you know about your A65/A77, the more you'll want to move away from the more automatic modes. You'll want to set the controls yourself — things like aperture to blur the background and shutter speed to capture action without blurring. When you make your own creative decisions, your photos may get worse. Don't worry. With practice, they'll get better again. This chapter — as well as Chapters 7 and 8 — helps make the transition as easy as possible.

Solid Settings for all Occasions

It pays to know what settings you should use in general situations. Table 9-1 has setting , when you should change them, and the chapter that has more detailed information. You can get to some of the settings by pressing a dedicated button (for example, the Drive button), you also can change the shooting functions by pressing the Function button. Some settings, such as image quality, can only be changed from the menu system.

Use these recipes for taking good photos in any situation. Try them out and learn when and where to break the rules. The rest of the chapter talks about how best to shoot specific types of subjects.

Table 9-1	Settings Cheat Sheet	
Option	**Recommended Setting**	**See This Chapter**
Exposure mode	A, S, or M	2
Quality	Fine, Extra Fine, or Raw+JPEG	2
Size	Large	2
Flash mode	As required	2
Drive mode	Action photos, Continuous (Hi or Lo)	2
	Others, Single	
AF mode	General purpose, AF-A	8
	Still subjects, AF-S	
	Moving subjects, AF-C	
AF area	Still subjects, Local	8
	Moving subjects, Zone or Wide	
ISO	Generally, 50–400 (A77)/100–400 (A65)	7
	Auto in low light	
White balance	Auto	8
DRO	Auto	7
Picture Style	Standard	2
Face Detection	On, although optional	2
Smile Shutter	Off	2
Object tracking	On for action	8
Metering mode	Multi-segment	7

The settings appear on the camera several ways. Figures 9-1 and 9-2 show two variations. Figure 9-1 is the recording information display that shows up on the back of the camera when you've configured it for live view. Figure 9-2 shows the same information when the camera is configured for viewfinder. It appears on the LCD when you are not looking through the viewfinder.

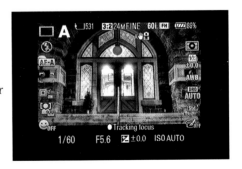

Figure 9-1: Settings via live view.

Both displays show the same information, formatted differently.

Astute observers will notice that P mode is missing from the table. The problem with P (program auto) is that you don't get to choose a specific aperture or shutter speed. As such, it's not a bad automatic mode if you want to control aspects of the camera, such as the white balance or metering mode, but leave the exposure decisions to the camera.

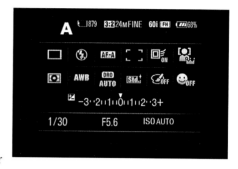

Figure 9-2: An optional display for the monitor.

Developing a Shooting Strategy

Successful photo shoots (even if you're just planning on a walk down the street) depend, in part, on good preparation. The worst time to deal with confusion, dead batteries, or an incorrect set up is when you're trying to take pictures.

What's more, having a pre-shooting strategy routine will keep you from missing settings that you've changed and then forgot to change back.

Prepare beforehand

Commit some prep time to the following *before* you go out with your camera:

- ✔ *Battery:* Batteries are the life blood of digital SLRs, and these cameras really eat up batteries, especially if you're using the monitor a lot. Unfortunately, you can't pop into the corner convenience store to buy more. You have to be prepared.

 Buy more than one battery if you shoot a lot. Maybe several. Always have one in the charger so you can pop a fresh battery in the camera at a moment's notice. If you go on a trip, take the charger(s) with you. If you're using an external flash, take extra batteries with you.

- ✔ *Lenses:* Clean your lens before packing up. Don't wait until you're on location where it might be windy, dusty, or wet. Make sure the lens caps (front and rear, if applicable) are on securely.

- ✔ *Memory cards:* Have at least one backup. If you're going to shoot a lot, especially rapid-fire continuous shooting or brackets for High Dynamic Range Photography, buy more than one extra. Make sure all photos and

movies are transferred to your computer, then format the memory cards using your camera before you pack them up.

If you shoot movies, consider buying several extra cards. You may even want to keep photos on a separate card than your HD movies.

✔ *Camera settings:* It's frustrating when you've got the camera set up to shoot action shots one day and accidentally leave things that way when you go out to shoot landscapes. It's even more frustrating when your camera's set up to save Standard JPEGs and you find out too late that you forgot to change that to Raw+J.

Reset the main functions to their defaults by going to Setup menu 3 and choosing the Initialize option. Once you do that, change the settings that you prefer to customize one at a time. For example, you might reset everything and then change the Image Size and Quality options from their default of Large/Fine to Raw+J (for Raw plus JPEG).

✔ *Packing list:* Whether you have an actual list or not, know what goes in your camera bag and check that everything is there before you leave.

✔ *Set goals:* Have a good general idea of what you want to accomplish. Categorize these ideas into camera-oriented groupings like wide-angle landscapes, the sunset, close-ups, action shots, portraits, or casual shots of the family.

Double-check battery level and memory card

Getting to where you want to take photos may mean stepping outside where you live or driving across town. When you're there,

✔ Get your camera out.

✔ Put the lens on (if necessary).

✔ Make any other connections (such as flash or tripod).

✔ Power on.

✔ Check the battery power (so you don't immediately have to swap out).

✔ Make sure your memory card is empty and ready for action. (But you did this before you left home, right?)

If you get to your shoot location and photos are on the memory card, replace it with one you know has been emptied. This is especially important if you've mounted the camera on a tripod. Although the battery/memory card cover is to the side of the tripod receptacle, it's a hassle to change memory cards when the camera is mounted on a tripod.

Establish specific goals for the shoot

Now that you are on location, take the general ideas you developed earlier and get specific. The following questions are examples of what you might ask yourself:

- What about this event or location do you want to showcase?
- What angle looks best?
- Where is the light coming from?
- Is focusing going to be a challenge?

Set the mode dial and main exposure parameter

The first camera-related decision you need to make is what exposure mode to use. Refer back to Table 9-1 and the following sections for help choosing.

- If you entered A priority mode, choose an aperture now and set it using the Main dial.
- If you entered S priority mode, choose a shutter speed and set it now.

After you meter the scene, you can change settings if the camera can't take the photo.

Configure the camera

Set the Mode dial first. (If you're in an Auto mode, some of these options aren't available.)

1. **Run through the menus by pressing Menu.**

 You can't change these menu items anywhere else. Although these options (shown in Figure 9-3) aren't the only changes you can make now, they do impact the photo:

 Figure 9-3: Check to make sure you have menu options set up.

 - *Image Parameters:* Choose image size, quality, and aspect ratio.

 - *SteadyShot:* Make sure SteadyShot is on if shooting handheld. You can turn it off if you're using a tripod.

 - *Noise Reduction:* If you want to disable long exposure or high ISO noise reduction, so do now.

2. **Check the functions by pressing the function button.**

You may already know if you want to change settings. For example, you may want to change Drive from Single Shooting to Continuous Shooting. If so, do that now. The names of the functions appear beside them when you have selected an option in that column. Figure 9-4 shows the functions in the right and left columns. (Each column is shown or hidden depending on the function you have highlighted.)

Figure 9-4: Changing settings via the function button.

3. **Choose a display mode by pressing the Display button.**

4. **If you know you want to use the built-in flash, pop it now.**

5. **Confirm your focus mode.**

> *Auto:* Set the focus mode switch on the lens and camera to Auto. A77 users should use the focus mode switch on the camera to select a specific autofocus mode: AF-A, AF-C, or AF-S.

> *Manual:* Use the focus switch on the lens (if you have one) to choose manual focus. Leave the camera on Auto. If your lens lacks this switch, use the one on the front of the camera.

Meter and autofocus

Press the shutter button halfway to initiate metering and establish autofocus. Don't stab at the button — press it smoothly. Practice a bit to know what halfway feels like, and how much more pressure causes the camera to take a photo. If you're focusing manually, use the focus ring.

If you use a remote shutter release, it will feel different than the camera. Know your equipment and what to expect.

Compose the scene

Zoom in or out, if necessary. Look through the viewfinder or at the LCD screen and frame the scene. Remember to focus before this step. Otherwise, you'll be looking at blobs and vague shapes. You want to see what you're seeing, even if you have to refocus after. If you have a zoom lens, use the ring to zoom in or out. If not, physically move toward or away from your subject.

Adjust exposure and shoot

At this point you need to:

1. **Make any changes to the main exposure settings.**

 Those settings include ISO, shutter speed, and aperture.

2. **Press the shutter button fully to take the photo.**

3. **Press the playback button to review your photo.**

 Check to see that it's in focus, well-lit, and framed the way you want it. If necessary, use the zoom in or zoom out buttons to look closely at the photo, and the left, right, up, or down buttons to pan.

Correct problems

Correcting problems is an important step. If you identify problems when you review a shot, make the changes to the camera (if possible) to correct them.

You're looking to solve these general issues:

- Composition: level, even, as planned.
- Exposure: good, with details, or as intended.
- Focus: sharp most often, unless you're after a blur.
- Subject-related: eyes are open, looking at the camera.

For example, you may be taking a portrait of someone with strong back-lighting. If you left the metering mode set to Multi-segment, the light may overpower the person's face and leave them in shadow. Change the metering mode to Center Weighted or Spot to see if you can get the camera to correctly expose their face. You may also need to use the exposure compensation button, or change the flash intensity by using flash compensation. If the problem lies with you, such as a tilted photo, note what you did and correct it in the next photo.

Popping Out Portraits

If you're like me, you love taking photos of your family, friends, and pets. This section is full of information that will help you shoot nice portraits versus casual snapshots.

A *portrait* is a photo where the subject takes center stage. In other words, the subject dominates the frame and is the reason you're taking the photo. The setting may be casual or formal, and the photo may be planned or taken at the spur of the moment. Additionally, portraits separate the subject from the background by purposefully softening the background while keeping the subject in sharp focus.

Portrait shooting is one of the most rewarding aspects of photography because they tend to picture us at our best. The A65/A77 has a few automatic modes that you can use to take portraits: Auto+, Auto, and Portrait. At night, try the Night Portrait scene.

Trade tips

Figure 9-5 shows a nice portrait of my wife standing in front of the back fence. This photo represents what you want out of a portrait:

- It's staged, but not too formal.
- The subject is well lit and sharply focused.
- The background is pleasingly blurred.
- The noise level is very low.

Although shooting portraits is relatively easy, you might benefit from these pointers when shooting in Portrait mode:

- **Get close:** Don't be afraid to zoom in. You don't have to do this for every photo, but it places the focus of attention squarely on the subject and removes distractions.

- **Vary your height:** When photographing kids, kneel down and get on their level. The same thing goes for pets.

Figure 9-5: Portraits bring out the best of people.

- **Flash:** Don't forget about the flash, especially when taking photos outside during the day. Yes, during the day. Set the Flash mode to Fill Flash to brighten people's faces and remove shadows. If the flash seems too bright, dial it down with flash compensation; see Chapter 7. On an A77, use manual flash mode; see Chapter 11.

✔ **Background:** What's happening in the background? Nothing ruins a good portrait faster than a messy room, power lines, or other distractions. If working inside is too restrictive, go outside and stand your subject in front of a nice bush, fence, or take them to the park. The possibilities are endless.

Shooting manually

In Figure 9-5, the camera was set to Aperture mode and the aperture was set to f/3.2. (I used the very nice Carl Zeiss 24–70mm f/2.8 lens). The combination of the wide aperture, the distance to the fence, and the focal length (70mm) takes the fence and trees out of focus.

You'll find a number of ways and suggestions for shooting portraits. You can lean on these general principles, however:

✔ **Mode:** Set mode dial to Aperture priority. This lets you control the aperture, and therefore, the depth of field. If you want total control, choose Manual mode.

✔ **Aperture:** Dial the lowest possible f-number for the largest aperture to minimize the depth of field.

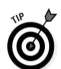

If you have a high-quality lens, with a maximum aperture of something like f/1.4, you may need to set the aperture smaller than the largest it's capable of. If you don't, the freckle on someone's face may be in focus but the hair follicle just behind it may be out of focus because the depth of field is microscopically small. If that's the case, choose something like f/2.8, f.3.2, or larger.

✔ **Focal length:** Choose a longer focal length to accentuate the subject and create a shallow depth of field. The focal length lets you stand farther back. If you're using either the 18–55mm or the 16–50mm lens, the most you have is 55/50mm. That's not ideal, but it isn't terrible, either.

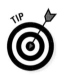

Lenses that have at least 70mm are more suited to portraits, and some photographers like using 85mm to 105mm lenses.

✔ **Background:** If you've set a reasonably low f-number, the background will be a pleasing blur. If you want it softened even more, try zooming in, moving closer to the subject, or moving your subject away from the background.

✔ **Flash:** Whether you use the flash depends mostly on where you are.

 • *Inside:* Using the pop-up flash inside can be tricky. It can make faces too bright, cause reflections or shadows, and leave the background dark. The first image in Figure 9-6 illustrates some of these perils. First, I am very close to him, which concentrates the flash. Also, he is standing too close to a wall, which captures distracting shadows. Finally, although the exposure is decent, areas of his face are reflecting the strong flash.

The next image in Figure 9-6 illustrates that you can use the flash effectively inside. In this case, he is standing well away from the door behind him and I am, in turn, farther away from him than I was the subject in the other shot. This eliminates shadows and gives the flash some space to breathe. Although his face is bright, it isn't overpoweringly so.

To reduce flash strength, experiment with flash compensation. Dial down the strength to minimize shadows or bright spots. The third image in Figure 9-6 shows a photo taken with the flash at -1.0EV.

Too close Just right -1.0EV

Figure 9-6: Don't stand too close.

- *Outside:* If you're shooting outside, pop the flash to add fill light to faces. Figure 9-7 shows the youngster outside in front of the bushes. One of the photos was taken without the flash. Although the light is good, he appears darker than the background, almost as if he were in shadow. I took the other with the flash.

Figure 9-7: Using the flash outside often makes people look better.

Goodbye, City Life

Landscape photos can take your breath away with their color and detail. There is a sense of depth and breadth to landscape photos that snapshots of your back yard don't offer. Figure 9-8 shows a landscape shot taken on Lake St. Clair, from the Grosse Point area of Michigan.

The goal of landscape photos, barring exceptions for creative framing

Figure 9-8: Landscapes often showcase breadth, depth, or scale.

and subjects, is to emphasize the size of the scene. You do this by maximizing the depth of field. You do that by standing back from what you're photographing and using a moderately small aperture, such as f/8.

Landscapes are fun to shoot. When you go out to shoot them, keep these things in mind:

- **Time:** The time of day matters. You'll get more aesthetically pleasing results right after sunrise or an hour or so before sunset. These times are called the *golden hour* because the light is softer and prettier.

- **Direction:** Think whether you'll be shooting into, away from, or across from the sun. Direction, along with time, determines whether some of your landscape will be in shadow, silhouetted, or brightly lit.

- **Weather:** Landscapes in particular benefit from how the changing weather changes the scene. Not every season will produce a photo with the same look. Snow, rain, heat, fall colors, wind, and other factors all affect your photos in different ways.

- **Wide angle works best:** Don't zoom in when shooting landscapes. In fact, zoom out as far as you can. If you don't have a lens capable of wide angles (below 24mm or so), try sweep shooting to capture as much scenery as possible. See Chapter 3 for more on sweep panoramas.

Tripods aren't just for taking photos with long shutter speeds. This shot was taken using a tripod, and the shutter speed was quick: 1/320 second. The tripod allowed me to carefully think about how the scene was composed. Tripods also help you take steady brackets for High Dynamic Range (HDR) photography, discussed later in this chapter.

This is but one example of a scenic landscape. There are as many others as there are landscapes. If you want to use an automated mode to shoot landscapes, use Auto+, Auto, or the Landscape scene. You can also achieve good results shooting landscapes by using Sweep Shooting to photography panoramas. Exceptions exist, but keep these general tips and tricks in mind when taking landscape photos:

- **Mode:** Set the mode dial to Aperture priority or Manual priority. This gives you control over the aperture, which gives you control over the depth of field.

- **Aperture:** Set the f-number anywhere from f/8 to f/22 to create photos with a large depth of field.

- **ISO:** Rarely do you need to raise ISO when shooting landscapes. Put it at 50 (A77) or 100 (A65) and don't let it rise except when you can't set the shutter speed and aperture to the values you want.

- **Light and time:** Noon is rarely the best time to take photos outdoors. Rather, go out during the morning or evening hours. (The scene in Figure 9-9 was taken looking east as the sun was setting in the west.)

During these times, the light hits the sides of buildings and trees. Shooting away from the sun means shadows are cast away from you. The light is really nice: softer than at midday and more appealing.

Figure 9-9: The light is amazing just before sunset.

✐ **Clouds:** When possible, shoot landscapes when the skies are partly cloudy (not hazy or overcast though). Clouds make the sky more interesting, as seen in Figure 9-9. In that case, they were interesting enough to be featured in the top two-thirds of the frame.

✐ **Sunsets:** Sunsets are a subset of landscape photography. They're challenging because of the bright sun, which tends to cast everything in

Figure 9-10: Use a small aperture when shooting directly into the sun.

silhouette. Figure 9-10 shows a High Dynamic Range image of a sunset taken over the Maumee River in Ohio. I used nine exposures to capture every part of the scene with a different exposure. The shots were combined and processed so that the brightness of the sun didn't wash out the sky and details in the rest of the photo.

Regardless of whether you're shooting brackets for HDR, set the aperture very small to create the star effects shown here. (Figure 9-10 was taken at f/22.) Larger apertures make the sun look all blobby.

Give Me Park Avenue

Cityscapes, buildings, and other facets of urban life can be just as compelling as landscapes and nature. Most times, your goal should be to take photos with a good depths of field and low noise level that show off the building, city, or activity in question. Figure 9-11 shows a classic city shot of Detroit's Renaissance Center taken from several blocks away on Brush Street. The buildings in the foreground act like canyon walls as they lead your eye to the main subject. The depth of field provided by an aperture of f/8 ensures everything looks sharp and clear. The light was bright enough to allow an ISO of 100 and a shutter speed of 1/60 second — perfect for handheld photography.

Figure 9-11: Some cityscapes evoke the same feelings as landscapes.

You can use Auto, Auto+, or Landscape mode to shoot building and cities. At night, use Night View or Handheld Twilight.

You have a lot of other ways to shoot cities and buildings. Although no one recipe satisfies all circumstances, keep these tips in mind:

- **Mode:** Choose Aperture priority to control depth of field. If you're moving and can't stop to stabilize yourself (maybe you're on a downtown rail or shuttle system), select Shutter priority.

- **ISO:** As with landscapes, try to keep ISO low. ISO will climb, however, when you take photos at night and if you need to raise it due to motion in the scene. Raising ISO lets you speed up shutter speed.

- **Looking at:** When you're featuring a tall building and you're far enough away, you can shoot more or less directly at it. The building will look natural. Foreground objects, like the trees at the bottom and top right of the scene, help frame the building and give a feeling of the distance.

✔ **Looking up:** When you're close to a building, it's best to look up and live with the fact that there will be vertical distortion in the scene. In other words, the building seems to lean away from you. You can often fix these problems when they aren't too pronounced, but not with the tools Sony provides. This is more of a job for Photoshop. Figure 9-12 shows a close-up shot of the entrance to the Compuware World Headquarters building, also located in downtown Detroit. There's really no other way to photograph a tall building from this close. The recipe for shots like this is to walk up, zoom out, point up, and snap the photo.

✔ **Get out and walk:** Cities are alive. Find where the people are and get over there to take photos. Figure 9-13 shows a street scene near the Greektown Casino-Hotel in Detroit. The street is full of cars and people, going about their daily lives. They may live there, work there, or be visitors, like we were.

✔ **Night scenes:** Cities and buildings are fun to photograph at night. Choose buildings with interesting light sources, spotlights, or street

Figure 9-12: Look up to capture tall buildings.

Figure 9-13: This area is a hive of activity.

lights. Use a tripod when you can, which lets you lengthen the exposure time without blurring. Much like sunsets, use small apertures (in the order of f/22) to create star effects in bright lights.

✔ **Metering:** Be prepared to switch metering mode to Spot or Center if you're focusing on a building and the sky is interfering.

✔ **Tripod:** Use a tripod when the shutter speed is slow. Because tripods can be cumbersome to carry, feel free to shoot handheld as long as the shutter speed is above 1/30 second. (Your mileage may vary, but you get the idea.)

Freeze Frame Moments

Action shots are all about shutter speed. Your subjects are moving, sometimes rapidly, in or across your field of view, toward or away from you. No matter how you slice it, your goal is to capture moving objects quickly and clearly. Figure 9-14 is a classic sports action shot of a friend playing basketball. He's moving across my field of view. The ball is moving. His hands are moving. In order to have any chance of freezing him in place, the shutter speed has to be fast. In this case, that was 1/500 second.

Figure 9-14: Pay attention to shutter speed when capturing action.

The best two automated modes to capture action (or avoid blurring) with are Sports Action and Continuous Advance Priority. Keep these tips in mind as you take your action shots:

✔ **Mode:** Set the exposure mode to Shutter priority or Manual priority.

✔ **Shutter speed:** In general, 1/80 second is fast enough to capture some action, but you'll want to choose speeds (if you can) upwards of 1/250 to 1/500 second. On bright days with a wide aperture, you may be able to shoot at 1/1000 second or faster. Those speeds are fast enough to capture virtually anything without blurring.

✔ **ISO:** When shooting action shots, expect the ISO to climb. You may set it there yourself or rely on the ISO: Auto setting to take care of it. Figure 9-15 shows the balancing act of ISO versus shutter speed and aperture in action.

In this case, I used the 18–55mm lens, which doesn't have the best maximum aperture. As a result, I could only open it up to f/5.6. Because the singer was moving (faster than you think; even when standing still), I needed a shutter speed of 1/125 to come close to freezing her. With aperture and shutter speed set, the ISO had to rise to 1600 to get the exposure.

Getting the right exposure in situations like this is hard because of the lighting and need for fast shutter speeds. Having a *fast* lens (one with an above-average maximum aperture) is very helpful. The solution is to open your lens wide, set your shutter speed (1/500 second in this instance), and raise the ISO.

Figure 9-15: Be prepared for higher ISOs when shooting in low light with fast shutter speeds.

✔ **Brighter is better:** Because of the premium that sports and action photography place on fast shutter speeds, the brighter the scene, the better. This means you'll often find the best conditions during bright days. Figure 9-16 shows this in action. In this case, I was photographing the river using techniques appropriate to landscape photography when some people came by. I

Figure 9-16: Bright conditions enable fast shutter speeds and small apertures.

was in Manual mode and had the aperture set to f/22. At 1/250 second, the shutter speed was fast enough to capture the action.

✔ **Fast is relative:** You don't have to dial in shutter speeds of 1/2000 second or faster to catch all the action. You may want a bit of motion blur in some photos. At other times, you may want to completely freeze the action.

✔ **Not just sports:** As you can see from the photos, Shutter mode isn't just useful for sports. Photograph kids, pets, people, and anything else that's moving when you don't want excessive blurring.

✔ **Autofocus mode:** Set the AF mode to AF-C, which stands for Continuous AF, to keep the camera actively focusing for as long as you have the shutter button pressed at least halfway. This is pretty important for moving subjects.

✔ **AF area:** Zone AF area is a great way to give the camera a general region in which to look for a moving subject. You don't have to keep the area on top of the subject, as you do with Spot or Local. See Chapter 8.

✔ **Use tracking:** Experiment with tracking objects. This features takes some of the hassle out of autofocusing on moving subjects. See Chapter 8 for more on the topic.

✔ **Flash:** Use fill flash when necessary. Be aware that you'll run up against the camera's *sync speed* — the fastest you can set the shutter and use the flash. For the A65, sync speed is 1/160 second, which may not be fast enough. The A77 sync speed is 1/250 second, which is marginally better. Using the flash also limits your burst speed. Figure 9-17 is another shot of a friendly basketball game, this time taken with the flash. The shutter speed was at 1/250 second,

Figure 9-17: Fill flash limits shutter speed, but is sometimes necessary.

which was fast enough to freeze this relatively static scene. The flash balances the light coming from behind the subjects, and it also let me lower the ISO to 400.

So Close You Can Touch It

Give someone a camera and they will, sooner or later, want to stick it really close to something and take a picture. It's only natural. I do it. You do it. The question is, how should you set up the camera to take close-ups? *Close-ups* are any photo where the subject dominates the frame. You don't necessarily have to be close to what you're photographing (that's what telephoto lenses are for), but it has to appear large. Macros are a special type of close-up photos that captures an object close to life size on the camera's sensor.

Figure 9-18 shows an example of the type of close-up you might want to photograph. Nice shots that feature a product or object will help you sell your wares on sites like Etsy and eBay. They should be clear, well-lit, have minimal noise, and have an unobtrusive background.

Figure 9-18: Posed close-ups don't have to be a hassle.

You don't need a studio to take nice close-ups. I straightened up a small corner of our kitchen before lunch one day and set this horse on a rolling cart beside the stove. I didn't use extra lighting or other special studio tricks. The overhead light was on and there was light coming in from the window to the left. The one odd thing I did do was go downstairs and bring up a piece of wood paneling to put behind the cart. The yellow wall, normally very photogenic, clashed with the horse. The paneling offered better contrast.

When taking close-ups, follow these steps:

1. **Set up your camera on your tripod.**

 You need it to shoot close-ups like this because of longer shutter speed times. You don't want to blur the photo.

2. **Set your mode to Manual.**

 Manual mode gives you total control over exposure.

3. **Choose an aperture.**

 Setting a large aperture results in a shallow depth of field. At close distances, it can sometimes be too shallow. Try f/5.6 or f/8 to begin with. Adjust the aperture accordingly after taking a few test shots if the depth of field looks too shallow or not shallow enough.

4. **Set the ISO to 100 (A65) or 50 (A77) and leave it there.**

 That's your noise reduction.

 You can switch metering mode to Spot or Center, but Multi-segment works fine unless there's a big difference between the light in the room and the light on the subject.

5. **Dial in the shutter speed.**

 - Spin the control dial left to increase the exposure and move the marker to the right.

 - Spin the control dial right to decrease the exposure and move the marker to the left.

 You can configure the A77 to assign either shutter speed or aperture to use either the front or rear control dials in Manual mode. See Chapter 7.

 When it's above 0EV, the exposure is what the camera suggests. You've just set the camera up to take a photo that is generally well exposed. The next part takes a bit of practice.

6. **Pop the flash to enable fill flash.**

7. **Take a test photo.**

8. **Press the Playback button and review the photo.**

 If necessary, zoom in and then pan using the arrow buttons. Look to see if the flash is too bright. You want something that illuminates the subject but doesn't overwhelm it and create dark shadows.

9. **If necessary, press the Function button and turn flash compensation down.**

10. **Take another test photo and adjust as necessary.**

 Adjust shutter speed or flash compensation to balance the foreground with the background. The settings for Figure 9-18 ended up being 1/2 second shutter speed, f/5.6, ISO 100, and flash compensation -1.0EV. I set the tripod back from the horse and zoomed in to use the longest focal length of the 18–55mm lens, 55mm.

The best automated mode to shoot close-ups is the Macro scene. Here are some other technical pointers to consider when taking close-ups:

- **Mode:** Set mode dial to Aperture priority or Manual priority. Manual mode is helpful when shooting close-ups for fun or for an Etsy account or eBay listing.

- **Aperture:** Set the aperture low (f/5.6 or lower) to create a limited depth of field when the subject is on the same linear plane as the background. A small aperture is less important when the subject is very close to the camera and the background is farther away. Around f/8 will do nicely.

 Set the aperture very small, from f/11 to f/22, when the distance is very close and you want the depth of field to be large enough to cover your subject. Too large an aperture puts the front half of your subject in focus and makes the back half blurry.

Figure 9-19 is some grass I planted in our backyard. I go out to check it every day. You can tell from the figure that it's coming along nicely. The secret to this shot was to get down on the ground and use a wide aperture, f/5.6, for the kit lens. The aperture and close distance helped create the shallow depth of field. The fact that the camera is on the same level as the grass gives the photo depth. If you stood over it and looked down, the entire patch you took would be in focus.

Figure 9-19: The shallow depth of field makes this close-up more interesting.

- **ISO:** For handheld close-ups, expect ISO to go up so you can achieve a blur-free shot. For studio close-ups, set ISO to 100 (A65) or 50 (A77) if possible, and only raise it if you must.

- **Focus:** When possible, manually focus close-up shots. You have total control that way. Use the zoom magnifier, if necessary. However, in some situations (especially handheld) you may need to use autofocus. Switch the AF area to Spot to use the center AF area exclusively, or choose Local and set the AF area. Frame your shot by placing the precise point you want in focus under the AF area and take the photo.

If you're using the A77, you can temporarily switch to manual focus by pressing the AF/MF button or enable direct manual focus. (See Chapter 11.)

✔ **Flash:** You'll want the flash off for most close-ups. If you need extra light, turn on the overhead, go outside when it's sunny, or bring in small, inexpensive flood lamps with daylight (not soft white) bulbs. Figure 9-20 shows what happens when you use the flash on something very close:

Figure 9-20: Flash often creates terrible reflections in close-ups.

unattractive and distracting glare of the flash reflecting off the globe and back to the camera. The other photo in Figure 9-20 was taken with a wider aperture (f/5.6), high ISO (ISO 1600), a relatively slow shutter speed (1/20 second), and no flash. The depth of field is so shallow at this distance that the center of America is in focus but the northern and southern states are blurry.

✔ **Tripod:** A tripod is recommended for table-top close-ups. It frees you to set the shutter speed long enough to counter dim light and a low ISO.

✔ **Background:** The background doesn't have to be anything fancy, but it should look nice when blurred. Several of the shots throughout the book I took with a plain white background. It's great for isolating cameras and other objects. I also have a black background that produces the same effect, only from the opposite direction. Compare Figures 1-6 to 5-5. Don't feel like you always have to shoot with an official background. Be creative. Figure 9-21 is a close-up of one of a vacuum tube (12AX7 pre-amp tubes, if you're curious). I use them in my guitar amplifiers. For this scene, I put several on a bookshelf behind my desk and set up the tripod to shoot at a shallow angle. The extra tubes and the curtain in the background help make the scene. I took this at f/8, which creates a limited depth of field at this distance. Look for a similar subject-background separation in your close-ups.

Figure 9-21: Some backgrounds are right behind you.

Exploring HDR Photography

I can't show you all the ins and outs of High Dynamic Range (HDR) photography. However, I can relay enough about it so you can decide if it's something you want to try. HDR photography is very rewarding and no more difficult than the other types of photography once you get the hang of it.

HDR is a term that describes a discipline of photography that uses more than one photograph to push the light-capturing capability of the camera beyond what is possible in a single photograph. These additional photos are called *exposure brackets*. The bracketed photos are framed identically (or nearly so) but exposed differently. The most common practice is to take three photos: one underexposed, one correctly exposed, and one overexposed. That's why they are called

Underexposed Correct Overexposed
 Exposure

Figure 9-22: HDR uses exposure brackets to capture more detail than one photo can.

exposure brackets. You "bracket" the ideal exposure with other photos. Figure 9-22 shows three exposure brackets of a single scene.

After the brackets are photographed, you use special HDR software to combine them into an HDR image, which you convert to a TIFF or JPEG. That process is called *tone mapping*, and is similar in theory to converting a Raw photo into a JPEG or TIFF. You are able to make decisions using a bunch of information to distil the photo down to a format that has less information. Specifically, you're able to change the relative brightness, darkness, and detail across the scene. In the end, you end up with one photograph that was created with light captured by three or more photos. Figure 9-23 shows a finished HDR image.

Photomatix Pro (www.hdrsoft.com) is one of the leading HDR applications available today.

Technically, you can shoot HDR in Manual exposure mode by setting the aperture and then adjusting the shutter speed by regular increments. You're the one who has to make the adjustments and take the photos.

Figure 9-23: The final result is a magnificent combination of shadows and highlights: HDR.

You can also use the A65/A77's automatic exposure bracket feature. This Drive mode makes the exposure changes and takes the photos in rapid sequence if using continuous bracket. For more information on automatic exposure bracketing, please turn to Chapter 7.

Figure 9-24 illustrates another HDR example. This one was taken of a fountain enthusiastically shooting water upwards. No matter. The combined effect is as if a single photo was taken with a longer shutter speed. The water looks smooth rather than freeze frame.

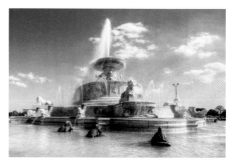

Figure 9-24: HDR is great for many types of scenes.

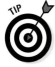

You can use the auto HDR function to create images without having to mess with more than one exposure or additional software. The A65/A77 takes multiple shots and combines them into one photo by itself. To access the option, press the D-range button and choose Auto HDR. When shooting brackets for HDR, there's no need to have the D-range optimizer on. No one will come arrest you, though, if you forget to turn it off. Similarly, you should turn off SteadyShot when using a tripod.

Dial "F" for Fun

Photography can be a lot of fun, especially if you seek out different types of photos and different ways to take them. Try these scenes and suggestions on for size.

✔ **Inside out:** I took a photograph from inside our garage, looking out. The garage door frames the scenery outside. To pull this off, I change the metering mode to Spot and keep the outside in the center of the frame. This tells the camera to make outside look good and ignore the inside.

✔ **Capturing fireworks:** Ignore exposure when shooting fireworks. Set up your camera on a tripod, connect a remote shutter release, and select Manual exposure mode. Next, lengthen the shutter speed to BULB, set the aperture to something like f/8, and the ISO to 50 (A77) or 100 (A65). Frame the shot to catch the fireworks and manually focus on infinity. Hold the shutter open before a launch, then close it after one or more fireworks. If there aren't any other bright lights or other movement in the frame, you can capture several fireworks this way in one photo.

✔ **Splash and spray:** Getting into the action makes for dynamic photos. I took a photo of the James Scott Memorial Fountain on Belle Isle, near Detroit. When shooting into the sun, keep the aperture small. This was taken at f/25, which resulted in the cool-looking lens flares. That makes the water seem even more vibrant.

Don't let the camera get too wet. A few drops won't hurt it, but dousing it may.

- **Shooting the moon:** The moon is easy to photograph if you have a telephoto lens of at least 250mm. Anything smaller isn't worth it. Set your camera up on a tripod and enter Aperture priority mode. Set the f-number to a setting your lens is sharpest at. f/8 is a good place to start. Put the ISO on 50 (A77) or 100 (A65). Change the Metering mode to Spot and center the moon to get the right exposure.

- **Reflections:** If you want beautiful, ethereal photos, look no further than your nearest body of water and photograph reflections in it. I went to a local fountain one evening to shoot moving water at sunset, only to find the water had been turned off over the weekend. After moping around a bit, I looked down and saw a gorgeous scene. I later processed it in HDR.

- **The Cocker Spaniel School of Photography:** When you're riding (not driving), roll down your window and photograph interesting objects. If you need some lead to catch your subject just right, focus through the front window. If the camera wants to focus on the glass, switch to manual focus. You have to be fast. Regardless, switch to Shutter mode and set the shutter speed to 1/500 second or faster. Open the aperture up and raise the ISO to make it possible to expose the scene properly. This shot was taken at f/5.6, 1/2000 second, and ISO 400. It's action photography, only *you're* the one moving.

 Don't take photos while you're driving.

Part IV
The Part of Tens

The 5th Wave By Rich Tennant

"Remember, when the subject comes into focus, the camera makes a beep. But that's annoying, so I set it on vibrate."

1/3 F16 ⬛ ISO100

_A_s a reader, one of the things I like the most about Parts of Tens chapters is that they're easily digested. This particular PoT shows you several easy ways to spruce up your photos using the free software that shipped with your camera, whether you're on Windows or using a Macintosh. You find techniques for correcting brightness and contrast problems, strengthening colors, removing red-eye, sharpening things up, and more. You also get an introduction to ten camera features worth investigating, from GPS to picture effects, to wireless flash and customization features.

Ten Ways to Customize Your Camera

In This Chapter

- Reworking Power Save mode
- Changing the folder-naming format
- Turning off Live View effects
- Peaking your interest
- Configuring the displays
- Changing noise reduction settings

*T*he A65 and A77 are fantastic cameras with a lot of extra features worth investigating. The material in this chapter isn't strictly necessary, but it can be very helpful and downright interesting sometimes.

By the way, this chapter makes extensive use of the enter button. It's labeled AF on the A65 and is the circular button in the center of the control button on the back of the camera. You'll also use the outer control button to go up, down, left, and right within menus and to make selections. The A77 features a multi-controller instead. Press the multi-controller in the direction suggested (left, right, up or down) to navigate and press in as the enter button.

Reconfiguring Power Save Mode

Your A65/A77 saves power by taking a coffee break every minute as long as you aren't pressing buttons. Power Save mode is written into the camera's contract, but you can renegotiate. The cost of making the camera pay attention longer is the additional drain of battery power.

To break out of Power Save mode, press the shutter button halfway.

To change the amount of time the camera waits to enter Power Save mode, follow these steps (no lawyer required):

1. **Press the Menu button and go to Setup menu 1.**

2. **Highlight the Power Save option and press enter.**

3. **Highlight the time that should pass before Power Save mode comes on.**

 These options are available:

 - 30 Min
 - 5 Min
 - 1 Min
 - 20 Sec
 - 10 Sec

 No matter what setting you choose, the camera ignores Power Save mode when it's connected to a TV or the drive mode is set to Remote Cdr. (Remote Cdr stands for Remote Commander, and is a drive mode that lets you shoot with a wireless remote.)

4. **Press enter to set the time.**

Changing the File Numbering Scheme

By default, your A65/A77 begins numbering image files at 0001 and continues until it reaches 9999. After you take your 9999th picture, the number rolls over to 0001.

You can change this behavior if you like. Here's how:

1. **Press the Menu button and go to Memory Card Tool menu 1.**

2. **Highlight File Number and press enter.**

3. **Select Series or Reset.**

✔ *Series:* Filenames are numbered from 0001 to 9999 no matter what folder they're in or how many times you remove, replace, or format the memory card.

✔ *Reset*: Resets the file number counter back to 0001 according to the following criteria:

 • When you change the folder format. (See this chapter's "Changing the Folder Naming Format.")

 • When you've deleted all the photos in the folder.

 • When you take out the memory card and replace it.

 • When you format the memory card.

4. **Press enter to finish.**

Changing the Folder Naming Format

Your A65/A75 creates folders (and then subfolders) to hold pictures. These subfolders are normally named according to the standard form naming scheme, which consists of an automatically generated 3-digit number and then the letters *MSDCF*. They look like this: 100MSDCF. When you need another subfolder, the number is simply incremented, like this: 101MSDCF.

If this naming system doesn't strike your fancy, use date form folders, which are named according to this setup:

✔ A 3-digit number

✔ The last number of the current year (Remember to set your date and time correctly, as described in the manual. Chapter 1 has information on setting your area.)

✔ A two-digit number representing the month

✔ Another two-digit number representing the day

Get out your decoder rings. This is odd because you're not used to seeing dates displayed in this format. If you took some photos on August 5, 2012, the folder name would be 10020805. The folder number is 100. The last number of the year is 2. The month and day are 08 and 05, respectively.

Movies are always stored in their own folders. MP4 movie folders are named by tacking ANV01 to a folder number. It looks like this: DCIM\MP_ROOT\100ANV01. AVCHD movies are hidden in an AVCHD folder, but the folders and files within it are best left alone.

The long and the short of it is that if you're interested in managing your photos by date on your memory card, then date form folders are for you. Here's how to make it happen:

1. **Press the Menu button and go to Memory Card Tool menu 1.**

2. **Highlight Folder Name and press enter.**

 In Figure 10-1, you can see the empty Select REC Folder field. The card had just been formatted and no photos had been taken. If you've already started taking photos, an initial 100 folder (at least) will exist when you change to date form.

3. **Select either Standard Form or Date Form.**

4. **Press enter to lock in your changes.**

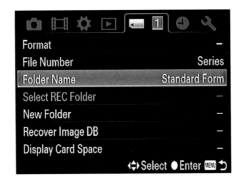
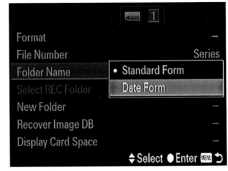

Figure 10-1: Changing the folder naming scheme.

Turning off Live View Effects

The A65/A77's electronic viewfinder gives you a great idea of what your photo will look like before you even take it. This applies to creative styles like Black and White, and to picture effects like Toy Camera. See on versus off in Figure 10-2. The camera shows you what the photo will look like, even with exposure compensation, as opposed to simply what they lens sees.

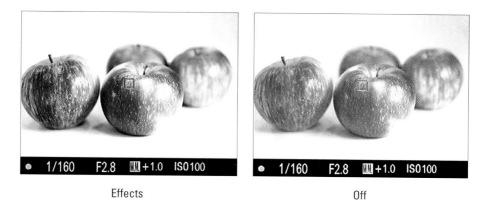

Effects Off

Figure 10-2: Seeing life with and without the rose-colored glasses.

That's good, but you may want to see the scene without any effects. To turn off effects, follow these steps:

1. **Enter a compatible shooting mode.**

 You can't turn off effects when in Auto, Auto+, Sweep Panorama, 3D Sweep Panorama, Scene Selection, or Movie mode.

2. **Press the Menu button.**

3. **Visit Custom menu 2.**

4. **Highlight Live View Display, as shown in Figure 10-3, and press the enter button.**

5. **Select Setting Effect Off.**

 If you're in Manual exposure mode, the scene may still be bright or dark, depending on the exposure settings you have set.

 Select Setting Effect On to turn Live View effects back on.

6. **Press the enter button to finish.**

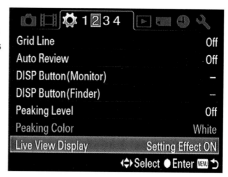

Figure 10-3: Turn off effects to see the unmodified scene.

Peeking into Peaking

Peaking is one of the more ingenious features of the A65/A77. Peaking outlines a scene's in-focus areas with a specific color. Figure 10-4 shows peaking in action. In this particular scene, I laid out a set of blocks at different distances on my photography table. I focused on the blocks in the back, which you can see are highlighted in yellow. The blocks in the foreground appear normal. Peaking is a particularly fun feature to play with, and a very helpful tool when manually focusing. You can easily visualize the depth of field with this feature.

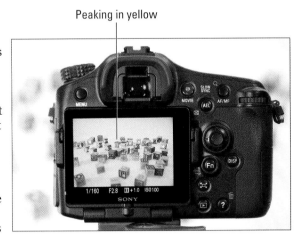

Peaking in yellow

Figure 10-4: Peaking highlights edges in focus.

To turn on peaking, follow these steps:

1. **Press the Menu button.**

2. **Go to Custom menu 2.**

3. **Highlight Peaking Level, as shown in Figure 10-5, and press the enter button.**

4. **Choose a level: High, Mid, or Low.**

 If you want to turn off peaking, choose Off.

5. **Press the enter button to finish.**

Figure 10-5: Peaking is off by default.

To change the outline color, follow these steps:

1. **Press the Menu button.**

2. **Go to Custom menu 2.**

3. **Highlight Peaking Color and press the enter button.**

4. **Select a new color: Red, Yellow, or White**

 White is the default. See Figure 10-6.

5. **Press the enter button to finish.**

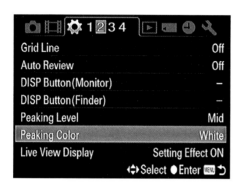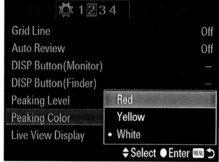

Figure 10-6: Select a peaking color that will stand out.

Displaying What You Want

By default, the A65/A77 cycles through every available display when you press the Display button. If you want to exclude some of the display modes, you've come to the right place. If that isn't cool enough, you can customize the viewfinder and monitor so they show their own unique display.

Here's how it works:

1. **Press the Menu button.**

2. **Go to Custom menu 2.**

3. **Choose a display to customize (see Figure 10-7) and press enter.**

 - *DISP Button (Monitor)* affects the LCD monitor.

 - *DISP Button (Finder)* controls the electronic viewfinder.

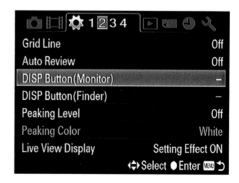

Figure 10-7: Customize the display in either the monitor or the finder.

4. **Highlight display to toggle and press enter.**

Those with checkmarks are in the rotation. Those without checkmarks do not show up when you press the Display button. For more information on each display, read Chapter 1.

Options are shown in Figure 10-8:

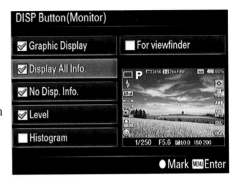

Figure 10-8: Check to view; uncheck to hide.

- *Graphic Display:* Has a graphical display of shutter speed and aperture.

- *Display All Info:* Shows all information, including shooting functions.

- *No Disp. Info:* Only displays exposure information.

- *Level:* Displays the electronic level.

- *Histogram:* Activates the brightness histogram.

- *For Viewfinder:* This special display appears on the back LCD monitor and shows the camera settings in a grid. The option is available only when you choose Display Button (Monitor).

5. **Press the Menu button to exit.**

Don't let this step trip you up. Press Menu, not the enter button.

Disabling the Head Detector

When you stick your noggin up by the camera, the eyepiece sensors (see Chapter 1) detect your presence and shift the display from the LCD monitor up into the viewfinder. As usual, there are times when this is convenient, and there are times when it isn't. The inconvenient times tend to occur if you're a viewfinder aficionado and don't want the camera always switching the display to the LCD when you back your head off a bit.

If you'd rather be in control of the process, turn the Finder/LCD setting to Manual control. Here's how:

1. **Press the Menu button.**

2. **Select Custom menu 1.**

3. **Highlight the Finder/LCD Setting, as shown in Figure 10-9, and press enter.**

4. **Select Manual.**

 If you want to give control back to the camera, select Auto.

5. **Press the enter button.**

 From this point on, if the Finder/LCD is set to Manual, you have to press the Finder/LCD button to switch the display to the venue of your choice. Enjoy!

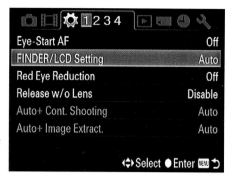

Figure 10-9: Normally, the view switches between the finder and LCD automatically.

Changing a Button's Stripes

If you don't mind living in a world where the ISO button enables face detection and the AEL button changes the metering mode, then this section is for you. The A65/A77 has plenty of customizable buttons that you can reassign to perform the chores *you* want them to.

Changing labeled buttons to perform tasks other than what the label says can play some freaky-deaky mind games on you. Don't go a-changin' right before an important photo shoot or vacation. And when you do change, experiment and practice. That way, if you don't like it, you can change it back.

Since changing each button is basically the same, I've condensed everything into one series of simple steps. To assign different function to these buttons, follow these steps:

1. **Press the Menu button.**

2. **Go to Custom menu 3.**

3. **Highlight the button you want to change and press the enter button.**

 The buttons in question are:

 - *AEL button:* Normally locks the auto exposure when you press and hold it.

 - *AF/MF button (A77):* Enables you to manually focus even when in an autofocus mode.

- *ISO button:* Displays the ISO selection screen for you to choose an ISO. Highlighted in Figure 10-10.

- *Preview button:* By default, is an aperture preview button.

- *Focus Hold button (A65):* Holds the autofocus.

- *Smart Teleconverter button:* Digital zoom.

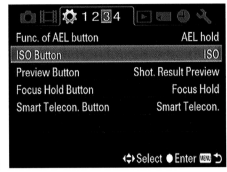

Figure 10-10: Changing the function of the ISO button from ISO . . .

4. **Select a new function and press enter.**

Some buttons have extensive lists.

- The AEL, ISO, and AF/MB (A77 only) buttons can be assigned the following functions: Exposure compensation, drive mode, flash mode, Autofocus mode (A65), AF area, face detection, Smile Shutter, ISO, metering mode, flash compensation, white balance, D-range optimizer, auto HDR, creative style, picture effect, image size, quality, AF/MF control hold (A77), AF/MF control toggle, AEL hold (A65), AEL toggle (A65), object tracking, AF lock, aperture preview, shot result preview, smart teleconverter, focus magnifier, and memory (A77). See Figure 10-11.

- The preview button can be reassigned as shot result preview and aperture preview. See Chapter 7 for more information.

- The focus hold button (A65) can change between holding the focus and previewing depth of field.

- The smart teleconverter button can change between being a smart teleconverter and focus magnifier button.

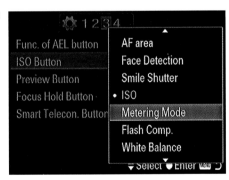

Figure 10-11: . . . to one of these functions.

86ing the AF Illuminator

When the light is dim or the contrast isn't great enough for the camera to discern details, your camera may not be able to autofocus. The backup plan is for the camera to use its built-in flash and finish focusing. This is called AF (autofocus) illumination. The AF Illuminator is a great idea if you don't mind the flash needed to autofocus. Sometimes you may want to turn it off.

Two bits to remember about auto flash:

✏ If you're in Auto+, Auto, or a Scene mode, the built-in flash automatically pops up. When you're in an advanced shooting mode (P, A, S, or M), you have to pop up the built-in flash yourself.

✏ Switching to manual focus doesn't turn the AF Illuminator off. When you're in an automatic mode or have the flash up in an advanced mode, it will still fire.

Try this out: at night, get your camera and go into a dark room and see if the camera can focus on something across the room. If the lights are dim enough, it won't. Change shooting mode between Auto and A to see how the camera reacts. Pop the flash in A mode. Evaluate the strength of the AF Illuminator flash firsthand.

To turn the AF Illuminator off, follow these easy steps:

1. **Press the Menu button and go to Still Shooting menu 2.**

2. **Highlight the AF Illuminator option and press enter.**

3. **Highlight Off, as shown in Figure 10-12.**

 Choose Auto to turn it back on.

4. **Press enter to finish.**

 Now you're free to shoot in low light and use manual focus without the AF Illuminator going off.

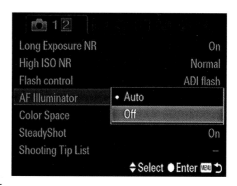

Figure 10-12: Turning off the AF Illuminator.

You should be aware of this fine print concerning the AF Illuminator:

✔ It won't work when the autofocus mode is set to AF-C.

✔ The AF Illuminator won't fire when the subject is moving and you're in AF-A autofocus mode.

✔ The AF Illuminator won't work if you're in Local or Zone AF area mode and you haven't selected the center AF area. (Sheesh, when does this thing work?)

✔ If you have a telephoto lens of 300mm or larger, the AF Illuminator may not work.

✔ When you have an external flash mounted on top of your A65/A77, the external flash fires its AF Illuminator when necessary.

✔ The AF Illuminator won't work when you're in Smile Shutter mode.

Turning It Down to 10: Noise Reduction Settings

If your A65/A77 decides to perform noise reduction when you're ready to take more photos, it may feel like the camera has gone on an extended coffee break. Believe it or not, it's actually trying to help.

Automated noise reduction kicks in after you take a photo with a long exposure time (1 or more seconds) or when the ISO is high. For more information on ISO, which determines the camera's sensitivity to light, please turn to Chapter 7.

After you take the shot, the camera takes over and cleans up the photo. The problem is, you can't take another photo while this is happening. You have to wait it out.

What are you to do? Take control of the noise reduction settings before you get frustrated.

1. **Set the exposure mode to P, A, S, or M.**

 You can't turn off noise reduction when in Auto+, Auto, Flash Off, Scene Selection, where long exposure NR is on, or Sweep Panorama, 3D Sweep Panorama, Continuous Priority AE, Continuous Shooting, Continuous Bracketing, Sports Action scene, or Hand-held Twilight scene, where it is off by default. High ISO NR is always on in the basic shooting modes (except Continuous Advance Priority AE).

2. **Press the Menu button and go to Still Shooting menu 2.**

3. **Highlight the type of noise reduction you want to adjust, and then press enter.**

 Choose from two types of noise reduction:

 - *Long Exposure NR:* Controls the amount of noise reduction the camera applies to exposures of one second or longer. The amount applied is equal to the exposure duration, which means if you took a two-second exposure, noise reduction is processed for two seconds.

 - *High ISO NR:* Controls the amount of noise reduction applied after you take a photo with a high ISO.

4. **Choose a setting.**

 The setting depends on the type of noise reduction you're adjusting. Long exposure NR has two options:

 - *On:* This setting enables long exposure NR and puts the emphasis on photo quality.

 - *Off:* This setting disables noise reduction for photos taken with long exposures, which lets you get back to shooting quicker.

 High ISO NR has three options:

 - *Normal:* A compromise between noise reduction and speed.

 - *High:* Your priority is to remove as much noise as possible.

 - *Low:* Noise reduction is applied, but it doesn't take as long and removes less noise.

5. **Press enter to finish the process.**

In-camera noise reduction is a good choice to make, provided you aren't in a rush and can wait for the camera to process the shot. However, you should think about turning it off (or using the Low setting, in the case of high ISO) if you would rather handle noise reduction in your favorite photo editor. If you have a third-party noise reduction filter such as Noiseware (www. imagenomic.com), Noise Ninja (www.picturecode.com), or Neat Image (www.neatimage.com) for Photoshop, you can tweak noise settings to try and get better results than the camera.

Turning noise reduction on and off has some fine print:

- **You can't turn on long exposure noise reduction when the camera is in certain modes, even if you turn on the setting.** Those exposure modes include Sweep Panorama, 3D Sweep Panorama, Continuous Advance Priority AE, Continuous Shooting, Continuous Bracketing, Hand-held Twilight (a scene), and when the ISO is set to Multi-Frame NR. The good news is that when you're in any of those modes, you don't have to worry about turning off noise reduction to improve the frame rate of the camera; it's already off.

- **You can't turn on noise reduction for Raw photos.** JPEGs only, if you please.

- **You can't turn off noise reduction when you're in an automatic mode.** Auto modes include Auto, Auto+, or a scene. In these cases, you get long exposure NR whether you want it or not.

Ten More Camera Features
Worth Investigating

*T*he A65 and A77 are fantastic cameras with a lot of extra features worth investigating. The material in this chapter isn't strictly necessary, but it can be very helpful and downright interesting sometimes.

By the way, this chapter makes extensive use of the enter button. It's the circular button labeled AF in the center of the control button on the back of the A65. You'll also use the outer control button to go up, down, left, and right within menus and to make selections. On the A77, use the multi-controller to navigate and press the middle for the enter button.

Becoming One with the Level

Sony calls it the *digital level gauge.* Others call it an *artificial horizon.* Still others call it a *level* or *electronic level.* If there were ever an optional gizmo that you don't absolutely need but can benefit from, it's the digital level built into the A65 and A77.

Turn on the level by pressing Display until it shows up. (See Chapter 10 for information on customizing which displays are displayed.) That's not the hard part.

Believe it or not, the tool is actually two levels in one. That's right. The camera senses when it is off kilter from left to right (horizontal) or tilting forward or backward. For reference, Figure 11-1 shows the gauge as it appears when everything is level.

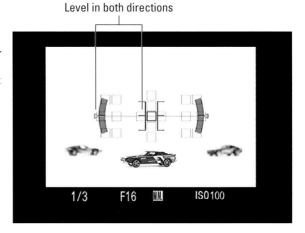

Figure 11-1: The camera is level as evidenced by the green indicators.

Of course, there are times and places when the level is completely irrelevant. However, if you are taking photos of buildings, interiors, in a studio, or in anywhere else that requires that the camera be level either with the horizon, vertically, or both, then the level is an outstanding feature to use. The camera can be out-of-level in either or both of two ways.

What's more, I find the level indispensible when shooting Sweep Panoramas. Keep the level level and your panorama will be level, and that's on the level.

Left-to-right level (horizontal)

This part of the level occupies both ends and tells you when the camera is out of level with the horizon. If you hold the camera vertically, it becomes a front-to-back level. Regardless of the direction you hold the camera, this display has more precision than the other because it's longer. Longer levels are always better.

You should be concerned with the ends of the horizontal level, as shown on the left in Figure 11-2. The triangles outside the arcs as well and the small index in the arc turn don't move. They green when the camera is level on this plane. Otherwise, they are white (though this figure makes them look light gray). When it isn't level, the camera's position is shown by an orange index that rides inside the arcs on either side. To level the camera, rotate it so those marks point to the triangles and turn green.

Front-to-back level (vertical)

The center of the level shows you if you're tilting the camera from front to back (or vice versa). It's smaller that the horizontal component, which means there is a bit less precision than in the other direction.

Unlike the horizontal level, the vertical level doesn't have large triangles that you should match your position to. Rather, it has two small indices on either side of the center AF area. When the camera is out of level, the indices are white. When the camera is level, they turn green. You can see your position by two markers that travel up and down the vertical display on both sides. They're orange unless they merge with the white indices, in which case the camera is level and everything turns green. See Figure 11-2.

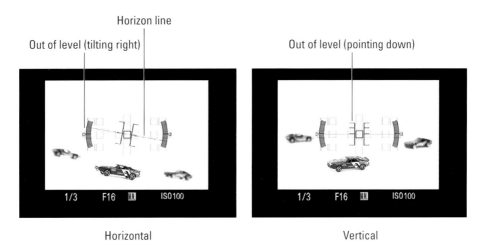

Figure 11-2: Rockin' and rollin'.

Using Memory Recall (A77)

The A77 can store your favorite settings (within certain limits). Then, you can grab those settings at a moment's notice.

First, you have to save *(register)* your settings. To register your own settings, follow these steps:

1. **Set up the camera how you want.**

 Here is a list of things that you can save into memory and recall later:

 - *Exposure and drive:* Exposure mode, aperture, shutter speed, ISO, drive mode, metering mode, exposure compensation, and DRO/Auto HDR.

 - *Focus:* Face detection, Smile Shutter, object tracking, local AF area.

 - *Flash:* Flash mode, flash compensation.

 - *Color, effect, and style:* White balance, picture effect, creative style.

 - *Still Shooting menu:* Everything. This includes photo size, quality, color space, and so forth.

2. **Press the Menu button.**

 This is important. *Don't* set the mode dial to MR just yet. You do that when you want to *recall* your saved settings, not when you want to store them. Press the Menu button with the mode dial set where you want to save.

3. **Go to Still Shooting 3 menu.**

4. **Highlight Memory and press enter. See Figure 11-3.**

 The current camera settings are displayed (in this case, optimized for shooting action outdoors). Review them to make sure they represent the correct camera state that you want to save.

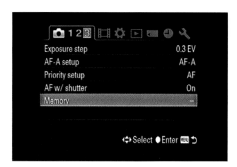
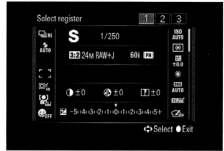

Figure 11-3: Saving settings to a memory location.

5. **Highlight a numbered tab (save location).**

 You can store up to three different configurations. That means, for example, you can optimize one for portraits, another for action, and another for landscapes. You make the call.

6. **Press enter again.**

 This saves the configuration.

To recall a configuration, follow these steps:

1. **Set the mode dial to MR, as shown in Figure 11-4.**

 This is where you get to set your mode dial to MR. I know you've been dying to. The settings for each configuration are shown as selectable tabs.

2. **Go left or right to highlight the number you want to load.**

 The display reflects the properties you saved earlier. In Figure 11-5, I'm recalling settings that I've optimized for shooting portraits. I'm pulling the settings from memory location 2.

3. **Press enter to lock in your choice.**

 When you're in MR mode, you can press the Function button to display the shooting functions screen and change configurations. Simply highlight Memory Recall and choose a new configuration.

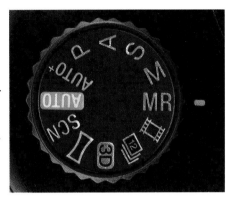

Figure 11-4: Setting the mode dial to MR.

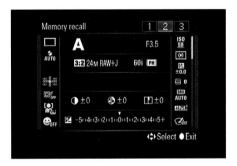

Figure 11-5: Recalling settings from memory location 2.

Keep in mind these important Dos and Don'ts when you're using memory recall:

- **Don't touch that dial:** When you set the mode dial to MR and recall a preset, *don't change the dial.* When you do, the camera reverts to the settings you were using beforehand.

- **Shift:** Program or manual shift settings aren't saved.

- **Don't believe your lying eyes:** The recalled settings aren't reflected in the dial positions (the focus mode dial, for example). Refer to the LCD, viewfinder, or top display to see the actual shooting settings.

- **Changing an existing configuration:** To change the existing memory configuration, follow the preceding steps to recall the configuration (set the mode dial to MR), then follow the steps to save it (press the Menu button) using the same configuration number.

- **Overwriting without recalling:** To overwrite a memory configuration, set up the camera the way you want, then save the settings to whatever memory configuration that you want to overwrite (1, 2, or 3).

- **Clearing:** To clear a memory configuration, go back to the default configuration and save that to a memory location.

Shooting with Picture Effects

The A65 and A77 have lots of interesting picture effects. The effects are located with the other shooting functions; you can get to them by pressing the Function button. Each effect is unique and gives you ways to make your images and videos pop. That's right, the effects aren't restricted to still photos. Feel free to use them when shooting movies! The effect also overrides any creative style, such as Portrait or Vivid, that you've enabled. (To review creative styles, please turn to Chapter 8.) When you take the shot, the effect is applied and the photo is saved as a JPEG.

Picture Effect mode only works with JPEGs. You can't choose an effect when the image quality is set to Raw or Raw + J, and any effect you might already have turned on is disabled when you do.

To use picture effects, follow these steps:

1. **Set the mode dial to a compatible mode.**

 You can use picture effects in P, A, S, M, and Movie modes.

2. **Set Quality to Standard, Fine, or Extra Fine (A77).**

 Picture effects aren't applied if you shoot any form of Raw photo. See Chapter 2 for information about quality settings.

3. **Press the Function button.**

4. **Highlight Picture Effect and press the enter button.**

5. **Highlight an effect.**

 You get to choose from these effects:

 - *Posterization (Color)* creates abrupt changes in tone with no or very little gradient using a limited color palette. You get a wildly posterized photo; see Figure 11-6. These photos look like something out of a graphic novel.

 - *Posterization (B/W)* creates an effect similar to Posterization (Color) but in black and white. Photos taken with this effect look like pen-and-ink drawings.

 - *Pop Color* adds zing to hues.

 - *Retro Photo* reduces contrast color, creating a photo that looks aged, complete with subtle sepia tones.

 - *Partial Color (Red, Green, Blue, or Yellow)* is fantastic for singling out and showing specific colors while converting everything else to black and white. See Figure 11-7.

 - *High-Key* makes photos bright, happy, and softer than normal.

 - *High-Contrast Monochrome* creates a black-and-white photo that has more contrast than normal.

 - *Toy Camera* simulates what the photo would look like if you took it with a really cheap camera. The colors are bright but the corners are shaded *(vignetted).*

Figure 11-6: Posterization effects are wild and crazy.

Red

Yellow and Green

Blue

Yellow

Figure 11-7: These effects let only a single color show through.

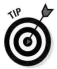

You won't see the result of the final four effects (see Figure 11-8) until you take the photo. In addition, you can't change the Drive mode. When using HDR Painting or Rich-tone Mono, you may not get the greatest photos in the world if the contrast is low and the camera is shaking a bit. If you get a warning (after the fact), try again.

- *Soft Focus* softens the lighting and focus. It's a "misty-eyed" photo.

- *HDR Painting* takes three exposure-bracketed photos to capture more brightness detail than a single photo can, and then processes the merged result to make it look like an otherwordly HDR image.

- *Rich-tone Mono* takes three photographs when you select Rich-tone Mono, and processes them to create a single black-and-white image with lots of detail.

- *Miniature* simulates the Tilt-Shift effect, where a small strip of the photo is in focus and everything else is blurred. The end result makes it look like you've photographed a miniature model.

Soft Focus HDR Painting

Rich-Tone Mono Miniature

Figure 11-8: The great thing about effects is that you don't need a software program to get them.

6. **(Optional) Press left or right to alter the intensity of the effect.**

 These effects let you alter their intensity: Toy Camera, Posterization, Partial Color, Soft Focus, HDR Painting, and Miniature (in which you change the focus area).

 A77 users can use the front control dial to select an effect, and the rear control dial to alter the intensity.

7. **Press enter to lock in your choice and return to shooting mode.**

 If you change your mind and want to choose a different picture effect (either before or after you take a photo), press the Function button and highlight Picture Effect. Turn the main dial to quickly scroll through the effects. (Use the rear control dial on the A77 to adjust intensity.)

8. **Take the picture.**

Navigating with GPS

The A65 /A77 has a global positioning system (GPS). When you enable it, GPS records the location of every photo you take. The data goes in each photo's EXIF metadata. To take advantage of GPS, you have to make sure it's on. Follow these steps to get it running:

1. **Press the Menu button and go to Setup menu 1.**

2. **Highlight GPS Settings and press enter.**

 This puts you in the GPS Settings menu. See Figure 11-9.

3. **Highlight GPS On/Off and press enter again.**

4. **Highlight On or Off.**

5. **Press enter to finish.**

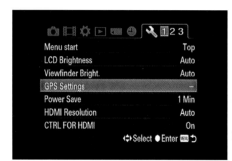
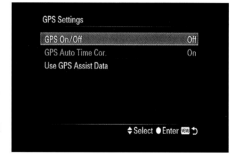
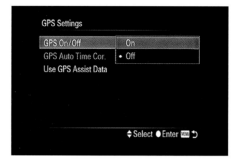

Figure 11-9: Navigating through the GPS menu to turn it on.

Navigation uses *triangulation.* If you can determine your bearing to two points a known distance apart using a compass, you can draw a line from each point toward your location. You're located where the lines cross on the map.

The ideal location to receive GPS data is outside, in the open. If you get good data, the camera can calculate its location with quite a bit of precision. The problem with GPS, however, is getting the data. You won't receive a good satellite signal in many areas — most notably, between tall buildings, in trees, tunnels, in some buildings, underground, and near electronic devices that generate competing radio signals on the same frequency.

Thankfully, the camera tells you its status through a series of handy symbols shown in Table 11-1. They tell you what sort of reception you're getting and whether there are any problems.

Table 11-1	A55 GPS Iconography
Symbol	*Message*
None	Your GPS is off. Turn it on if you want to use it.
![sat]	You aren't getting any location information. Move to an open area to see if you can get a signal.
![sat]	The camera is getting location information but needs a minute to figure out where you are.
![sat]	The camera has your location and it will be recorded, but the information may be outdated. If you want to update your position, get out in the open.
![sat]	Jackpot! The camera has a good position and will record that. The bars indicate signal strength.
![sat] ERROR	The symbol you don't want to see. Reboot by turning the GPS off, then back on again.

If you're having trouble getting a signal, even in the open, try GPS Assist Data. You can use GPS Assist Data by plugging your camera into a Windows computer with Picture Motion Browser installed. (See Chapter 6 for a summary.) The software should recognize your A65/A77 and automatically update the GPS Assist Data. If you like, you can run the routine from the PMB Launcher. The GPS choice is in the list.

These tips will help you get a good GPS location:

✔ Be in a location with good satellite reception. Surprise there, huh?

✔ Keep still. Don't move back and forth between areas.

✔ Pay attention to the GPS status indicators.

✔ Wait for your camera to update.

✔ Use GPS Assist Data.

PMB isn't available for the Mac. Several home-brewed applications are available. Search online for **sony mac gps assist**.

If you're moving around a lot, purposefully wait for the camera to get updated data. If you don't, the camera is likely to use data from its last known good position, which may be miles off.

Unleashing the Smart Teleconverter

The Smart Teleconverter is a neat feature found on both the A65 and A77. Think of it as a fancy digital zoom. I know what you're thinking: You bought a dSLT with an expensive zoom lens so you didn't have to rely on digital zoom. That's what point-and-shoot cameras are for.

However, zooming in beyond your lens is handy when you need just a *little* more zoom than your current lens can provide. Here's how to use it:

1. Set up your camera so it can use the smart teleconverter.

That would be:

- *Exposure mode:* Anything but Sweep Panorama, 3D Sweep Panorama, and Movie. You can't use it when shooting movies solely from pressing the Movie button either.

- *Quality:* JPEG only. Set image quality to Standard, Fine, or Extra Fine (A77).

- *Focus:* Smile Shutter has to be off and you can't have assigned the Focus Magnifier to the Smart Teleconverter button.

And just so you know:

- AF area is automatically set to Spot when using the Smart Teleconverter.

- So is the Metering mode (Spot).

2. Press the Smart Teleconverter button.

- *Press it once:* The scene is magnified by approximately 1.4 times and the image size is automatically set to Medium (4,240 x 2,832 pixels, for 12 total megapixels). See Figure 11-10.

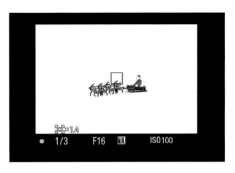

Figure 11-10: He's making a list: 1.4x magnified.

- *Press it twice:* The zoom jumps to 2x and the image size is automatically set to Small (3,008 x 2,000 pixels, for 6 total megapixels). See Figure 11-11.

- *Press it three times:* You jump back to normal.

3. Frame, focus, meter, and take the shot.

Turning On the Lens Compensatrixators

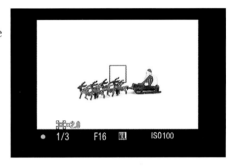

Figure 11-11: And checking it twice: 2x magnified.

What's better than having a camera that can compensate for the undesirable characteristics of any lens that is certified as an Automatic Compensation Compliant Lens by Sony?

(Thinking. Thinking. Well, I can think of a lot of things, but go with me on this one.)

The A65 and A77 both have something called *lens compensation.* You must have a compatible lens and turn on the feature. If you do and have, good things happen. Specifically, the camera takes the lens' bad characteristics and automatically corrects the photos so you don't have to do it yourself later. This works only with JPEGs. Raw files are uncompensated.

As time goes by more will be added, but at the time of this writing only these Sony lenses support automatic compensation:

- **SAL-1650:** 16–50mm f/2.8 Standard Zoom Lens
- **SAL-1855:** DT 18–55mm f/3.5–5.6 Zoom Lens

- **SAL-55200-2:** DT 55–200mm f/4–5.6 Zoom Lens (Make sure to get the dash 2, which is the second version.)

- **SAL-18250:** DT 18–250mm f/3.5–6.3 Zoom Lens

- **SAL-1680Z:** DT Carl Zeiss 16-80mm f/3.5-4.5 Zoom Lens (support added for both cameras with the 1.04 firmware update)

- **SAL-16105:** DT 16-105mm f/3.5-5.6 Zoom Lens (support added for both cameras with the 1.04 firmware update)

Three types of Bad Things Happen with Lenses:

- **Peripheral shading (aka *vignetting*):** When the photo's corners are darker than the center. Sometimes it looks cool and old-fashioned. Sometimes it stinks. Of the three types of problems, this is easiest to fix in software.

- **Chromatic aberration:** When the lens bends different wavelengths (therefore colors) of light differently, they don't focus on the same spot on the camera's sensor. Most often you see this as color fringing around sharp edges in a photo. Fixing this in software is possible, but I usually find it messy and troublesome to get rid of it completely.

- **Distortion:** When light passes through a lens and hits the sensor, not everything that appears to be straight and flat to your eyes ends up being straight and flat in the photo. Most lenses have some amount of bulging in the center *(barrel distortion)*. Some lenses produce the opposite: *pincushion distortion* (the photo pinches in). Mixing them together produces complex distortion patterns reminiscent of a mustache. When it's complex, distortion is very hard to fix in software. Straightforward barrel or pincushion distortion isn't much of a problem.

To enable or disable lens compensation, follow these steps:

1. **Press thy Menu button.**

2. **Go to Custom menu 5 (A65) or go to Custom menu 4 (A77).**

3. **Highlight the option you want, as shown in Figure 11-12.**

 They are:

 - *Lens Compensation:* Peripheral Shading: On Auto by default.

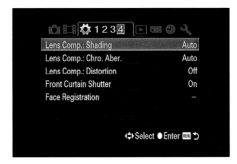

Figure 11-12: Lens Comp a doo wop.

- *Lens Compensation:* Chromatic Aberration: On Auto by default.

- *Lens Compensation:* Distortion: Off by default.

4. Press enter and then highlight your choice.

You can turn each option off or put it on Auto.

5. Press enter to confirm your choice.

You're free to exit the menu.

Ye Olde Electronic Front Curtain Shutter

Normally, digital SLRs and SLTs use a mechanical focal plane shutter. This is the tried and true approach inherited from older film SLRs. This design relies on moving shutter leaves positioned in front of the film or sensor. They block or expose the digital sensor, depending on whether you're taking a photo or not. The engineers at Sony have been busy developing an alternative approach. Namely, an electronic front curtain shutter that reads data from the camera's already exposed sensor similar to the way a mechanical shutter would expose it. (That's why it's called *front curtain*: The electronic part begins after the first or front mechanical curtain opens but before the rear mechanical curtain closes.)

Within certain limitations, this method has advantages — not least of which is parts moving less often. In the end, it also lets you take photos faster.

Use the front curtain if you want to shoot faster. However, Sony recommends against using the electronic front curtain shutter in the following circumstances:

- **Fast shutter speed with a large aperture:** You may see ghosting or blurring when shooting in this circumstance.

- **Konica Minolta lenses:** Turn this feature off when using an older Konica Minolta lens. They apparently aren't compatible.

The electronic front curtain shutter is enabled by default. Try it out with your favorite lenses and in different circumstances. If you see uneven exposure, though, chances are that something isn't entirely simpatico.

To turn off the electronic front curtain shutter (and revert exclusively to the mechanical shutter), follow these steps:

1. **Press the Menu button.**

2. **Go to Custom menu 5 (A65) or 4 (A77) and highlight Front Curtain Shutter. See Figure 11-13.**

3. **Press enter, and then choose an option, as shown in Figure 11-14.**

 Choose Off to turn the electronic front curtain shutter off.

4. **Press enter again.**

 You can exit the menu now.

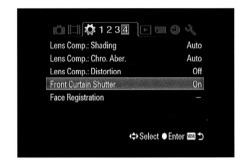

Figure 11-13: Accessing the electronic front curtain shutter setting.

Flashing without Wires

If you haven't had a chance to play around with wireless flash, let me encourage you. You do need the right equipment, though. Thankfully, the list of things you need is short.

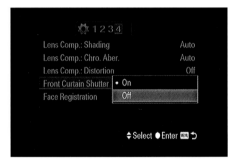

Figure 11-14: Turning it off.

Aside from your A65/A77, all you need is a compatible wireless flash.

I recommend Sony units because they play nice with Sony cameras. Of the three Sony flash units currently available, the HVL-F58AM and HVL-F43AM offer wireless capabilities. Their cost-conscious model, the HVL-F20AM, is a nice upgrade from the built-in flash, but can't act as a *wireless slave* (a flash that waits for another flash or controller to tell it when to fire). Other companies (Metz, Neewer, Bower, and Sigma for example) make flashes compatible with the Sony wireless flash system.

When shopping, make sure you look at models that are

- Designed for Sony dSLRs (as opposed to Canon, Nikon, and others)
- Capable of acting as wireless slaves

Taking the flash off the camera gives you a lot of lighting flexibility and can produce better results (especially in studio-type situations) than the pop-up unit or a flash mounted in the hot shoe.

Before you get started, change the function of the AEL button to AEL Hold. And, when you're testing the flash, press the AEL button to lock in the exposure. Turn to Chapter 10 for how to change the AEL button.

Once you have the flash, setting it up is easy:

1. **Slide the external flash onto the camera's auto-lock accessory shoe.**

 Yes, that's weird. The first step of getting your remote, wireless flash operating in wireless mode is to mount it on the camera. It works, though.

2. **Press the Function button.**

 See Figure 11-15. More advanced flash coverage is in Chapter 7.

3. **Highlight the Flash Mode option and press enter.**

4. **Highlight the wireless flash icon.**

 Taking this step configures the two flashes to act as a wireless flash unit.

5. **Press enter.**

6. **Remove the flash unit from your camera.**

 You can position it now or after the next step.

7. **Raise the camera's built-in flash by pressing the flash pop-up button.**

 Raising the built-in flash prepares it to act as the wireless flash commander. It will flash when you take a photo. That flash, however, isn't meant to light the scene. That flash is what triggers the wireless unit.

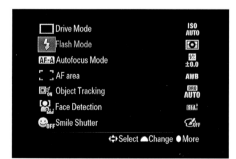
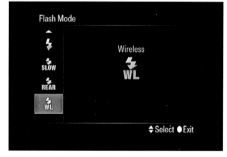

Figure 11-15: Enable the wireless flash option from the Flash Mode screen.

With everything set up between the camera and wireless flash, you can position the flash where you want it. Mini-stands, which often come with the flash, are handy ways to move the flash around. Place the flash on the floor or on a table. The stand supports the flash so it doesn't fall over.

Figure 11-16 shows a small still life of a wooden vase with flowers and a polar bear. The image shot with the built-in pop-up flash is well lit. The polar bear, vase, and flowers look fine. The flowers and vase, however, cast a distracting shadow onto the white background. The wireless flash photo in Figure 11-16 was shot with the flash sitting on the table to the right, 20 inches away from the vase. In this case, the point was to cast a shadow to the left (as opposed to the rear) and reveal the complex but pleasing shape of the vase, flowers, and bear. This type of shot is impossible with the in-camera flash or with a flash mounted on the hot shoe.

Pop-up Flash Wireless Flash

Figure 11-16: The polar bear is undoubtedly evaluating the difference between pop-up and wireless flash.

Consult your flash's manual for specific placement guidelines and other limitations.

Wireless flash also opens the door to other professional setups. You can mount the flash on a lighting stand, and with an umbrella adapter, use a soft box or umbrella to diffuse the light from the flash. You'll look like a professional photographer in a studio. (Don't let the idea of setting up an external flash with an umbrella intimidate you. Once you have the wireless flash, the hard part is over. Grab your stand, umbrella, and flash, and set it up in your living room to take photos of your kids opening presents. It produces good results and is very easy to pull off.)

If you put your A65/A77 in wireless flash mode, don't forget return to normal when you're done. Otherwise, you'll wonder why your flash photos are dark to the point of illegibility. (Trust me, I know from experience.) The pop-up flash doesn't put out anywhere near the amount of light in wireless mode that it does in normal operation.

I Spy an Eye-Fi Memory Card

Your A65/A77 is compatible with Eye-Fi cards, which are memory cards that let you wirelessly transfer photos and movies from your camera to a computer.

However, consider a few things before jumping into the Eye-Fi pool:

- **Time and trouble.** It takes more time, trouble, and money to buy an Eye-Fi card compared to a standard memory card for your camera. You have to get the right one, install Eye-Fi software on your computer, and register for a free Eye-Fi account. Yeouch.

- **Battery power.** When you're transferring photos from your camera to a computer, you're draining the batteries. Consider whether it's worth using anything that sucks extra battery power.

- **Speed.** Eye-Fi transfer speeds, although not as slow smoke signals, aren't as fast as a card reader or a USB connection.

If you take the Eye-Fi plunge, get the right card. Not all Eye-Fi cards transfer Raw photos. If you need one that does, make sure to get the right model. At the moment, out of the three card types suitable for digital photography, only the Pro X2 transfers Raw photos wirelessly. The others support JPEGs and movies only. If you shoot JPEGs only, you're good to go if you buy one of the cheaper varieties — either the Connect X2 or Mobile X2. Just pop the Eye-Fi card into your camera and start taking photos. (If you want to format the card in your camera, make sure you first transfer any Eye-Fi information you want to keep off the card.)

You can't configure your Eye-Fi card to act in Endless Memory mode. Turn off that mode from the Eye-Fi Center.

By default, your A65/A77 will enable the card. If not, insert an Eye-Fi card into your camera (see Chapter 1 if you need help with this) and follow these steps:

1. **Press the Menu button and go to Setup menu 2.**

2. **Highlight the Upload Settings option and press enter.**

 You won't see this option unless you have an Eye-Fi card inserted in the camera.

3. **Choose On.**

 Choose Off if you need to disable the connection.

 Turning *off* the Eye-Fi connection is important if you take the camera on a plane or are in an area that prohibits you from trying to establish a wireless connection. Protect yourself and your camera by following any posted rules about wireless devices.

4. **Press enter to finish.**

 You see an Eye-Fi status indicator on the monitor (see Figure 11-17) that shows connection and transfer status. This icon takes the place of the normal memory card symbol. (I used the For viewfinder display to spice things up.)

Any of six Eye-Fi status indicators may appear on your LCD screen or through the viewfinder. Table 11-2 shows you.

Eye-Fi symbol and status indicator

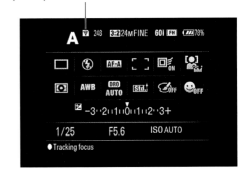

Figure 11-17: An Eye-Fi symbol replaces the normal memory card.

Table 11-2		Eye-Fi Status Indicators
Symbol	**Name**	**Message**
🛜	Standby	The card is in your camera, but you're not taking photos and nothing's being uploaded.
🛜 ⁞	Upload Standby	You're connected and uploading, but waiting on something.
🛜 ⇅	Connecting	The card is connecting to your wireless network.
🛜 ↑	Uploading	The card is transferring photos or movies to your computer.
🛜 ⚠	Error	You've got a problem. Pull the card out of your camera and reinsert it, or turn off the camera and then turn it on again. If that doesn't work, your card may be damaged. Insert it in the drive it came with to see if Eye-Fi Center recognizes it. If not, it's probably toast.
🛜 OFF	Off	You've switched the upload settings to Off from Setup menu 2.

Control transfer settings from within Eye-Fi Center on your computer. Figure 11-18 shows the options enabled for uploading photos to a computer. The right side of Figure 11-19 shows the Transfer Mode tab active with the Selective Transfer options displayed.

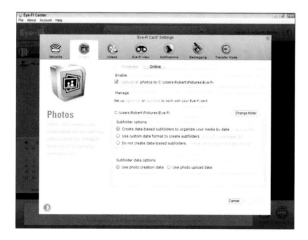

Figure 11-18: Control photo and transfer settings from your computer.

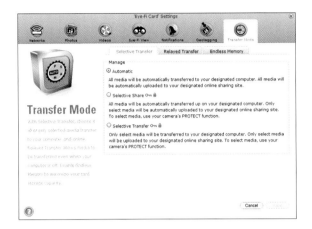

Figure 11-19: The Transfer Mode tab is ready.

Some Brainiac Features on the A77

The A77 is a certifiably cool camera with lots of personality. It's also got a lot of brains and more features than you can shake a tripod at. Some of these extra features just might be your cuppa tea (as the English say). Try them out.

Power ratio (aka manual flash)

Power ratio is an obscure name for being able to manually control the strength of the built-in flash. You do, of course, have to set the flash to Manual. Here's how:

1. **Press the Menu button.**

2. **Go to Still Shooting menu 2 and highlight Flash Control.**

 See Figure 11-20.

3. **Press enter and choose Manual Flash.**

4. **Press enter again.**

5. **Press the Menu button.**

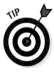

Once you're in manual flash mode, you have to be able to adjust the power. It may help to think of the manual flash strength in terms of exposure. Since the power is halved between each Power Ratio setting, that equates to a stop of exposure.

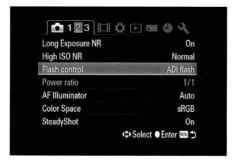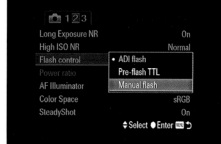

Figure 11-20: Set Flash control to manual.

To do that, follow these steps:

1. **Press the Menu button.**

2. **Go to Still Shooting menu 2 and highlight Power Ratio.**

3. **Press enter and choose a setting, as shown in Figure 11-21.**

 Choose from these options:

 - *1/1:* Full power. Think of this as 0.0EV.

 - *1/2:* Half power. One stop less, or -1.0EV compared to 1/1.

 - *1/4:* One quarter of the total possible strength. Another stop less, which equates to -2.0EV.

 - *1/8:* 12.5% of the original power, or -3.0EV.

 - *1/16:* 6.25% of the original power, resulting in -4.0EV.

4. **Press enter to set the power ratio.**

5. **Press the Menu button to continue shooting.**

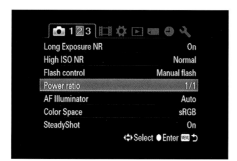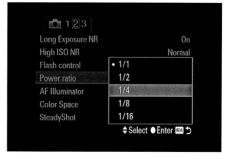

Figure 11-21: Use the power ratio to set the flash strength.

Exposure step

Normally, the A77 measures the differences between stops of exposure in 1/3 EV increments. Most users might never need to change this setting. However, if you're one who does, you'll appreciate having the option.

If you'd rather use 1.2 EV increments (larger steps), follow these steps:

1. **Go to Still Shooting menu 3.**
2. **Select Exposure Step.**
3. **Change the step value from 0.3EV to 0.5EV.**

The idea is to give up precision in favor of speed. If you're constantly dialing in adjustments, reducing the number of clicks between stops will help you get where you want to go (or close to it) faster.

AF/MF button

Don't expect to tune in radio stations with the AF/MF button. It is a fine-tuning mechanism, but not for radio. Rather, it enables you to switch quickly and temporarily between auto and manual focus.

Here's how it works:

- ✔ **Auto focus:** When you're in an Auto Focus mode and press *and hold* the AF/MF button, the camera temporarily switches to manual focus. This unlocks the focusing ring on the lens so you can make adjustments.
- ✔ **Manual focus:** Conversely, when you're in manual focus mode and you press and hold the AF/MF button, the camera temporarily switches to auto focus and locks onto your subject.

You can change the behavior of the AF/MF button to toggle rather than hold, or change it in favor of another function entirely. See Chapter 10.

According to Sony, you can't use this feature with the inexpensive kit lens, the DT 18–55mm f/3.5–5.6 SAM. You wanted brainiac, right?

AF-A setup (aka direct manual focus)

Here's another auto and manual focus tweak. You can change the A setting on the dial from simple Automatic AF (AF-A) to AF with a touch of M.

Off you go:

1. **Press the Menu button.**

2. **Go to Still Shooting menu 3 and highlight AF-A Setup, as shown in Figure 11-22.**

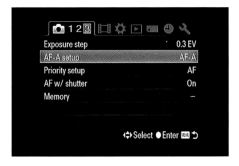 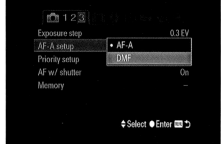

Figure 11-22: Switching to direct manual focus.

3. **Press enter.**

4. **Change the option to DMF and press enter.**

 This changes the behavior to direct manual focus. If you want to revert back to the default, select AF-A.

5. **Press the Menu button.**

6. **Turn the focus mode dial on the front of the camera to A, as shown in Figure 11-23.**

7. **Compose your shot, then press the shutter button halfway.**

Figure 11-23: Ye olde focus mode dial.

8. **Fine-tune the focus by manually turning the focus ring on your lens.**

9. **Fully press the shutter button to take the photo.**

Wouldn't you know it? Some lenses aren't compatible with this feature. If you have a SAM (Smooth Autofocus Motor) or SSM (SuperSonic Motor) lens, you're out of luck. This knocks out both of the standard kit lenses: the inexpensive DT 18–55mm f/3.5–5.6 SAM and the more capable DT 16–50mm f/2.8 SSM.

AF Micro Adjust

There's a pattern here. The A77 has a lot of really advanced features that have to do with focus. Here's another, and it's a doozie: For whatever lens you have mounted on the camera, you can subtly adjust the focus to perfection. That's the good news. The bad news (in a manner of speaking) is that if you want to get the right setting, you have to be willing to do some work. Once you figure out the right adjustment for each lens, the camera will remember it. There's no need to re-test each lens unless you notice it's not as sharp as it used to be.

The whole process of evaluating the lens is like trying on pairs of prescription glasses. You have to compare them all before you can tell which one is best.

Turning on AF micro adjust

First, you have to turn on AF micro adjust:

1. **Press the Menu button.**

2. **Go to Setup menu 2 and highlight AF Micro Adjust, as shown in Figure 11-24.**

3. **Press enter.**

4. **Select AF Adjustment Setting and press enter.**

5. **Highlight On and press enter.**

6. **Press Menu to exit.**

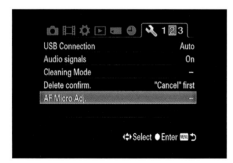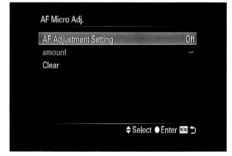

Figure 11-24: Enabling AF micro adjust is like putting corrective glasses on your camera.

Evaluating AF micro adjust

To perform the initial evaluation, grab your A77, the lens you want to dial in, and a tripod. Although you can perform this in the studio, if you normally shoot outside at things farther than five feet away, go outside and pick a far-away interesting scene with detail.

Once you get everything set up and are ready, follow these steps:

1. **Set Quality to Fine.**

2. **Set Size to Large.**

3. **Turn the focus mode dial to S.**

4. **Enter aperture priority mode.**

5. **Open the lens.**

6. **Press the Menu button.**

7. **Go to Setup menu 2, highlight AF Micro Adjust, and press enter.**

8. **Highlight Amount, as shown in Figure 11-25.**

9. **Select a new value, as shown in Figure 11-25.**

 The values range from +20 to -20. Positive numbers correct nearsighted focusing by moving the focusing position further away. Negative numbers to the opposite.

 Start at one end or the other when testing. You'll work your way through every setting.

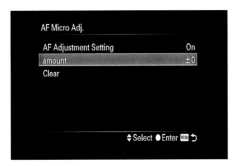 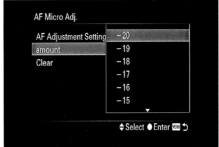

Figure 11-25: Setting an adjustment amount to begin testing.

10. **Press enter to make the selection.**

11. **Press the shutter button halfway to meter and focus, then take a photo.**

 These are your evaluation shots. Take one and only one at each setting.

12. **Return to Step 1.**

 Work your way through each micro adjustment setting, from -20 to +20, and take a photo. You will end up with 41 photos. If you need to, write down the photo name and the adjustment on a notepad so you can decode things later. Alternatively, you can perform a limited evaluation, and go from -10 to +10, or take a photo using every other adjustment setting. This will ease your work load. In that case, you will have to review 21 photos.

When the photograph is finished, follow these steps:

1. **Transfer the photos to your computer for analysis.**

 See Chapter 6 for those instructions. Alternatively, you can review them on the camera. If you do, zoom in and inspect the sharpness of small details.

2. **Compare each shot and select the one with the best focus.**

 Once you select the photo, calculate which adjustment number corresponds to the photo. For example, if you shot from -20 to 20, and the photo you like best is the 18th, then that photo was shot with a setting of -3. If you wrote the settings and names down, simply refer to your notes.

3. **Finally, return to steps 1 through 4 and enter the adjustment number that is best for this lens.**

 This locks the correct adjustment number in for the lens you are testing.

Clearing AF micro adjust data

To clear adjustment data for all lenses, follow these steps:

1. **Return to your camera and press the Menu button.**

2. **Go to Setup menu 2, highlight AF Micro Adjust, and press enter.**

3. **Highlight Clear, as shown in Figure 11-26, and press enter.**

 This makes sure you're entering a good value for this lens in the camera's database.

4. **Highlight Enter when you're prompted to clear the data.**

5. **Press enter.**

6. **Highlight Enter again and, when prompted, and press enter.**

This is your last chance to cancel. If you continue, you'll delete all the adjustment data stored in the camera for all lenses, not just the one you've attached.

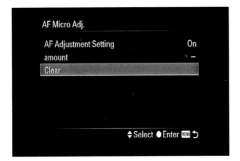
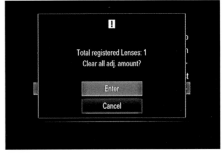
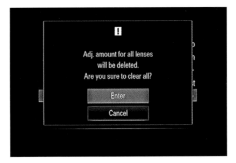

Figure 11-26: Are you sure? Are you *really* sure?

Index

• *T* •

• *U* •

• *V* •

• W •

• Z •

Apple & Mac

iPad 2 For Dummies,
3rd Edition
978-1-118-17679-5

iPhone 4S For Dummies,
5th Edition
978-1-118-03671-6

iPod touch For Dummies,
3rd Edition
978-1-118-12960-9

Mac OS X Lion
For Dummies
978-1-118-02205-4

Blogging & Social Media

CityVille For Dummies
978-1-118-08337-6

Facebook For Dummies,
4th Edition
978-1-118-09562-1

Mom Blogging
For Dummies
978-1-118-03843-7

Twitter For Dummies,
2nd Edition
978-0-470-76879-2

WordPress For Dummies,
4th Edition
978-1-118-07342-1

Business

Cash Flow For Dummies
978-1-118-01850-7

Investing For Dummies,
6th Edition
978-0-470-90545-6

Job Searching with Social
Media For Dummies
978-0-470-93072-4

QuickBooks 2012
For Dummies
978-1-118-09120-3

Resumes For Dummies,
6th Edition
978-0-470-87361-8

Starting an Etsy Business
For Dummies
978-0-470-93067-0

Cooking & Entertaining

Cooking Basics
For Dummies, 4th Edition
978-0-470-91388-8

Wine For Dummies,
4th Edition
978-0-470-04579-4

Diet & Nutrition

Kettlebells For Dummies
978-0-470-59929-7

Nutrition For Dummies,
5th Edition
978-0-470-93231-5

Restaurant Calorie Counter
For Dummies,
2nd Edition
978-0-470-64405-8

Digital Photography

Digital SLR Cameras &
Photography For Dummies,
4th Edition
978-1-118-14489-3

Digital SLR Settings
& Shortcuts
For Dummies
978-0-470-91763-3

Photoshop Elements 10
For Dummies
978-1-118-10742-3

Gardening

Gardening Basics
For Dummies
978-0-470-03749-2

Vegetable Gardening
For Dummies,
2nd Edition
978-0-470-49870-5

Green/Sustainable

Raising Chickens
For Dummies
978-0-470-46544-8

Green Cleaning
For Dummies
978-0-470-39106-8

Health

Diabetes For Dummies,
3rd Edition
978-0-470-27086-8

Food Allergies
For Dummies
978-0-470-09584-3

Living Gluten-Free
For Dummies,
2nd Edition
978-0-470-58589-4

Hobbies

Beekeeping
For Dummies,
2nd Edition
978-0-470-43065-1

Chess For Dummies,
3rd Edition
978-1-118-01695-4

Drawing For Dummies,
2nd Edition
978-0-470-61842-4

eBay For Dummies,
7th Edition
978-1-118-09806-6

Knitting For Dummies,
2nd Edition
978-0-470-28747-7

Language & Foreign Language

English Grammar
For Dummies,
2nd Edition
978-0-470-54664-2

French For Dummies,
2nd Edition
978-1-118-00464-7

German For Dummies,
2nd Edition
978-0-470-90101-4

Spanish Essentials
For Dummies
978-0-470-63751-7

Spanish For Dummies,
2nd Edition
978-0-470-87855-2

Math & Science

Algebra I For Dummies,
2nd Edition
978-0-470-55964-2

Biology For Dummies,
2nd Edition
978-0-470-59875-7

Chemistry For Dummies,
2nd Edition
978-1-1180-0730-3

Geometry For Dummies,
2nd Edition
978-0-470-08946-0

Pre-Algebra Essentials
For Dummies
978-0-470-61838-7

Microsoft Office

Excel 2010 For Dummies
978-0-470-48953-6

Office 2010 All-in-One
For Dummies
978-0-470-49748-7

Office 2011 for Mac
For Dummies
978-0-470-87869-9

Word 2010
For Dummies
978-0-470-48772-3

Music

Guitar For Dummies,
2nd Edition
978-0-7645-9904-0

Clarinet For Dummies
978-0-470-58477-4

iPod & iTunes
For Dummies,
9th Edition
978-1-118-13060-5

Pets

Cats For Dummies,
2nd Edition
978-0-7645-5275-5

Dogs All-in One
For Dummies
978-0470-52978-2

Saltwater Aquariums
For Dummies
978-0-470-06805-2

Religion & Inspiration

The Bible For Dummies
978-0-7645-5296-0

Catholicism For Dummies,
2nd Edition
978-1-118-07778-8

Spirituality For Dummies,
2nd Edition
978-0-470-19142-2

Self-Help & Relationships

Happiness For Dummies
978-0-470-28171-0

Overcoming Anxiety
For Dummies,
2nd Edition
978-0-470-57441-6

Seniors

Crosswords For Seniors
For Dummies
978-0-470-49157-7

iPad 2 For Seniors
For Dummies, 3rd Edition
978-1-118-17678-8

Laptops & Tablets
For Seniors For Dummies,
2nd Edition
978-1-118-09596-6

Smartphones & Tablets

BlackBerry For Dummies,
5th Edition
978-1-118-10035-6

Droid X2 For Dummies
978-1-118-14864-8

HTC ThunderBolt
For Dummies
978-1-118-07601-9

MOTOROLA XOOM
For Dummies
978-1-118-08835-7

Sports

Basketball For Dummies,
3rd Edition
978-1-118-07374-2

Football For Dummies,
2nd Edition
978-1-118-01261-1

Golf For Dummies,
4th Edition
978-0-470-88279-5

Test Prep

ACT For Dummies,
5th Edition
978-1-118-01259-8

ASVAB For Dummies,
3rd Edition
978-0-470-63760-9

The GRE Test For
Dummies, 7th Edition
978-0-470-00919-2

Police Officer Exam
For Dummies
978-0-470-88724-0

Series 7 Exam
For Dummies
978-0-470-09932-2

Web Development

HTML, CSS, & XHTML
For Dummies, 7th Edition
978-0-470-91659-9

Drupal For Dummies,
2nd Edition
978-1-118-08348-2

Windows 7

Windows 7
For Dummies
978-0-470-49743-2

Windows 7
For Dummies,
Book + DVD Bundle
978-0-470-52398-8

Windows 7 All-in-One
For Dummies
978-0-470-48763-1